Impressionism

A FEMINIST READING

Impressionism

A FEMINIST READING

◆

THE GENDERING OF ART, SCIENCE, AND NATURE IN THE NINETEENTH CENTURY

NORMA BROUDE

ICON EDITIONS

WestviewPress
A Division of HarperCollins*Publishers*

Originally published in 1991 by Rizzoli International Publications, Inc., New York, N.Y.
Westview Press/Icon Editions paperback published in 1997.

Published in 1997 in the United States of America by Westview Press, 5500 Central Avenue, Boulder, Colorado
80301-2877, and in the United Kingdom by Westview Press, 12 Hid's Copse Road, Cumnor Hill, Oxford OX2 9JJ

Library of Congress Cataloging-in-Publication Data
Impressionism: A feminist reading: the gendering of art,
science, and nature in the nineteenth centry / Norma Broude.
p. cm.
Includes bibliographical references and index.
ISBN 0-8478-1397-5.—ISBN 0-06-430232-6 (pbk.)
1. Impressionism (Art)—France. 2. Painting, Modern—19th century—France.
3. Feminism and art—France. I. Title.
ND547.5.I4B76 1991
759.05'4—dc20 91-10846
CIP

The paper used in this publication meets the requirements of the American National Standard for Permanence of
Paper for Printed Library Materials Z39.48-1984.

10 9 8 7 6 5 4 3 2 1

Note on the illustrations:
All works reproduced in this book are oil on canvas unless otherwise indicated. Measurements are given in inches
and centimeters, height before width. Unless otherwise noted, all photographs have been supplied by the owners or
custodians of the works and are reproduced with their permission. In the paperback edition the colorplates between
pages 81 and 109 are printed in black and white.

Table of Contents

◆

PREFACE *6*

INTRODUCTION. *On Impressionism and the Binary Patterns of Art History 8*

PART I
Impressionism and Romanticism *17*

CHAPTER 1. *Thematic Continuities 18*
CHAPTER 2. *Effect and Emotion in Romantic and Impressionist Painting 28*
CHAPTER 3. *Effect and Finish: The Evolution of the Impressionist Style 69*

PART II
Impressionism and Science *110*

CHAPTER 4. *"Romantic" versus "Normal Science" in the Eighteenth and Nineteenth Centuries 111*
CHAPTER 5. *Science and the Arts 114*
CHAPTER 6. *The Optical as a Path to the Personal: The Writings of Duranty, Martelli, and Laforgue 124*

PART III
The Gendering of Impressionism *144*

CHAPTER 7. *The Gendering of Art, Science, and Nature in the Nineteenth Century 145*
CHAPTER 8. *Impressionism and Symbolism 159*
CHAPTER 9. *The Republican Defense of Science and the Regendering of Impressionism 165*
CHAPTER 10. *Impressionism and Modernism 174*

NOTES *181*

INDEX *190*

In this book I have applied the insights of feminist scholarship to offer a new reading of the history of Impressionism, one that alters our understanding of the Impressionists and their art and that holds implications for many areas of debate in this field. The book is not directly about women or the roles they have played as makers, subjects, or viewers of works of art—some of the issues conventionally associated with feminist inquiry. Rather, it is about the socially constructed category of gender and the crucial role that gender distinctions have played in shaping not only the reception but also the interpretations and misinterpretations of Impressionist landscape painting that have prevailed over the last one hundred years.

This study represents a fusion of several interrelated facets of my intellectual life. I have been thinking about French Impressionist landscape painting in relation to the Romantic tradition since the 1960s, when Impressionism was being broadly equated with Realism and Naturalism. At that time, my study of the Romantic elements in nineteenth-century Italian painting prompted me to recognize that French Impressionism, too, was a subjective art, an art that emphasized the expression of feeling and emotion generated by contact with nature. How this art came to be seen by the middle of the twentieth century as objective, scientific, and devoid of feeling was the question that took form and intermittently troubled me during the 1970s and the early 1980s, when my increasing identification with the feminist branch of art history led me to think more critically about the canonical myths and misconceptions of the traditional discipline and about the role that gender bias had played in their formulation.

Even then I recognized that Romanticism and Realism had been endowed with culturally gendered attributes and identities in the art history and criticism of the earlier twentieth century, and I suspected that the insistence upon placing Impressionism in one camp rather than the other had something to do with those associations. Then, in the 1980s, an explosion of gender studies not only in art history but in such fields as the history of science, literature, philosophy, linguistics, and cultural anthropology provided insights that helped me to understand the scientific justification for Impressionism developed by critics in the late nineteenth and early twentieth centuries as a function of the gender-laden values of modern culture. Although I began this book with a series of questions, my project soon shifted from simply trying to answer those questions to tracing a dynamic pattern of cultural myth making, one in which the social construction of gender played a key role.

The gendered relationship between nature, art, and science has a long and complex history that predates the modern period and the particular problem of interpretation on which this book has focused. That older history, which still remains to be told, is the subject of a study currently in progress by my colleague and partner, Mary D. Garrard, to whose work in this area my own is intimately connected and deeply indebted. In application to our separate fields, we have long shared a fascination with the issues that provide the conceptual basis for this book. I am grateful to her for shared insights and creative discussions, and for understanding, more than anyone else could, what the unfolding and real-

ization of this project have meant to me over the years. Her own forthcoming book on nature, art, and gender in Renaissance Italy will tell another part of this story.

I am grateful not only to the scholars in cognate fields but also to the many art historians whose names appear throughout this book and whose innovative thinking has greatly stimulated me—even when, as in the case of many recent writers on Impressionism, I have disagreed with some of their basic premises and conclusions. In part, my revisionist interpretations have differed from theirs because I have chosen a different position—one afforded by the interdisciplinary perspective that has helped us in recent years to locate some of the most powerful and influential beliefs and intellectual constructs of our culture within a larger gender discourse.

I would like to express my appreciation to The American University for the Sabbatical Support Award (1989–1990) that enabled me to complete my work on this manuscript. I am also fortunate to have had the assistance of the able staff members at Rizzoli International Publications who saw this book through its various stages of production. I would like to mention in particular Cynthia Deubel Horowitz (picture researcher), Michael Bertrand (production editor), Pamela Fogg (designer), and Vittoria Di Palma (editorial assistant). Finally, my sincere and special thanks go to Charles Miers, Associate Editorial Director at Rizzoli, for his astute editorial guidance and unfailing support.

March 1991
Washington, D. C.

On Impressionism and the Binary Patterns of Art History

Throughout much of the twentieth century French Impressionism has been regarded as an emotionally impassive art of "optical realism," diametrically opposed in spirit and intention to the Romantic art that preceded it. In the interests of being objectively and even scientifically true to visual reality, the Impressionists were said to have painted exclusively out-of-doors, before the motif in nature. There they worked quickly, spontaneously, and necessarily without reflection, so that they might win the race with changing, fleeting nature and accurately record the scene before them under a single and consistent moment of natural illumination. According to this once canonical view, the Impressionists cared nothing for traditional concepts of composition or meaning in art. The motifs before which they set up their easels were of no intrinsic interest or importance to them, for they were concerned only with recording their optical sensations of light and atmosphere as accurately and as immediately as possible. A major exponent of this popular position in the early twentieth century was the influential formalist critic Roger Fry, who described Claude Monet in 1932 as an artist who "cared only to reproduce on his canvas the actual visual sensation as far as that was possible." Fry continued:

> Perhaps if one had objected to him that this was equivalent to abandoning art, which had always been an interpretation of appearances in relation to certain human values, he would have been unmoved, because he aimed almost exclusively at a scientific documentation of appearances.[1]

The authority of this critical position, which provided the underpinnings for the mid-twentieth century's formalist view of Impressionism, reverberated in the literature even as late as 1973, when Kermit Champa wrote of Impressionism:

> Its iconology is uninteresting, its sociohistorical role unimportant. The greatness and the depth of Impressionist painting lies, so to speak, on its surface—a surface which year after year expands its importance as an object of purely visual interest. . . . Subject matter seems in most instances to be a pretext rather than an essential factor in determining the final appearance of a given picture.[2]

This understanding of Impressionism as a form of optical realism, devoid of significant content or feeling, was thus remarkably stable during the first three quarters of the twentieth century. And to this day, even in the wake of postmodern revisionism, it is a view that has been only partially dismantled and discredited. The clearest inroads to date have been made by a recent generation of social historians of art, whose approach to Impressionism was anticipated in the 1930s by the work of Meyer Schapiro. In an era when the influence of Fry and

formalism was still strong, it was Schapiro who first courageously pointed to the fact that Impressionist pictures do indeed have subjects and, what is more, a definable iconography. In 1937 he wrote:

> In its unconventional, unregulated vision, in its discovery of a constantly changing phenomenal outdoor world in which the shapes depend on the momentary position of the casual or mobile spectator, there was an implicit criticism of symbolic social and domestic formalities, or at least a norm opposed to these. It is remarkable how many pictures we have in early Impressionism of informal and spontaneous sociability, of breakfasts, picnics, promenades, boating trips, holidays and vacation travel.[3]

Arguing for the significance of the Impressionists' subjects and their point of view as part of the process of changing life-styles and values in France during the second half of the nineteenth century, Schapiro took a position, more than a half century ago, which has borne significant fruit only in the last decade in the consistently applied, sociohistoric approach to Impressionism of such scholars as T. J. Clark, Robert Herbert, Paul Hayes Tucker, Richard Brettell, and Scott Schaefer, among others.[4] Although this approach has perhaps had its most far-reaching effect on interpretations of the work of figurative painters associated with the movement (for example, Clark's analyses of such pictures as Manet's *Olympia* and *A Bar at the Folies-Bergère* in relation to concepts of "modernity," popular culture, and shifting categories of class in late nineteenth-century capitalist society), the meanings of the Impressionist landscape have also been explored. The relationship between Paris and its environs as sites for industry and recreation and the political self-image of France as embodied in its countryside and landscapes are among the issues that have been taken up by these writers, who have thus radically altered the old formalist notion that the subject matter of Impressionism was without particular meaning or importance.

More resistant to revisionism, however, has been the contention that Impressionist landscape painters were impassive recorders of vision, faithful both to nature and to the operations of the human eye — and hence motivated by an impulse that was at once naturalist and scientific. Even among recent writers who have emphasized the social and historical context of Impressionism, the myth of its "objectivity" and its unbridgeable separateness in this regard from the Romantic art that preceded it has remained a central tenet. Thus, Scott Schaefer writes of the Impressionists in the catalogue of the 1984 exhibition *A Day in the Country: Impressionism and the French Landscape*:

> Their interest was in reducing the subjective interpolation of the moods of man on to his surroundings, in eliminating the reflection of human feelings in nature seen, for example, in works by the Barbizon painter Diaz. They took the Barbizon landscape, then, and cleared it of its more overtly Romantic associations, of its subjective morality. They brought to it a degree of objectivity that had existed before only in sketches painted directly from nature. These are the most significant differences between the Impressionist landscape and its predecessors.[5]

Behind this statement, and in part responsible for the persistence of the view of

Impressionism that it presents, is the binary thinking that has long been entrenched in the art historical literature of the modern period, a literature that has defined the heroic and canonical struggles of nineteenth-century French art in dualistic and chronologically linear terms: Romanticism in opposition to Neoclassicism, Realism and Impressionism pitted against Romanticism, and Realism and Impressionism ultimately vanquished by their opposites in Symbolism and Post-Impressionism. A major example of and support for this mode of art historical patterning in the twentieth century has been Walter J. Friedlaender's book *David to Delacroix*, first published in 1930. Here, the influential German art historian identified two major and antithetical currents in French painting after the sixteenth century, the "rational" and the "irrational." He then traced this ethical and stylistic polarity in French art back to the *Poussinistes-Rubénistes* debates of the seventeenth-century French Academy, and projected it forward in time to the Ingres versus Delacroix, line versus color, Classicism versus Romanticism debates of the early nineteenth century, maintaining further that the influence of this basic polarity can be seen in French art throughout the nineteenth century.[6]

Why, then, in spite of its reliance on color instead of drawing, has Impressionism come to be aligned in our own century with the so-called rational and objective currents in the aesthetic tradition of mid-nineteenth-century France (namely Realism in painting and Naturalism in literature)? In the 1870s and 1880s the authority of science was invoked by a few early supporters of Impressionism, who attempted to justify this unorthodox style by linking it to current scientific explanations of how the human eye operates. For example, some of these early defenders of Impressionism made use of the work of the German physiologist Hermann von Helmholtz, who had established that the human eye itself distinguishes only sensations of color and tone, thus demoting "line," in scientific terms, to the level of perceptual illusion. Building upon an issue that had thus already been introduced into the critical debates about Impressionism, Symbolist critics in the 1890s—who were now disparaging rather than defending Impressionism—characterized it as an art of optical realism and scientific objectivity, a characterization that has clung to it ever since. One result of this has been the irrevocable dissociation of Impressionism from the so-called emotional and subjective currents in French art of that period, namely the Romantic movement, from which, in fact, many of its strategies were clearly derived.[7]

Strangely enough, the positioning of Impressionism in this binary system on the side of "rationality" and in the camp of science and Naturalism has persisted even though it has only rarely been the basis for positive assessments of the movement and its goals. During the early years of the twentieth century, this positioning of the movement elicited unfriendly and pejorative judgments, first from antinaturalist critics such as Emile Bernard and Maurice Denis and then from formalist critics such as Fry. By the 1930s the prevailing point of view, which linked a "scientific approach" with a loss of "emotion" in Impressionist painting, was summed up most clearly by James Johnson Sweeney, who wrote in 1934 of Monet's paintings that they are "frankly documentary in character" and that they "ape the scientific in their mode of approach." Sweeney drew a further analogy between Monet's Impressionism and Naturalist literature, in particular the writings of Emile Zola and Anatole France, with whom, he said, Monet shared a taste for "scrupulousness of *reportage*. . . delicacy of nuance [and a] complete disregard for structural unity." He continued:

This shift of interest from structural integrity, like the decay of faith in other walks of life, had left the artist without any sound plastic basis. The encouragement of a scientific, detached impassivity struck directly at any link with the emotions. And in a conscientiously reportorial notation of natural phenomena there was no place for the imagination or fantasy.[8]

Such criticisms of Impressionism were widespread during the 1930s, when Surrealism dominated the avant-garde. With the emergence of Abstract Expressionism in the 1940s and 1950s, however, positive attention became focused on the fluent brushwork and painterly surfaces of Impressionism. And Monet was now rehabilitated, thanks largely to the efforts of the formalist critic Clement Greenberg, who praised Impressionism for having planted "the first seed of modernism" and for having treated nature impassively, as "the springboard for an almost abstract art." [9]

While qualitative assessments of French Impressionism and its avant-garde status have thus fluctuated during the twentieth century, the prevailing critical and art historical understanding of its attitudes and methods nevertheless stood firm, in accordance with the binary pattern that governed the writing of modern art history. As a result, an impenetrable critical wall was erected and maintained between Romanticism and Impressionism, and much of the evidence that might have supported their relationship was for a long time forced into other interpretive channels.

In 1959, for example, George Heard Hamilton altered the prevailing view of Claude Monet as a lifelong Impressionist by detaching the artist's series paintings of the 1890s from his earlier, Impressionist oeuvre and grafting them instead onto the history of Post-Impressionism. Finding in these late Monet paintings elements "which are different from and even antithetical to the character of earlier Impressionism," Hamilton suggested that "such art might more properly be described as symbolist since whatever appears in these paintings is presented and received as much by the inner as by the outer eye."[10] Supporting his contention with a careful reading of one of Monet's own rare statements of intention at this time, Hamilton wrote:

In an important letter to Geffroy on 7 October 1890, when he was working on the "Haystacks," he revealed in a few words the change which had occurred in his ideas: "I am driven more and more frantic by the need to render what I experience." The French words for the last clause are: *"du besoin de rendre ce que j'éprouve."* The verb *éprouver* means to feel, to experience (as a sensation), to sustain, to suffer, to undergo. It is a word rich in expressive connotations, but it cannot be twisted to mean merely "to see."[11]

"The true subject of the 'Haystacks'" (colorplates 1 and 10), said Hamilton elsewhere in the same essay, "is not the stacks themselves or the weather or even the light (so long considered by contemporary and later critics as Monet's real subject), but the painter's experience, the projection of his particular feelings."[12] Of the "Cathedrals" (colorplates 2 and 3), he wrote:

The ultimate meaning of these paintings is not to be found in what they

represent to us but in what they do to us. . . . the twenty moments represented by the twenty views of Rouen are less views of the cathedral (one alone would have been sufficient for that), less even twenty moments in the going and coming of the light (which is an insignificant situation), than twenty episodes in Monet's private perceptual life. They are twenty episodes in the history of his consciousness.[13]

While Hamilton's perceptive reading of these pictures did much to alter the prevailing understanding of the development of Monet's oeuvre, it did nothing to change the conception, then current, of the larger goals and methods of Impressionism in general. Historically speaking, Monet's late series paintings were seen by Hamilton as both products and manifestations of the dominant Symbolist milieu of the 1890s, and as such they represented to him Monet's belated rejection (the more clear-cut defections of Pissarro and Renoir had come in the 1880s) of his earlier, Impressionist point of view. That Impressionist point of view was still understood by Hamilton to have dictated a passionless and objective recording of visual sensations. If Monet's "Post-Impressionist" pictures of the 1890s were "statements of the conditions of consciousness," then, by contrast, the earlier, "Impressionist" works were for Hamilton merely "pictures of places."[14] Citing Monet's Gare Saint-Lazare series of 1876–1877 (colorplates 29–32) as typical of the Impressionist outlook and its limitations, Hamilton wrote:

> Monet was as much at the mercy of the objects he was observing as is a passenger on a train . . . he must paint the shifting clouds of smoke and steam as they appeared to his eye. In the documentary sense, such pictures are temporally and spatially very much like photographs. . . . Because the observer's visual experience is apparently instantaneous, it necessarily precludes any possibility of reminiscence or reflection . . . never yet in the history of painting had visual experience been so spatially and temporally, so intellectually and emotionally restricted.[15]

Hamilton's placement of Monet's late work within the context of late nineteenth-century Symbolist art has been sustained by most later writers despite the serious and generally overlooked problem that it raises — namely, that there exists nothing truly comparable to Monet's work of the 1890s, either visually or emotionally, in Symbolist or Post-Impressionist painting of the same period. To find a meaningful parallel for Monet's continuing attentiveness to coloristic and tonal effects of atmosphere and for his creation of effects of light that range from the bold and spectacular to the ethereal and evanescent in his paintings from the 1890s on, one must turn not to Symbolism but rather to the earlier Romantic landscape traditions of the 1830s from which Monet developed, and in particular to the work of such artists as Turner, Rousseau, and Millet (colorplates 4–7, 11, 18).

But in 1959, when Hamilton was redefining Monet's late works as projections of his personal feelings and experiences, such a broader connection with historical Romanticism was strangely inadmissible in the art historical literature. And it remained largely so during the decades that followed, even though art historians often had to struggle to bring anomalous responses to Impressionist painting into line with the inherited dualistic pattern that continued to govern nineteenth-century French art historiography. To accommodate perceived contradictions and to

maintain the paradigm, scholars were driven, for example, to postulate a "crisis in Impressionism" that occurred in the early 1880s, thus shifting the dividing line between Monet's so-called Impressionist and Symbolist phases backward in time, from the 1890s to the early 1880s, and effectively shrinking the period for which the traditional definition of Impressionism as an optically oriented, emotionally impassive style of painting need remain plausible down to a single decade, the decade of the 1870s.[16]

It was not until 1978, with the appearance of Richard Shiff's groundbreaking essay "The End of Impressionism," that the way was finally prepared for a major shift in Impressionist scholarship and for a change in our understanding of the goals and intentions as well as the duration of the Impressionist movement. Setting out to clarify the nature of the critical climate in which Symbolism grew, Shiff pointed to elements in Impressionist criticism from the 1870s, 1880s, and 1890s that belied the prevailing view of Impressionism as an "objective" and "Realist" art, thereby establishing the ground for a renewed and more historically accurate understanding of Impressionism as an expressive and subjective form of painting. Positing a natural evolution and continuity between the critical language and aesthetic concerns of the Impressionists and those of the Symbolists, Shiff went so far as to conclude: "By this argument the distinctions between Impressionism and Symbolism do not become irrelevant; but in some cases these general categories collapse."[17]

In a revised version of this essay published in 1986, Shiff noted that the Symbolist qualities of late Impressionism have been taken increasingly into account by scholars in the recent literature, but the significance of these qualities for our understanding of early Impressionism, he said, "remains largely unrecognized." "Critics and historians," Shiff continued, "have persisted in contrasting early styles to late ones and have, at the same time, endorsed the notion of an artistic evolution from materialism to spiritualism. They appear reluctant to give up such formulaic appreciations."[18]

An attachment to dichotomous thinking, as Shiff observes, does indeed persist among art historians in this field, despite evidence that has steadily mounted during the last two decades that might effectively challenge the Impressionist paradigm. In addition to Shiff's theoretical studies of Impressionism in general, major contributions to the Monet literature—in particular the work of John House, Joel Isaacson, Robert Herbert, and Grace Seiberling—have shown us that Claude Monet (dubbed "the Impressionist, *par excellence*" in 1878 by Théodore Duret) was an artist who—contrary to the later popular depiction of him as "only an eye," a spontaneous but essentially passive and impassive recorder of nature out-of-doors—did in fact paint upon occasion in the studio away from nature, was capable throughout his career of changing his mind and changing nature within his pictures for the sake of working out and balancing his compositions, and was equally capable of reflecting upon and endowing his work with intentional meaning.[19] These findings, however, which might be used to paint a picture of Monet as a "feeling" artist, have been used almost exclusively to depict him as a "thinking" artist, sustaining the point of view that separates Monet and his work from the context of Romanticism and buttressing the traditional association of Impressionism with the "rational" currents in the nineteenth-century tradition.

Thus the paradigmatic definition of "pure" Impressionism as an emotion-free, objective, and scientifically motivated form of optical realism persists, even

though the binary thinking that supports it has been gradually undermined by postmodern theorists outside the discipline of art history and has lost much of its former authority as a structural discourse. What accounts for art history's reluctance to question this definition and to jettison the rigid dividing line between Impressionism and Romanticism that was set up by earlier twentieth-century criticism?

In this book, a feminist reading of the history of Impressionism, I will argue that such binary thinking about nineteenth-century art movements derives much of its power in the twentieth century from its traditional basis in the social construction of gender opposition, and, specifically, from our culture's habitually gendered understanding of the relationship between art, science, and nature. I will examine the crucial role played by gender stereotype and association in determining not only the early critical reception of Impressionism, but also its eventual dissociation from Romanticism and its realignment with Naturalism in the art historical literature.

The gendering of eighteenth-century and nineteenth-century styles of painting has long been a familiar part of the writing of art history in our century. Friedlaender, for example, formulated his distinctions between "rational" and "irrational" currents in French painting on this basis, associating the "irrational" with the "feminine" frivolity, amorality, painterly style, and colorism of the Rococo and connecting the "rational" with the "virile" attitudes, didactic fervor, and linear style of Neoclassicism.[20] Such gendering of the elements of style was common in the nineteenth century as well, reflected for example in the statement by Charles Blanc, the influential Beaux-Arts administrator and historian, that "drawing is the masculine sex of art and color the feminine one."[21]

In accordance with this established polarity, Impressionism, with its colorism and diffuse drawing, was described by conservative detractors in the 1880s and 1890s as a feminine style of painting. It was not style alone, however, that elicited this characterization, but, even more centrally, what was described as the Impressionist painter's "passive" attitude toward nature. The identification of this "feminine" attitude and the hostile criticism it generated have long been obscured by the emphasis that early supporters placed on the Impressionists' style and the justification of that style in scientific, or "masculine," terms—an emphasis that laid the groundwork for the eventual regendering of the movement in our own century. That process, however, has been by no means a simple or direct one. Over the last one hundred years, a variety of competing discourses has been brought to bear upon the interpretation of Impressionism—not only in different periods but often in the same period—by groups and individuals who have had separate agendas or a personal stake in determining how Impressionism was to be understood and valued.

My project in this book, then, will be to trace the paths along which specific cultural readings and misreadings of Impressionism have been relayed to us in the twentieth century, and in so doing, to expose and deconstruct—in a far more general sense—the workings of Western phallocentrism in the production and dissemination of cultural meaning. While the analyses that I will present here did not grow out of a purely theoretical or philosophical position, they are nevertheless in accord with some of the basic tenets of postmodern and post-structuralist theory—in particular Jacques Derrida's conception of the inherently oppressive and hierarchical nature of binary oppositions, Michel Foucault's

analyses of the relationship between cultural discourses and power, and the postmodern recognition of the interpretive multiplicity of cultural meaning.

At the same time, however, as a historian, I have resisted the fashionable notion that "the author is dead" and that there can exist no stable interpretive context for the determination of meaning in a work of art.[22] While such meaning over time may be contingent upon how, where, when, and by whom a work of art is seen, I do not believe that this necessarily invalidates the historical existence of authorial intention. I would argue that it is not only possible to identify an artist's original intention but that it is all the more essential to do so when (as in the case of Impressionism) that intention was quickly subsumed by competing interests and discourses in contemporary and succeeding cultures. For we will never fully comprehend the fragility of artistic intention in the face of these larger forces of cultural history making —nor will we ever adequately measure the power of the dominant culture to absorb dissenting values and to impose meaning on and through works of art—if we deny ourselves this historical starting point: the artist's conception of his or her own unique intention (however culturally predetermined or philosophically mistaken this may seem to some today).

I therefore begin by demonstrating in part I the self-conscious continuity that existed between Romantic and Impressionist landscape painting, focusing on expressive goals and pictorial techniques shared in common, and considering some of the innovative methods and practices evolved by the Impressionists as responses to aesthetic issues and concerns inherited directly from their Romantic predecessors. My discussion of Impressionism as a form of Romantic painting is based on the work of the landscape school, exemplifed most consistently by Claude Monet. In thus defining Impressionism, I am adopting a distinction that was already being made in the late 1870s between the "real Impressionists," as the Italian critic Diego Martelli called them, referring to the work of the landscape school (represented principally by Monet, but also by Pissarro, Sisley, and others), as opposed to the very different, thematic modernity of figure painters such as Manet, who never showed with the Impressionist group, and Degas, who did exhibit with them but who preferred to be called a "Realist."[23]

Although the Romantic roots of Impressionism thus provide the essential foundation for this book, its organizing construct is not Romanticism per se, but rather the closely related and more embracing issue of gender. For in the early nineteenth century it was Romanticism that appropriated feminine subjectivity for the arts, setting up issues and problems concerning the status of subjectivity and the gendered role of art in nineteenth-century French culture that have remained fundamental to the course of art criticism—and art making—ever since.

In part II I offer a review and a contextual reinterpretation of the late nineteenth-century literature upon which connections between Impressionism and science have been based, distinguishing for the first time in this context between the positivist, or "normal," science that prevailed in France during the Impressionist era and the "Romantic" science, more congenial to the arts, that briefly challenged the mechanistic paradigm of mainstream science early in the nineteenth century. By thus examining the overly generalized notions of "science" and "positivism" that have been used in discussions of Impressionism until now, I aim to challenge the accepted view of their significance for artists in general in the nineteenth century and for the Impressionists in particular. In taking this approach, I have been stimulated by advances in thinking made in other disci-

plines, particularly in the history and philosophy of science itself. In the 1960s Thomas Kuhn's investigations into the nature of scientific communities, his theory of the role of the paradigm (a body of shared assumptions, procedures, and aims) in defining a given community's conception of "normal" science, and his description of scientific revolutions as paradigm shifts radically changed the way we look at science and its history, helping to dispel the myth of its unitary identity and objectivity.[24] Those insights, though broadly suggestive to scholars in a variety of disciplines, including art history, have never been applied in a specific way to the historical investigation of art movements—even when, as in the case of Impressionism (whose interpretation has depended closely on prevailing notions about science and its history), it makes particular sense to do so.

In part III I take up the feminine gendering of Impressionism in the late nineteenth century and explore some of the competing interests and interpretations that led to the movement's eventual regendering or "masculinization" in the criticism of the modern era. An essential framework for the analyses I present here is provided by recent feminist scholarship in a variety of fields, including literature, philosophy, anthropology, and, in particular, the history of science, where feminist scholars such as Evelyn Fox Keller, Carolyn Merchant, Brian Easlea, and Sandra Harding have explored the role played by gender ideology in the evolution of modern science. It was this revolutionary body of work that led me to consider some of the major issues discussed in part III of this book, namely, the gendered relationship of art to science and nature in the nineteenth century and the modern period's construction and evaluation of artistic subjectivity in gendered terms.

Recent art historical scholarship has begun to emphasize the role of "subjectivity," not only in the art of the Impressionists (the work of Shiff, who would in fact erase the boundary between Impressionism and Symbolism on these grounds), but even in the Realist art of Courbet.[25] Following both upon this line of thought and my own critique of binary patterning in this field, we might well ask at this point whether the time has come to collapse customary distinctions among art movements in the nineteenth century, distinctions that have traditionally been made on the basis of a dualistic opposition between subjectivity and objectivity. I would argue that such distinctions must continue to be made simply because, in historical terms, we are dealing with a culture that imposed these binary distinctions upon itself.

But what others have seen as a series of styles that contradicted and replaced one another in the nineteenth century in a succession of so-called subjective and objective points of view, I will present here instead as facets of a gendered discourse—one in which art struggled to define and to legitimize itself in the positivist nineteenth century vis-à-vis a scientific establishment that assumed the mantle of objectivity and reason (hence gendering itself as male) and a natural world (traditionally gendered as female) that served as the contested site and focus for the activities of both. By thus confronting the mechanisms of gender and power that supported the familiar subjective/objective dichotomy—and that have since produced consistent misreadings of Impressionism—my aim in this study will be to uncover the real issues that underlay the dualisms and to propose a major paradigm shift for our understanding not only of Impressionism and nineteenth-century French art but of modern art in general.

Impressionism and Romanticism

The Impressionists did not come of nothing, they are the products of a steady evolution of the modern French school.[1]
—Théodore Duret,1878

While most general accounts of the Impressionists briefly acknowledge the artists' Romantic predecessors and their involvement with nature, the precise ways in which the tradition of Romantic landscape painting might have continued to be meaningful to the Impressionists have never been adequately explored. Instead, the Romantic landscape painters have themselves often been treated ahistorically in this context, as *impressionnistes manqués*. In evaluating the importance of the Barbizon painters for the Impressionists in her book of 1967, for example, Phoebe Pool wrote: "Eventually, artists [i.e., the Impressionists] were to become more interested in the small dabs of paint than in what they represented. But Millet, Rousseau and Daubigny did not reach that point; they still had a more Romantic interest in nature."[2]

A similarly distorted, evolutionary view was also applied in the twentieth century to discussions of John Constable and J. M. W. Turner, who, for a long time, were essentially understood and valued as precursors of Impressionism.[3] This ahistorical approach to the Romantic landscape painters has been corrected by recent scholarship, which encourages us to look at Constable and Turner in the context of their own Romantic predecessors and contemporaries—artists such as John Crome, Alexander and John Robert Cozens, Philip de Loutherbourg, Caspar David Friedrich, and Théodore Rousseau—rather than as incomplete steps on the path toward the twentieth century's mistaken notion of a naturalist and formalist Impressionist ideal.

It is time now to extend to the Impressionists as well the implications of the late twentieth century's revised and historically more viable attitude toward Constable and Turner—to shift our perspective, in other words, so that the Impressionists, too, may be placed more consistently and more meaningfully within the context provided for them by their own predecessors and contemporaries—artists such as Camille Corot, Théodore Rousseau, Charles François Daubigny, and Johan Barthold Jongkind, as well as Constable and Turner. Approached this way, the formal and expressive resemblances between a Turner and a Monet, for example (colorplates 4 and 5; 14 and 15), would no longer be seen as a surprising prefiguration of the later artist on the part of the earlier one, but as the period itself would have been inclined to see it, as a growth and development of the later artist out of a tradition exemplified by the earlier one. As the French novelist and art critic Théophile Gautier wrote in 1877 on the relationship of the contemporary present to the Romantic past: "Today has its roots in yesterday; ideas like arabic letters are linked to what has come before and to what follows."[4]

CHAPTER 1

Thematic Continuities

In his book *Monet at Argenteuil* (1982), Paul Hayes Tucker describes the rapid encroachment of industry and urban blight in the 1870s that finally impelled Claude Monet to leave the once charming suburban town of Argenteuil, where he had made his home from 1871 to 1878, and to take refuge in the more isolated and still idyllic town of Vétheuil. He describes, too, how in the pictures painted during Monet's years in Argenteuil, the artist consistently turned his back on the uglier and more unpleasant aspects of the changing environment there.[5] But Tucker does not infer what we might be tempted to call "Romantic escapism" from these actions; in fact, he concludes that for most of the six years that he spent in Argenteuil, Monet's pattern of activity showed him to have been an artist who was committed to the principles of modernity and progress, an artist whose work was "celebrating progress, the new religion."[6]

The assumption of an unbridgeable gulf between Impressionism and Romanticism is thus as pervasive in the recent sociohistoric literature on Impressionism as it was in the older formalist canon. It was also perpetuated, ironically, in the work of Robert Rosenblum, whose 1975 book *Modern Painting and the Northern Romantic Tradition: Friedrich to Rothko* presented a new and daring alternative reading for the history of modern art, a reading based upon a vision of the centrality of the northern Romantic tradition. Rosenblum persuasively charted a vital and continuous current of Romantic feeling in the art of northern Europe and the United States from Friedrich to Rothko—virtually down to the present day. He saw this continuity, however, only in art that is overtly transcendental or symbolic in its structure or in its imagery and content. And in order to define the character of this art, he depended heavily on the conventional view of Impressionism—and in particular the art of Monet—to provide a contrasting foil. Of a typical Impressionist landscape, Monet's *The Banks of the Seine at Argenteuil* of 1872 (fig. 1), he therefore wrote:

> The picture includes almost every motif from which Friedrich extracted such portentous symbols—figures standing quietly on the edge of a body of water; boats that move across the horizon; a distant vista of a building's Gothic silhouette, enframed by almost a nave of trees; and even a rather abrupt jump from the extremities of near and far. Yet, somehow, though the painting conveys a gentle, contemplative mood, it also insists on the casual record of particular facts at a particular time and place. The clouds will shift, the figures will move, the trees will rustle in the breeze, the boats will pass. That quality of the momentary, of the random, of the specifically observed, thoroughly counters Friedrich's solemn and emblematic interpretation of the same motifs.[7]

As Rosenblum observed, "almost every motif" that is familiar to us in Friedrich's art recurs here. This is what should give us pause when we consider the differences between these two artists. It should encourage us to reexamine our emphases and to ask if we may not have been overstating those differences in

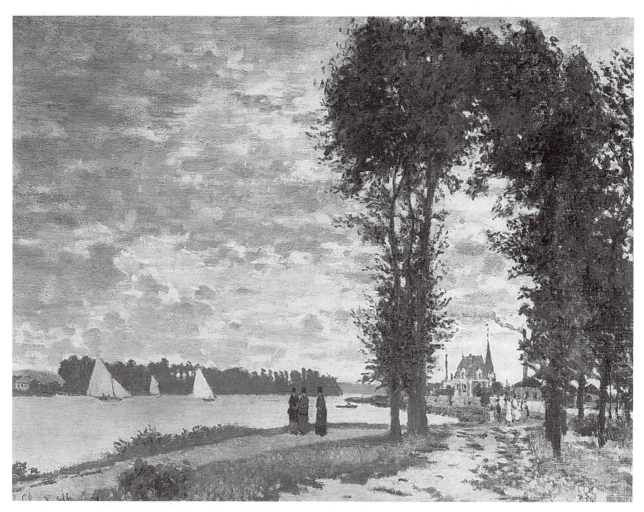

1. Claude Monet (1840–1926).
THE BANKS OF THE SEINE AT ARGENTEUIL. *1872.*
19 ¾ x 25 ½" (50 x 65 cm). Ronald Lyon Collection.
Photograph, A. C. Cooper, Ltd.; courtesy Christie, Manson & Woods Ltd., London

conformity with the rule of polarity that was for so long fundamental to art historical thinking about this period.

Certainly, the differences in mood and inflection between Impressionism and German Romanticism, which Rosenblum and others would emphasize, are obviously there. Even in the rare Friedrich landscape where the sun shines and the figures engage in relatively unambiguous, leisure-time activity, as in *Chalk Cliffs on Rügen* of 1818–1820 (colorplate 8), the human figures are still portentously dwarfed by the colossal forms of nature. In this instance, three well-dressed people, identified as the painter himself, peering over the edge of the cliff, with his wife, Caroline, and his brother, Christian,[8] are shown exploring the rugged and brightly illuminated landscape on an island in the Baltic. Like them, we cling to the rocks in the foreground, in awe of the abyss below, separated physically by insurmountable spatial barriers from the vastness of the sea and the almost supernatural glow of the light-filled space beyond. Despite the specificity of the

place, the people, and their activity, the symbolic implications of the image are unmistakable. The sea here, as in Friedrich's other pictures, can be interpreted as a symbol of infinity, and the ships that move upon it as a symbol of human destiny and transience. In the face of this, a comparable work by Monet provides a marked and misleadingly easy contrast in mood. In the *Garden at Sainte-Adresse* of 1867 (colorplate 9), Monet's vacationers, also well-dressed members of his own family, sit on a broad and comfortable terrace, which is fenced and smoothly landscaped. Here, there are no luminous and awe-inspiring depths, no rugged and threatening terrain. Instead, flags flutter in the breeze, sailboats and steamships move toward the horizon, and all is safe, cheerful, and relaxed.

But while there is certainly contrast, art historians, in their search for polarity, have tended to overlook the fact that there is also continuity. Although presented with a lighter inflection and without the overtly intrusive symbolism of Germanic imagery, all the motifs in Monet's work—as well as their implications—are inherited from the Romantic tradition, of which Friedrich is a quintessential representative. Monet's world, too, is one in which people go out into nature in order to feel, to experience, to empathize, and to commune, although, as Frenchmen of a later period, they do so without the melancholic or pantheistic intensity of their earlier Germanic counterparts. Nevertheless, like the paintings of Friedrich (fig. 2), Monet's *Garden at Sainte-Adresse* speaks to us of the stages of life by means of self-conscious juxtapositions, juxtapositions that involve the familiar symbolism of human generations and the movements of ships on the sea. In the foreground, Monet's father, Adolphe Monet, and aunt, Mme Lecadre, are seated with their backs toward us. They look out at the sea and at an array of ships, those Romantic symbols of the individual's passage through life from birth to death. Facing them, Monet's cousin, Jeanne-Marguérite Lecadre, and an unidentified friend or suitor—members of the younger generation—stand and gaze at one another on the edge of the terrace. Behind them, sailing vessels and steamships move upon the water in a deliberate pairing, as Robert Herbert has pointed out, of old and new, establishing in maritime terms the character of "this transitional generation of both sail and steam." In contrast to the fishing boat in the middle distance, a remnant of the fast disappearing traditional life and occupations of this area of France, we are also shown the pleasure boats and commercial vessels that had recently transformed Sainte-Adresse into a flourishing and fashionable suburban resort and neighboring Le Havre, where Monet had grown up, into the busiest seaport in France.[9]

This early work by Monet can be seen as a picture that speaks in terms that are both personal and universal, of past, present, and future, of transience and change, and of the cycles of human life and activity. It does so, moreover, in a symbolic language that is clearly related to that of Monet's Romantic predecessors and adapted, as theirs had been as well, to the conditions and particularities of the artist's own time and place. Precedents abound in Romantic art for such transformations of contemporary scenes and events into images of symbolic portent. A familiar example is Turner's *The Fighting Temeraire* of 1838 (fig. 3), in which an old battleship of that name, a relic of Lord Nelson's heroic victories in the Napoleonic wars, is shown as it is being towed away to scrap at a shipyard near Greenwich several decades after its days of naval glory. Inspired by the event, which he had witnessed on the Thames, Turner translated this ordinary and otherwise unmarked passage into an image that speaks to us in symbolic

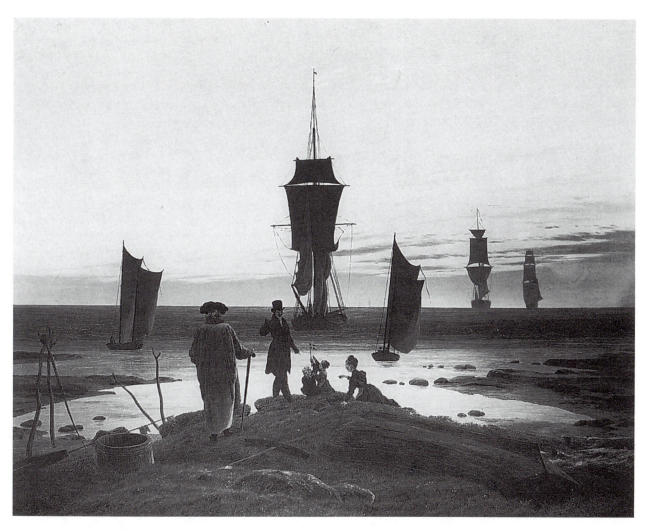

2. Caspar David Friedrich (1774–1840).
THE STAGES OF LIFE. *c.1835.*
28 ¾ x 37" (72.5 x 94 cm). Museum der bildenden Künste, Leipzig

terms—as does Monet's—about destiny and change and about the passing of human life and achievement.

The Romantic fascination with the cycles of life and nature—the stages of life, the cycles of the seasons, the times of the day—was always implicitly a part of Monet's constantly changing personal relationship with the natural world that he loved and painted; most obviously so in his later, serial motifs. In Robert Herbert's discussion of the so-called Haystack series of 1890–1891 (colorplates 1 and 10), which he has identified more precisely and meaningfully as "Stacks of Wheat," Herbert rightly urges us, following Hamilton, to recognize and reassess the rich, expressive, and symbolic significance of these images within the context of contemporary Post-Impressionist art:

Monet invited us to feel, *éprouver*, in front of his art, and to recognize that if there is "instantaneity" in his pictures, it is an instant full of a richness

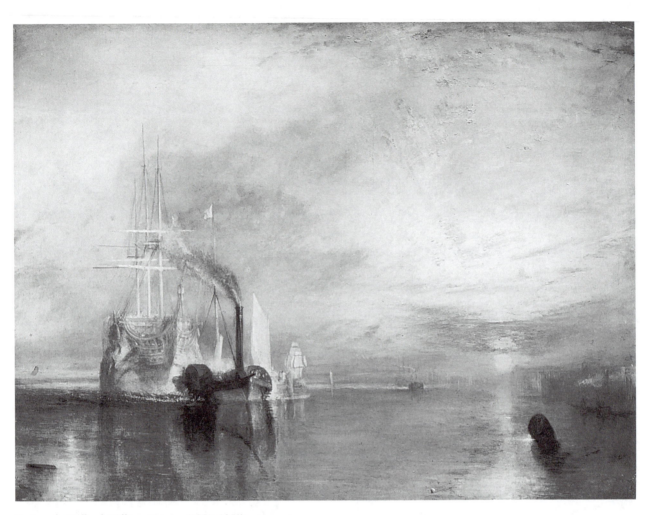

3. Joseph Mallord William Turner (1775–1851).
THE FIGHTING TEMERAIRE TUGGED TO HER LAST BERTH. *1838.*
35 ¾ x 48" (91 x 122 cm). Reproduced by courtesy of the Trustees, The National Gallery, London

that extends deeply into the consciousness of Western man, aware of the symbolic content in the hour of the day and in the season of the year, in the grain which is his provision for the future, in the house-like shape which encloses it, in the rich effulgence of color which is calculated, like that of Edvard Munch or Vincent van Gogh, to move us.[10]

But while the vibrating intensity of the color in some of these works may relate them in style and in general expressive purpose to the work of artists like Munch or Van Gogh, Monet's Post-Impressionist contemporaries of the 1890s, these paintings are far more closely related in their iconography and perhaps even in their message to the early nineteenth-century Romantic tradition, the tradition out of which Monet grew and which he extended well into the first half of the twentieth century.

Behind Monet's paintings of the grain stacks at different times of day and in different seasons of the year, we might recognize an impulse that is broadly

similar to the one that had guided the German artist Philipp Otto Runge in the first years of the nineteenth century when he planned an ambitious—though never completed—cyclical group of four paintings that were meant to represent, albeit in wholly symbolic and emblematic terms, the "Times of Day." Through them, Runge had hoped to express his intense feelings before nature—"this sensation of our kinship with the whole universe," as he put it, when "everything harmonizes in one great chord."[11]

More immediately relevant and even inspirational to Monet's undertaking in the second half of the century is Jean-François Millet's *Grain Stacks*, painted between 1868 and 1875 to represent Autumn in a traditional, four-picture cycle of the seasons (colorplate 11). Exhibited in Paris twice during the years just prior to Monet's work on the "Grain Stack" series —in a Millet exhibition at the Ecole des Beaux-Arts in 1887 and at the Exposition Universelle in 1889[12]— Millet's picture also takes as its subject stacks of grain, three in number, which, as carefully constructed, architectonic shapes, are clearly likened, both in form and in meaning, to three, similarly grouped houses in the distance. Thus, the prototype and perhaps the model for the stack as "the simulacrum of man's house," one of the poetic meanings that Herbert astutely recognizes in Monet's similar treatment of the motif of the grain stack and the house, is to be found in Millet's slightly earlier work. The more general relationship of these pictures, in spirit and in intention, to each other and to a still recognizable and ongoing Romantic tradition was not overlooked by Monet's contemporaries, in particular by those who were themselves still predisposed to identify with the Barbizon tradition. Referring to the "Grain Stack" pictures by Monet exhibited at Durand-Ruel's in 1891, the American painter Theodore Robinson, who worked with Monet at Giverny, wrote enthusiastically to a friend: "Don't fail to see some of his last winter's work, at Durand-Ruel's and elsewhere. It is colossal, something of the same grave, almost religious feeling there is often in Millet."[13]

Among Romantic painters during the first half of the nineteenth century, images that involved storms or catastrophes at sea were very popular as a metaphor for the frailty of humanity in the face of the forces of nature and destiny (fig. 4).[14] Although they lack the dramatic narrative and obvious symbolic portent of these pictures, some of Monet's seascapes and port scenes of the 1860s—for example, *The Jetty of Le Havre in Bad Weather* (fig. 5)—can be related, albeit distantly, to this tradition. Echoes of the Romantic vision of nature's awesome power are heard again, more clearly, in Monet's work of the 1880s, when he painted the spectacular rock formations at Etretat and Belle-Ile, as well as images of storms at sea that vie with Turner's paintings as spectacles of elemental nature (figs. 6 and 7). Also from this period are Monet's images of frail and gesturing trees, battered by wind and storm (fig. 8), which are the late descendants of the Romantic impulse to give anthropomorphic form to nature. They find their counterparts, earlier in the century, in a few of Caspar David Friedrich's more dramatic Alpine landscapes, where trees, in lonely isolation or huddled together in familial groupings, heroically fight off the elements and are suggestively human in their gestures, reaching out to one another across cavernous or windswept spaces (fig. 9).[15]

The reluctance of modern criticism to consider Impressionist landscapes as a manifestation of late nineteenth-century Romanticism may be related in part to difficulties sometimes encountered in dealing with the works of Constable and

IMPRESSIONISM AND ROMANTICISM

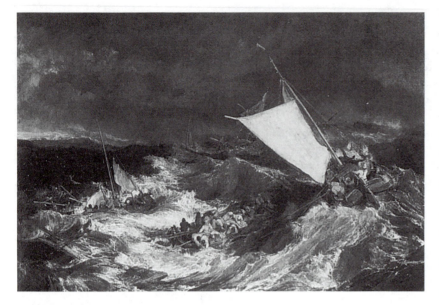

4. J. M. W. Turner.
THE SHIPWRECK. *1805.*
67 ⅛ x 95 ⅛" (170.5 x 241.5 cm). Tate Gallery, London; Art Resource

Turner—artists who seem so very different from one another—as two, complementary expressions of a single and coherent Romantic sensibility. In the art of Turner, we are far more likely to find visually dramatic presentations of the sublime, grandiose, or terrifying aspects of nature; while Constable's paintings usually offer the more commonplace, peaceful, and bucolic side of nature—Wordsworthian "plain speech," which dwells lovingly and painstakingly on natural phenomena.[16]

Claude Monet was heir to both these aspects of the Romantic sensibility, and they asserted themselves in his art sometimes side by side and sometimes separately at different times in his life (colorplates 4 and 5; 12 and 13). As a French artist of a younger generation, Monet naturally lacked a taste for the insistent literary symbolism and the programmatic pantheism that had marked the work of his German and English predecessors. He nevertheless shared with them and with other artists of that first Romantic generation, such as Théodore Rousseau, a fascination for light and its expressive properties (colorplates 6 and 7). With Turner in particular (colorplates 14 and 15), he shared a proclivity for looking at nature under unusual or extreme atmospheric conditions—for example, under dense fog or at the crack of dawn, with light so strong or so misty that it diffused the masses of water, trees, or architecture and rendered almost invisible or impalpable all the objects it surrounded. In the work of both Monet and Turner, light, which absorbs and dematerializes mass, also acts as a carrier of intense and subjective feeling, the artist's intense and subjective responses to nature.

This continuity with the Romantic landscape tradition is essential to understanding French Impressionist landscape painting, despite obvious stylistic differences between the two. With their vision conditioned by the pervasive influence of Japanese prints and photography, the Impressionists painted pictures that were much lighter in value and color range and much flatter in design than those of their predecessors. Nevertheless, it is to the tradition established by these earlier Romantic painters that we must turn to find many of the thematic conventions and symbols that help us to understand and interpret more fully important choices of imagery in Impressionist painting. It is also to the earlier Romantic landscape tradition and its relationship with nature that we will now look for an understanding of Impressionism's goals—which were essentially expressive—as well as for the origins of some of the evolving means, methods, and techniques through which the Impressionists achieved their expressive ends.

5. Claude Monet.
THE JETTY OF LE HAVRE IN BAD WEATHER. *1867.*
19 ⅞ x 24 ¼" (50 x 61 cm).
Private Collection, Switzerland.
Photograph, A. C. Cooper Ltd.; courtesy Christie, Manson & Woods Ltd., London

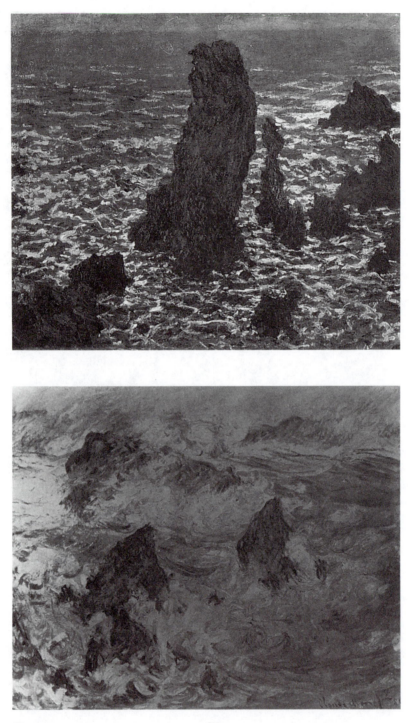

Top:
6. Claude Monet.
ROCKS AT BELLE-ILE. *1886.*
23 ⅔ x 28 ¾" (60 x 73 cm).
NY Carlsberg Glyptotek, Copenhagen

Bottom:
7. Claude Monet.
STORM AT BELLE-ILE. *1886.*
23 ⅔ x 28 ¾" (60 x 73 cm).
Private Collection, Switzerland

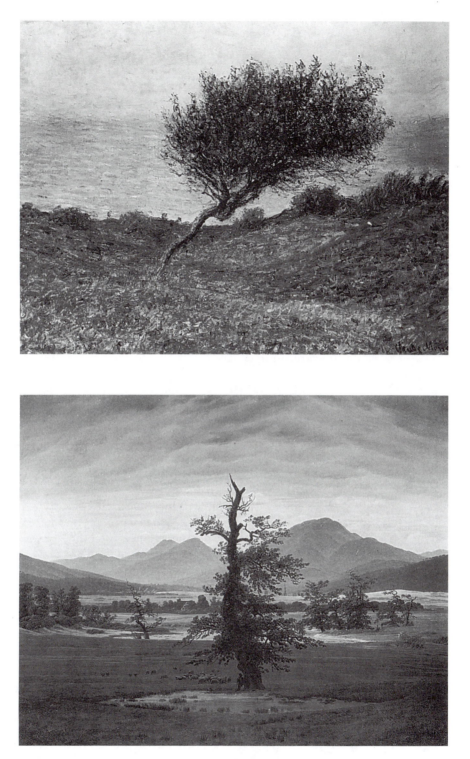

Top:
8. Claude Monet.
SEACOAST AT TROUVILLE. *1881.*
23 ½ x 31 ⅞" (59.7 x 81 cm).
*Gift of Theodora Lyman, John Pickering
Lyman Collection. Courtesy Museum of
Fine Arts, Boston*

Bottom:
9. Caspar David Friedrich.
VILLAGE LANDSCAPE IN THE MORNING
LIGHT ("THE SOLITARY TREE"). *1822.*
21 ⅔ x 28" (55 x 71 cm).
Nationalgalerie, Berlin

Effect and Emotion in Romantic and Impressionist Painting

Among writers and critics closest to the Impressionists in the 1870s, there was a response to Impressionist painting that has since been lost or suppressed in the art historical literature. In 1877, for example, on the occasion of the Impressionists' third group exhibition, Georges Rivière, a friend and sympathetic critic, published a weekly journal, *L'Impressionniste*, which was devoted to documenting and commenting on this exhibition. Of one of Monet's Gare Saint-Lazare pictures (such as fig. 10) — those same pictures that George Heard Hamilton was later to describe as merely "pictures of places," "intellectually and emotionally restricted," and precluding "any possibility of reminiscence and reflection"[17] — Rivière wrote:

> One sees the grandiose and frenetic movement of a station where the ground trembles with each turn of the wheels. The platforms are dank with soot, and the atmosphere is charged with that acrid odor that emanates from burning coal.
>
> Looking at this magnificent painting, one is seized by the same emotion as before nature, and this emotion is perhaps stronger still, for in the painting there is that of the artist as well.[18]

Of the viewer of the Impressionists' works, Rivière wrote: "This painting addresses itself to his heart; if he is moved, the objective is fulfilled."[19]

In thus describing the Impressionists as artists who feel and experience deeply "before nature" (a term used here to signify direct plein-air contact with the environment, whether in rural or urban settings) and in his understanding of them as artists who strived to convey their personal emotional experiences through their paintings, Rivière was not alone. In 1874 the critic Jules Castagnary wrote: "They are impressionists in the sense that they render not the landscape, but the sensations produced by the landscape."[20] And in 1877 Philippe Burty, though rejecting the term "impressionist" as vulgar and inaccurate, nevertheless wrote appreciatively of these artists, in the same spirit, that they could best be characterized as "impressionable people."[21]

In many writings by contemporaries of the Impressionists, the expressive intentions of these artists were directly and sometimes exclusively linked with their concern for rendering the "effects" of nature's light out-of-doors. Emile Zola, one of the Impressionists' earliest supporters in the 1860s, described them in 1880 as artists who "propose to leave the studio, where painters have been immured for centuries, to go and paint out-of-doors." He continued:

> This study of light, in its thousands of decompositions and recompositions, is what has been called more or less appropriately impressionism, because a painting becomes as a result the impression of a moment felt [*éprouvée*] before nature.[22]

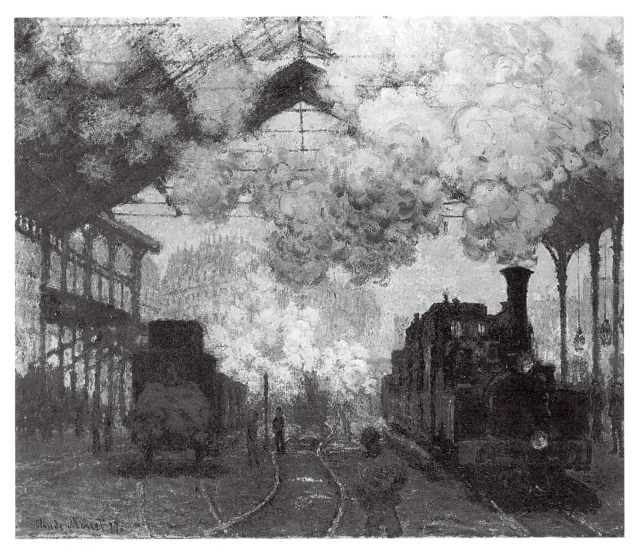

10. Claude Monet.
GARE SAINT-LAZARE, ARRIVAL OF A TRAIN. *1877.*
32 ¼ x 39 ¾" (82 x 101 cm). The Fogg Art Museum, Harvard University, Cambridge.
Bequest, Collection of Maurice Wertheim, class of 1906

In 1874 Burty wrote of the group that they pursued "a common artistic goal: in procedure, the rendering of the broad light of the outdoors; in feeling [*le sentiment*], the vividness of the first sensation."[23] In 1876 the critic Alexandre Pothey wrote of Monet's landscapes that "they are always distinguished by qualities of fresh execution, real feeling and beautiful light."[24] And of the group exhibition in 1877, the same critic declared:

Everyone knows that this group of eighteen artists was formed with a single goal: to render the effect and the emotion [*l'effet et l'émotion*] that nature produces directly in the heart or in the soul.[25]

The concept of "effect" thus evoked by Pothey and others was a commonplace but crucial element in the aesthetic vocabulary of the nineteenth century. Broadly speaking, the term referred to an arrangement of light and shadow, and as such it could have two distinct but sometimes interrelated applications: one with regard to a work of art and the other with regard to nature. In painting, the term referred to the broad ordering or unity of the chiaroscuro, the overall distribution of light and shadow, in a composition. It was an element that was generally acknowledged by nineteenth-century painters—by conservatives and progressives alike—to be an indispensable ingredient in good painting, for it provided the substructure that was supposed to stand out above details in the finished work and contributed order and harmony to the completed composition. Paillot de Montabert, whose nine-volume treatise on painting was one of the standard reference works of the period, defined "effect" in painting in the following way:

> By effect in painting is meant the vigor and beauty that result from the arrangements. . . of lines, of light and dark tones, or of hues. But, above all, it is to the arrangement of light and shadow that the effect owes its vigor, fluency and charm: the proof of this is that prints, despite their lack of color, possess a good deal of effect. Color produces its own kind of effect, but one that is visually subordinate to the effect that is obtained with masses of light and shadow.[26]

When applied to nature, the term "effect" referred to a specific luminary state, the quality of natural light through which it was widely believed in the nineteenth century that nature's moods are communicated to the sensitive observer. In landscape painting in particular, the "effect"—truly rendered "both in its values and in its colours"[27]—came to be regarded, almost universally, as a crucial expressive element. During the first half of the nineteenth century, the term "effect" appeared frequently in the titles the Barbizon painters gave to their works. These landscape painters characterized the various states of nature in terms of luminary effects and searched for an equivalent technique with which to translate these "effects" of nature into "effects" of painting—hence Rousseau's *Effect of Late Afternoon, Autumn in the Landes,* or *Effect of Noontime, Stormy Sky.* In Italy, a later generation of painters who came to be known as the "Macchiaioli" were inspired by the Barbizon school in the late 1850s and early 1860s to emphasize effect (called the *"macchia"* in Italy) and to make it the central expressive and structural feature of their work. The *macchia,* explained the critic Vittorio Imbriani in 1868, is "the first and characteristic effect which imprints itself upon the eye of the artist." He wrote:

> What in essence is the *macchia*? A harmony of tones, that is, of light and shadow, capable of reawakening some feeling in the soul, of stirring the imagination to productivity. . . . And this distribution of light and shadow, this *macchia,* is what really moves the spectator, and not, as most people would have it, the expressions on the faces or the sterile materiality of the bare subject.[28]

Throughout the second half of the nineteenth century, the word "effect" continued to appear with startling frequency in the titles that were given by the

Impressionists to their own works, although now the term was occasionally joined or replaced by the word "impression." The subtle but precise distinction to be made between these two terms has been explained by the art historian Albert Boime:

> The distinction is this: the impression took place in the spectator-artist, while the effect was the external event. The artist-spectator therefore received an impression of the effect; but the effect seized at any given instant was the impression received. . . . Monet told Sargent that his chief goal was to render his "impressions of the most fugitive effects." Monet thus entitled a work in 1872 *Effet de brouillard: Impression*.[29]

The goal of the Impressionists was to render their impressions of fugitive luminary phenomena, or "effects," a goal that was long regarded in the twentieth century as merely an optical exercise. But it was obviously far more than that for the Impressionists and their contemporaries. Their goal, we are told by Pothey and others, was "to render the effect and the emotion that nature produces directly in the heart or in the soul."

This connection in Impressionist criticism between nature's luminary states and the expression of an artist's subjective experience in nature provides a vital key to our understanding of Impressionism; although, as we have seen, it is not unique to its literature. It is a connection that can be found already well-developed and pervasive in the literature that surrounded Romantic landscape painting not only in France and Italy in the middle of the nineteenth century, but also in Germany, England, and the United States much earlier in the century. In its more transcendental form, this connection can be traced to the writings of the German philosopher F. W. J. von Schelling (1775–1854), who stressed the symbolic importance of light in the representation of nature's invisible soul. Schelling regarded light as the necessary component of genuine art and judged a work of art by its degree of truthfulness—that is to say, by the extent to which it could produce in the spectator a sensation similar to that produced by the forms of nature.[30]

During the first decades of the nineteenth century, Schelling's influential *Naturphilosophie* spread to France, England, and the United States through the writings of Mme de Staël, Samuel Taylor Coleridge, Ralph Waldo Emerson, and many others, and its impact on Romantic landscape painting is well known.[31] Echoes of these same ideas can still be heard quite plainly in critical writing about Impressionism during the 1870s. From Romanticism to Impressionism, in this sense, there is a continuous tradition—both verbal and visual—that remains to be explored.

◆ ◆ ◆

"Painting," wrote John Constable in 1821, "is but another word for feeling."[32] And for Constable the expression of feeling in painting was intimately bound up with the portrayal of light. In a letter of 1824, he spoke of "the light of nature, the mother of all that is valuable in poetry, painting, or anything else where an appeal to the soul is required."[33] Hence the great emphasis that Constable placed on the sky, both in his studies from nature and

in his final landscape compositions (colorplates 12, 16, and 17; figs. 51 and 52). "It will be difficult," Constable wrote, "to name a class of Landscape, in which the sky is not the *'key note,'* the *standard of 'Scale,'* and the chief *'Organ of sentiment'* The sky is the *'source of light'* in nature—and governs everything."[34]

The expressive importance of light and shadow is further discussed by Constable in his introduction to *English Landscape,* a collection of twenty-two mezzotint engravings after his works carried out with his approval by the printmaker David Lucas and first published in 1830. The purpose of the collection, Constable wrote, "has been to display the Phaenomena of the *Chiaroscuro of Nature,* to mark some of its endless beauties and varieties, to point out its vast influence upon Landscape, and to show its use and power as a medium of expression."[35] In a prospectus of 1835 for *English Landscape,* it is further stated:

> The landscape painter shall be aware that the *Chiaroscuro* does really exist in *Nature* (as well as Tone)—and, that it is the medium by which the grand and varied aspects of Landscape are displayed, both in the fields and on canvass: thus he [the landscape painter] will be in possession of a power capable in itself, alone, of imparting Expression, Taste, and Sentiment.[36]

Because he believed that his style was based upon the principle of chiaroscuro, Constable was confident that his paintings could be translated easily and successfully into the tonal medium of mezzotint, in which form they would serve to advertise and disseminate both his paintings and his ideas about art.[37]

The important role of chiaroscuro in Constable's art is further demonstrated by the emphasis that he placed upon the full-scale oil studies that he executed for each of his major pictures—his completed "six-footers"—between 1819 and 1825 (colorplates 16 and 17). Unlike Constable's sketches from nature and the finished works themselves, his full-size, preparatory studies were painted tonally, with an almost monochromatic palette (colorplate 17). Kenneth Clark pointed to the emotional expressiveness of their spirited execution and described Constable's motives for doing them as "perhaps more psychological than technical":

> . . . it was only possible to conserve the vividness of the original emotion on this scale if he felt free from all anxieties of finish and logical composition. The full-size studies were not so much dress rehearsals as emotional discharges which allowed him to attack his final canvas without a feeling of frustration.[38]

But given Constable's statements about "the Chiaroscuro of Nature" and its "power as a medium of expression," it would seem more likely that his full-size tonal studies played, in addition, a far more specific and conscious role for him in the creative process than this. Yet they would seem to have been pivotal, for two reasons: first, they allowed the artist to work out the tonal substructure that would give harmony and balance to the final composition; second, they helped him to preserve the "effect" of light through which his "feeling"—his emotional experience in nature—would be communicated. To borrow Constable's own words, it was in these tonal studies that he was able to concentrate exclusively on "the medium by which the grand and varied aspects of Landscape are

displayed, both in the field and on canvass," so that, in his final and more fin-
ished work, he might "be in possession of a power capable in itself, alone, of im-
parting Expression, Taste, and Sentiment."

Constable's view of the independent power of chiaroscuro to invoke, without
the aid of color, the moods and aspects of nature and to excite the imaginations
of both the artist and the spectator was a view shared by his English contempo-
rary J. M. W. Turner. This shared belief, despite stylistic differences between
the two painters, is a key element in understanding the community of intention
between these two Romantic landscape painters.

Through a careful study of Turner's remarks on color in the perspective lec-
tures that the artist delivered at the Royal Academy between 1811 and 1828, the
English art historian John Gage has concluded that in his use of the color wheel,
Turner, unlike his contemporaries, was not concerned with complementary col-
or harmony but with tonal oppositions of warmth and coolness—with "the con-
flict of light and dark."[39] Gage explains:

> The study of painting and engraving alike had shown Turner that tonal
> relationships were of fundamental importance to the artist; and it was a
> scale of tonal values from white to black, through yellow, red and blue,
> that he chose as his basic progression. . . in Lecture V of 1818, the great
> authority of Titian's late style, as well as that of Rembrandt and Tintoret-
> to, were invoked in favor of an almost monochrome palette. Light, as the
> notes on Rembrandt and Correggio and those from Lomazzo showed,
> was, as a theoretical study, an earlier and more urgent concern to Turner
> than colour itself; it was, indeed, the condition of colour: "colour cannot
> be seen without light," he quoted from Lomazzo. . . .[40]

Turner's preoccupation with the tonal basis of color structure was constant and
is reflected, Gage tells us, in his letters of instruction to his engravers, as he
sought to develop systems of line engraving that could translate color into its
tonal equivalents.[41] Similar concerns appear to have motivated Turner's interest,
late in life, in photography. In 1847 the American photographer J. J. E. Mayall
set up a daguerreotype studio in London, and over the next two years Turner of-
ten visited him and even helped to finance his work. Gage has written of the im-
pact that Mayall's work had on the artist: "Turner must have been fascinated by
the photographer's skill in translating colour into light and shade by the action
of the sun alone. He could see his own early attempts at similar translations in
engraving now carried through in terms of natural forces, light generating dark
and dark light in a way which had hitherto been the objective of the painter."[42]

The primacy of chiaroscuro as an expressive vehicle in Turner's art was in-
sisted on, with great eloquence, by the artist's contemporary, John Ruskin, who
wrote of Turner:

> Powerful and captivating and faithful as his color is, it is the least impor-
> tant of all his excellences, because it is the least important feature of na-
> ture. He paints in color, but he thinks in light and shade. . . . With him, as
> with all of the greatest painters, and in Turner more than all, the hue is a
> beautiful auxiliary in working out the great impression that is to be con-
> veyed, but is not the source nor the essence of that impression; it is little

more than a visible melody, given to raise and assist the mind in the reception of nobler ideas—as sacred passages of sweet sound, to prepare the feelings for the reading of the mysteries of God.[43]

Once again, for Turner, it is light and shade that, according to Ruskin, is the source of the artist's "impression"—the personal and, for this generation of artists, pantheistic experience of nature that the artist sought to capture and to re-create for his audience on his canvas.

Similar emphases appear slightly later in France in the work of the Barbizon painters, who were referred to by Alfred Sensier (friend and biographer of Théodore Rousseau and Jean-François Millet) as "the Sons of Light."[44] "It is the lyre of Orpheus," said Rousseau of the sun, affirming his belief in the expressive power of light. "It is the spring of all mobility, feeling and attraction; it makes the very stones eloquent"[45] (colorplates 6 and 18).

Among the first to explain and defend the approach to landscape painting that had been developed by the Barbizon school in the 1830s was the influential French critic and art historian Théophile Thoré. An expert in the field of Dutch painting and an enthusiastic supporter of landscape as a genre, Thoré wrote a series of important Salon reviews from the 1830s through the 1860s, some under his own name and some under the pseudonym W. Bürger. In these he expressed the view that great landscape painting is born of an artist's sincere love of nature and ability to respond in a creative and poetic manner to the variety of experience that nature offers. Singling out Théodore Rousseau as the leader of the Barbizon school, Thoré described him as a poet, a sensitive soul who was capable of penetrating and sharing "all of the passions of nature" and whose skill as an artist lay in his ability to convey to others these deeply felt subjective experiences.[46] Art, Thoré pointed out, is not and cannot be the mere laborious imitation of visual reality, for the transitory character of nature and its constantly changing effects have themselves taught the artist that faithful imitation of visual phenomena is a physical impossibility.[47] But even though a painting cannot be a precise visual recording of what the artist has *seen* at any given moment, nevertheless it can be an expression of a unique personal experience before nature: it can be a recording of what has been felt at a particular moment as a result of what has been seen. Poetry, said Thoré, is the principle of all the arts, and "poetry is not nature, but the feeling that nature inspires in the artist. It is nature reflected in the human spirit."[48] Expressing a similar thought, Rousseau himself said that "a composition exists at that moment when the objects represented are there not simply for their own sakes, but in order to contain, beneath a natural appearance, the echoes that they have placed in our soul."[49]

In a memorial article of 1868 on the life and work of Théodore Rousseau, the critic Philippe Burty wrote that nature reveals its different moments and moods to the artist through a series of characteristic luminary states or "effects." These are experienced and identified according to the individual sensibility of each artist and then internalized by means of an extensive program of plein-air sketching. As a result of this self-imposed training of hand and eye, Burty reported, Rousseau had achieved such a high degree of facility that he could set to work in his studio and choose from his palette, without hesitation, *le ton le plus juste et le plus séduisant* for the translation of his feelings onto canvas: "His long absorption in the study of daylight, of storms, of fogs, or the state of the sky at

different moments of the year, had so to speak catalogued in his brain the entire range of luminary effects. Hardly had he touched a canvas than he had disengaged from it a painting."[50]

Burty stressed the expressive and structural importance of light and shadow for Rousseau, telling of how the artist, in conversation, repeatedly discussed his idea of the compositional subordination of color to monochromatic tonal harmony. "If necessary," Rousseau advised a student, "you can do without color, but you can do nothing without harmony."[51] After capturing, through an immediate plein-air sketch, the luminary "effect" of a scene in nature, Rousseau described how he would build up his painting in the studio from that "effect"—that skeletal foundation of tonal masses—through a series of refinements and clarifications. In this process, he told Burty, "coloring is simply a matter of visual observation and organization. It should always be left for the end."[52]

By the 1850s a taste for tonal painting was widespread among artists in Paris, stimulated in part by the aesthetic philosophy of the Barbizon landscape painters, but also by the pervasive though not always acknowledged influence of photography on painters during this period. In 1859, for example, the critic Ernest Chesneau wrote:

> . . . one knows that the majority of painters today use photography as their most precious aid. They won't deprive themselves of it. I find the proof of this use in the general toning down of the color range during the last few years.[53]

Art historian Eugenia Parry Janis has rightly pointed to the complexity of the interaction between painting and photography in France at mid-century and to the resulting difficulty of determining, in specific and simplistic terms, the "influence" of one upon the other.[54] But given the nature of the Barbizon aesthetic and the expectations in regard to the interpretation of landscape that it had already begun to foster in the 1830s, we may assume that it was the experience of painting that helped to encourage recognition and appreciation among artists and amateurs of the tonal photograph—the calotype, made from paper negatives—as a form of visual poetry in its own right. In turn, as Janis contends, the calotype (which came into general use in the late 1840s and 1850s) engendered and popularized new conventions for seeing the landscape and for patterning light and shadow that would have conditioned the vision and influenced the practice not only of the Barbizon painters during the 1850s but also of the Impressionist generation that followed (figs. 11–14).[55]

Many of the major practitioners of the calotype had originally been trained in one of the more traditional visual arts. The striking affinities of this new breed of "artist-photographer" with the Romantic painters of their generation and the nature of the values, goals, and attitudes that they shared in common may be suggested by remarks from an article published in 1853 by one of their supporters, the critic Ernest Lacan:

> The artist-photographer is one who, having devoted his life to studying one of the arts such as painting, architecture, engraving, etc., perceived photography as being a new means by which to convey his impressions, to imitate the poetry, richness and beauty of nature. . . .[56]

Top:
11. Count Olympe Aquado (1827–1895).
ILE DES RAVAGEURS, MEUDON. *c.1855.*
Calotype, 7 ⅛ x 9 ½" (18 x 24 cm).
Bibliothèque Nationale, Paris

Bottom:
12. Henri Le Secq (1818–1882).
SUNSET IN DIEPPE. *c.1853.*
Calotype, dimensions unknown.
Private Collection

Describing the studio of one of these typical artist-photographers (probably a composite, according to Janis, of the studios of Gustave Le Gray and Charles Nègre[57]), Lacan continued:

> The astonished eye of the intruder occasionally pauses on a half-spoiled print in which it tries in vain to find something of worth. It does not notice that it contains some detail that has been admirably brought out, or a striking expression, or a lighting effect, or masses which have been captured on a large scale—in short, something "of character" and which the artist carefully preserves, without troubling himself over a mark, or a tear, or even imperfect printing.[58]

In contrast to the daguerreotype, a direct impression on a metal plate, the paper negatives of the calotype process produced far less clarity and detail; calotype images are tonally softer, more varied, and more evocative. Photographers who favored the calotype method (then considered technically inferior to the daguerreotype) aimed not to reproduce the natural world in infinite detail but to interpret it, personally and selectively, through the medium of light. Le Gray, for example (figs. 13 and 14), wrote in the early 1850s:

> The artistic beauty of a photographic print consists nearly always in the sacrifice of certain details; by varying the focus, the exposure time, the artist can make the most of one part or sacrifice another to produce powerful effects of light and shadow, or he can work for extreme softness or suavity copying the same model or site depending on how he feels.[59]

These ideas were amplified by his student, Henri de La Blanchère, who wrote later in the same decade:

> When we try to compose a picture consisting of a self-sufficient fragment from nature (for one can proceed in no other way), let us do it sparingly, and above all, broadly.
>
> Extinguish all detail. . . lighting is everything. . . .[60]

The calotype, as Janis has shown, was in essence a Romantic art form. But its aesthetic contributions, she points out, have long been ignored or undervalued in the larger arena of the history of photography because of the technological bias that has helped to shape that history—a history seen predominantly as a linear series of technical advances, which "had as its goal a clearly resolved image."[61] But the photographers themselves, Janis demonstrates, were as much if not more concerned with the variety of visual effects that could be produced by their technical methods as with the methods themselves. These "artist-photographers" viewed the camera not as an objective eye on the world but as an instrument that could support their individual creativity, and their attitude in this regard was shared by many of the Romantic painters.

Camille Corot's development as an artist would support such a view. His affinities with the landscape photographers of his era, some of whom were his

IMPRESSIONISM AND ROMANTICISM

Top:
13. Gustave Le Gray (1820–1882).
FOREST OF FONTAINEBLEAU. c.*1851.*
Calotype, 10 x 14" (25.6 x 35.7 cm).
Bibliothèque Nationale, Paris

Bottom:
14. Gustave Le Gray.
FOREST OF FONTAINEBLEAU. c.*1851.*
Calotype, 10 x 14" (25.6 x 35.8 cm).
Private Collection

friends, led Corot to experiment often with the *cliché-verre* technique between the years 1853 and 1874. Like the paper negatives of the calotype, coated glass plates also produced images that were tonally varied and subtle, given to indistinctness and effects of blurring. It has been suggested that the sudden and otherwise unexplained change in Corot's painting style in the 1850s, from his earlier more linear manner to his later soft and blurred style, with its insistently imposed, pearl gray tonalities and its far-away "romantic" mood (fig. 15), may have been connected with the emergence of the *cliché-verre* technique in photography at this time.[62]

Corot was to play a particularly important role as an inspirational teacher and informal mentor to many of the artists of the Impressionist generation, and the concerns and beliefs he imparted to them were consonant with those of other French Romantic landscape painters of his generation. The character of his teachings may be inferred from the following remarks, dating from the 1820s to the 1850s, which are drawn from Corot's notebooks:

I always try to see the effect immediately. . . .

I always begin with the shadows, and that is logical; for since that is what strikes you the most, it is what you should render first. . . .

Color, for me, comes afterward. . . because I prefer above all the ensemble by which we have been struck. . . .

Never lose the first impression which has moved us. . . .

No matter what the site or the object, let us submit ourselves to the first impression. If we have really been moved, the sincerity of our emotion will be communicated to others.[63]

The emphasis that Corot placed upon seeing and responding to nature's luminary effects and upon conveying the "sincerity of [his] emotion" through his first impression of those effects is reflected in the tonal subtlety and precision of his works (colorplate 19); and it is a concern that he imparted to the many young artists who admired and studied with him, both formally and informally, in the 1850s and 1860s. Corot strongly urged upon these younger artists the Romantic values of sincerity and individuality, and according to the report of his friend Théophile Silvestre he always advised his students "to choose only subjects that harmonize with their own particular impressions, considering that each person's soul is a mirror in which nature is reflected in a particular fashion."[64]

One of the young artists who profited from Corot's advice in the 1860s was Berthe Morisot, whose early work was in part shaped by Corot's example. During the summer of 1863 Morisot began to paint landscapes on the River Oise, and in the following summer she was admonished by Corot via a letter that he wrote to her mother: "Let's work hard and steadfastly and not follow too closely papa Corot; it is better to consult nature itself." That his advice was well-taken is indicated by works such as *The Harbor at Lorient* of 1869 (colorplate 20), in which the delicacy of tonal nuance and the attention to tonal structure and relationship are reminiscent of Corot's paintings, but in which the response to

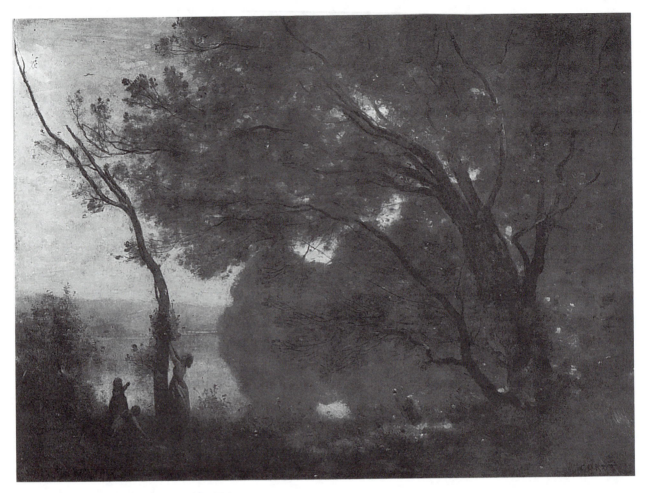

15. Jean-Baptiste-Camille Corot (1796–1875).
SOUVENIR OF MORTEFONTAINE. *Exhibited at the Salon of 1864.*
25 9/16 x 33 1/16" (65 x 89 cm). Musée du Louvre, Paris; Art Resource

nature is nonetheless the artist's own.[65]

Camille Pissarro, who referred to himself as the "student of Corot" when he sent two landscapes to the Salon of 1864, was reportedly given this advice by the older artist, who served informally as his mentor during this period:

> You must study values. We don't see in the same way. You see green, and I see gray and blond. But this is no reason for you not to work at values, for they are the basis of everything, and however one feels them and expresses them, one cannot do good painting without them.[66]

While acknowledging the younger man's already more vivid chromatic bent, Corot nevertheless emphasized for Pissarro the vital connection between luminary effect on the one hand and feeling and expression in painting on the other—the connection that supported and gave meaning to the Barbizon artists' studies from nature.

While most of Pissarro's early works were destroyed in 1870 by the Prussians

during their siege of Paris, those that survive demonstrate his debt in the late 1850s and the early 1860s to the Barbizon painters and in particular to Corot.[67] The extent to which Corot's example was internalized by Pissarro is reflected in the sensitively modulated tonal style that remained typical of Pissarro throughout his career. Corot's advice and philosophy was also echoed in Pissarro's own thinking. In the 1890s, for example, Pissarro, as an elderly man, advised the young painter Louis Le Bail: "Look for the kind of nature that suits your temperament. Don't proceed according to rules and principles, but paint what you observe and feel. Paint generously and unhesitatingly, for it is best not to lose the first impression."[68]

Although Corot was an artist for whom Claude Monet often expressed deep admiration,[69] Corot was not as much a mentor for Monet in his youth as he was for Morisot and Pissarro. Instead, the artists who were initially responsible for introducing the young Monet to landscape painting and to the procedures of plein-air study were the French painters Eugène Boudin and Charles François Daubigny and the Dutch painter Johann Barthold Jongkind. Independent artists who were not directly affiliated with the Barbizon movement, Boudin, Daubigny, and Jongkind are normally discussed as transitional "pre-Impressionists" and are thus considered to have had a "naturalist" orientation that separated them from the Romantic landscape painters of the Barbizon school. However, a commitment to the recording of optical experience *en plein air* was not necessarily antithetical to the expression of feeling in painting (as the binary systems of art history have assumed). In fact, the attitudes and goals of these artists, whose work and ideas were to have a profound effect on Monet's development, were situated firmly in the context of the Romantic tradition.

Monet met Boudin in Le Havre in 1858 and went, at first reluctantly, with the older artist on his excursions out-of-doors to paint. Later, in 1900, Monet told an interviewer about this experience: "Boudin, with untiring kindness, undertook my education. My eyes were finally opened, and I really understood nature."[70] Boudin, who is probably best known for his small and spirited plein-air depictions of fashionable vacationers relaxing and disporting themselves on the beaches of Normandy (see fig. 16), had indeed much to teach Monet, and in his notebooks are recorded the observations and precepts that he may have imparted to his young disciple. Like Corot, Boudin, insisted on "retaining one's first impression, which is the good one," declaring that "it is not one part which should strike one in a picture, but instead the whole." And he also observed: "Everything that is painted directly on the spot has always a strength, a power, a vividness of touch that one doesn't find again in the studio."[71]

It was probably Boudin who encouraged Monet's early interest in the Barbizon painters, and Monet's letters to Boudin from Paris are important documents that reveal the essentially Romantic orientation and sympathies that had been inculcated in the young painter by his mentor. In a letter of June 3, 1859, Monet described for Boudin the paintings at the current Salon and singled out the painters of mutual interest—among them, Rousseau, Troyon, Delacroix, Daubigny, and Corot. He wrote appreciatively of Troyon's *Le Départ pour le marché*, describing it, in terms of the luminary state it captures, as "an effect of fog at sunrise." Of the works by Delacroix, he said: "They are only indications, sketches [*ébauches*]; but as usual, he has verve and movement." The Corots, he said enthusiastically, "are simple wonders," and Daubigny was described, with

16. Eugène Boudin (1824–1898).
BEACH AT TROUVILLE. *1864–1865.*
Oil on wood, 10 ¼ x 18 ⅞" (26 x 48 cm).
National Gallery of Art, Washington, D.C. Ailsa Mellon Bruce Collection

what was obviously the highest compliment, as "a chap who does well, who un-
derstands nature!"[72] On February 20, 1860, Monet wrote to Boudin, telling him
of an exhibition of "modern paintings which includes the works of the school of
1830 and which proves that we are not as decadent as some would say." In the
same letter, he referred to Boudin's friend Jongkind as "the only good marine
painter that we have," and he mentioned a small painting by Daubigny *("le petit
Daubigny")* that he owned and that hung in his room.[73]

After two years of military service in Algeria, Monet returned to Le Havre in
1862 and continued his work with Boudin. That summer, he met and painted
with Jongkind, who worked during the summers from 1862 to 1865 on the
Normandy coast at Sainte-Adresse, Trouville, and Honfleur, painting mostly
watercolors but also some pictures in oil outdoors, works that apparently made
a considerable impression on Monet (figs. 17 and 18; colorplates 21 and 22). Of
his first meeting with Jongkind in 1862 and its subsequent impact, Monet said:

> He asked to see my sketches, invited me to come and work with him, ex-
> plained to me the why and the wherefore of his manner, and thereby com-
> pleted the teachings that I had already received from Boudin. From that
> time on he was my real master, and it was to him that I owed the final
> education of my eye.[74]

The archetypally Romantic attitudes toward art and nature that Monet would
have imbibed from Jongkind during the summer of 1862 are suggested by the

tenor of a letter written by Jongkind to Boudin in September of that year. In it, Jongkind declared that "one must love nature and gaze upon her always with pleasure, curiosity and interest, in order to interpret her, even weakly, in painting."[75]

In the fall, Monet returned to Paris, where he entered the studio of Gleyre and met Bazille, Renoir, and Sisley. In the spring of 1863 Monet and Bazille went to paint at Chailly, a village on the edge of the forest of Fontainebleau, where they made studies *en plein air*. They returned the next year, bringing with them Renoir and Sisley, to follow literally in the steps of the Barbizon painters whom they admired, several of whom they reportedly met in their wanderings through the woods.[76] Monet's debt in the mid-1860s to the Barbizon painters, as well as to the calotype photographers, is suggested by many of his paintings of forest interiors that date from these years.[77] Among them is *Women Carrying Wood, Forest of Fontainebleau* (fig. 19) of 1864, which quotes from Millet the familiar motif of the female peasant carrying wood on her back (fig. 20),[78] and *An Oak Tree at Bas-Bréau (Le Bodmer)* of 1865 (fig. 21), which is reminiscent of the photographs made by Gustave Le Gray at the same locale during the previous decade (figs. 13 and 14).

Monet's taste for depicting the same site at different times and under different conditions of weather and illumination was also rooted in Barbizon tradition, as well as in the work of contemporary Romantic landscape photographers (see figs. 13 and 14). This predilection, which was of course to be of far-reaching significance for Monet's later work, is already apparent in his art of the 1860s.[79] In his paintings, for example, of the road to the Saint-Siméon Farm, between Trouville and Honfleur, in different seasons — that is to say, under different effects of light (figs. 22 and 23) — Monet was already concerned not with the uniqueness of the motif but with the effect of light under which it was observed and emotionally experienced. This is identical to the concern that would motivate him some twenty-five years later, in 1890, when he wrote to his friend, the critic Gustave Geffroy of his work on *"une série d'effets différents (des meules)"* and spoke of his need *"de rendre ce que j'éprouve."*[80] In the realm of painting, of course, the precedent for the idea "that differentiation of light was a phenomenon sufficient in itself to distinguish two paintings identical in form" came from Rousseau, who had exhibited two pictures of the same site side by side at the Paris World's Fair of 1855,

17. Johan Barthold Jongkind (1819–1891).
THE CHAPEL OF NOTRE DAME DE GRÂCE, HONFLEUR.
Dated September 14, 1864.
Watercolor, 14 x 19 ¾" (35.6 x 50.2 cm).
Mr. and Mrs. Eugene Victor Thaw Collection, New York City.
Eugene V. and Clare E. Thaw Charitable Trust..
Photograph, Eric Pollitzer

18. Claude Monet.
THE CHAPEL OF NOTRE DAME DE GRÂCE, HONFLEUR. *1864.*
20 ½ x 26 ¾" (52 x 68 cm).
Present whereabouts unknown

Top:
19. Claude Monet.
WOMEN CARRYING WOOD, FOREST
OF FONTAINEBLEAU. *c.1864.*
Oil on wood, 23 ¼ x 35 ½" (58.8 x 90.2 cm).
Henry H. and Zoe Oliver Sherman Fund.
Courtesy Museum of Fine Arts, Boston

Bottom:
20. Jean François Millet (1814–1875).
WOMEN CARRYING WOOD. *1852–1854.*
Charcoal on light gray paper,
11 ⅜ x 18 ⅜" (29.9 x 46.7 cm).
Gift of Martin Brimmer.
Courtesy Museum of Fine Arts, Boston

21. Claude Monet.

An Oak Tree at Bas-Bréau (Le Bodmer). *c.1865.*
(Formerly called "The Chailly Road."). 37 ⅞ x 50 ⅞" (96.2 x 129.2 cm). The Metropolitan Museum of Art, New York City.
Bequest of Julia W. Emmons and Gift of Sam Salz, by exchange, 1964

The Edge of the Forest of Fontainebleau at Sunset (fig. 24) and *The Forest of Fontainebleau, Morning* (fig. 25),[81] and who was said to have advised his students "always to take two canvases to the motif, one for a morning study, the other for an effect of evening."[82]

A more immediate model and inspiration for this aspect of Monet's art in the 1860s may have come, however, from the work of Jongkind, with whom Monet once again painted at Honfleur in the summer and fall of 1864.[83] Among Jongkind's recent works were two views of the apse of Notre Dame (figs. 26 and 27), which, as John Rewald has pointed out, were painted weeks or even months apart during the preceding winter, from the same point of view but under different conditions of light: "One in the silvery light of a winter morning, the other under the flaming sky of a sunset."[84]

Monet's interest during the 1860s and even into the 1870s in coastal views of the sea and of seaports, under both stormy and more subtle moments of

Impressionism and Romanticism

22. Claude Monet.
Road to the Saint-Siméon Farm, Summer. *1864.*
23 ¼ x 31 ½" (59 x 80 cm).
Present whereabouts unknown.
Photograph, Durand-Ruel, Paris

23. Claude Monet.
ROAD TO THE SAINT-SIMÉON FARM, WINTER. *February 1867.*
32 x 39 ⅜" (81 x 100 cm).
Present whereabouts unknown.
Photograph, Durand-Ruel, Paris

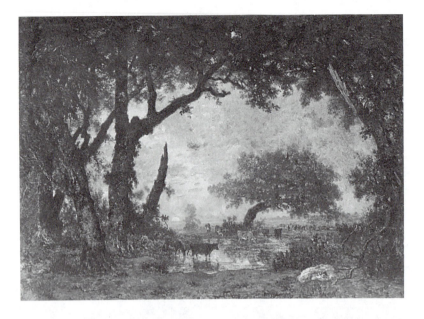

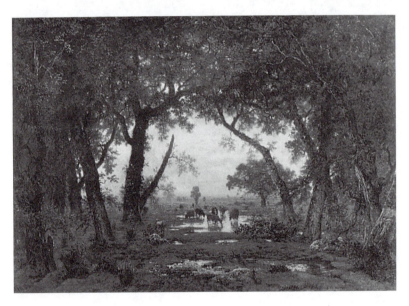

Top:
24. Théodore Rousseau (1812–1867).
THE EDGE OF THE FOREST OF FONTAINEBLEAU AT SUNSET. *1848–1851.*
56 x 77 ¾" (142 x 197.5 cm).
Musée du Louvre, Paris; Art Resource

Bottom:
25. Théodore Rousseau.
THE FOREST OF FONTAINEBLEAU, MORNING. *1848–1850.*
38 ⅜ x 52 ¾" (98.1 x 134 cm).
Reproduced by permission of the Trustees of the Wallace Collection, London

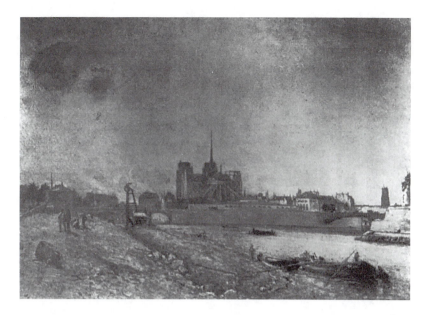

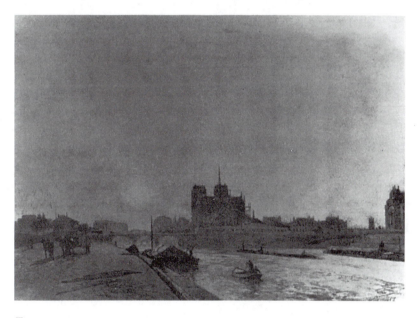

Top:
26. Johan Barthold Jongkind.
VIEW OF NOTRE DAME, PARIS. *1863.*
16 ½ x 22" (42 x 56 cm).
Private Collection

Bottom:
27. Johan Barthold Jongkind.
VIEW OF NOTRE DAME AT SUNSET. *1864.*
16 ¾ x 22 ½" (42.5 x 57 cm).
Private Collection

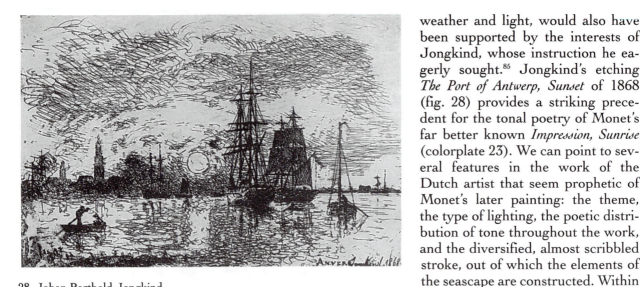

28. Johan Barthold Jongkind.
THE PORT OF ANTWERP, SUNSET. *1868.*
Etching, 6 x 9 ⅛" (15.1 x 23.3 cm). Cabinet des Estampes, Bibliothèque Nationale, Paris

weather and light, would also have been supported by the interests of Jongkind, whose instruction he eagerly sought.[85] Jongkind's etching *The Port of Antwerp, Sunset* of 1868 (fig. 28) provides a striking precedent for the tonal poetry of Monet's far better known *Impression, Sunrise* (colorplate 23). We can point to several features in the work of the Dutch artist that seem prophetic of Monet's later painting: the theme, the type of lighting, the poetic distribution of tone throughout the work, and the diversified, almost scribbled stroke, out of which the elements of the seascape are constructed. Within the Romantic tradition, there are other striking parallels and precedents for Monet's famous *Impression, Sunrise,* particularly works by Turner with which Monet might have been familiar (see fig. 29 and colorplate 24). And its antecedents in the seventeenth-century French tradition, in the work of Claude, are also clear (fig. 30). But it was most specifically from the example and instruction of Jongkind in the 1860s that Monet first received the impulse that was to lead most directly to this picture — the impulse to follow the looseness of his hand and to study and respond lovingly to moments of great poetic and expressive luminary effect in nature.[86]

In the early 1870s the artist who had the most important influence on Monet was Charles François Daubigny, whose work Monet had admired since the late 1850s. Probably in 1858, after Boudin had begun to shape his taste, Monet is reported to have found a small canvas of a grape harvest by Daubigny in the studio-attic of his aunt Mme Lecadre. Monet had so admired the painting that his aunt had allowed him to keep it.[87] It appears, however, that Monet would not have had an opportunity to meet Daubigny until the summer of 1865, when they were both working in Trouville along with Boudin, Whistler, and Courbet.[88] Thereafter, Monet enjoyed Daubigny's approval and support as well as the inspiration that

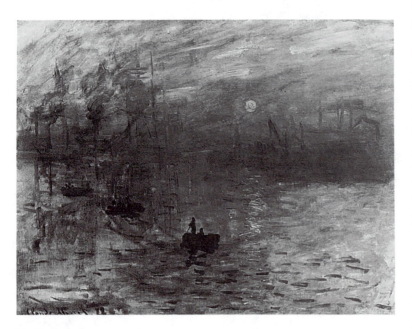

Claude Monet.
IMPRESSION, SUNRISE. *1873.*
(See colorplate 23)

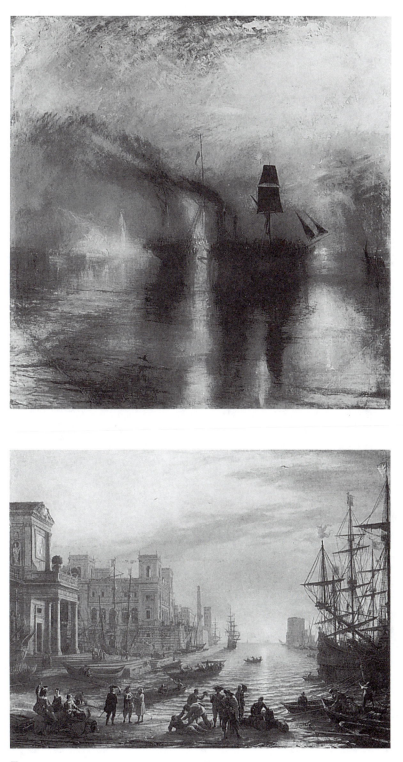

Top:
29. J. M. W. Turner.
PEACE—BURIAL OF WILKIE.
Exhibited at the Royal Academy, 1842.
34 ¼ x 34 ⅛" (87 x 86.5 cm).
Tate Gallery, London; Art Resource

Bottom:
30. Claude Lorrain (1600–1682).
SEAPORT WITH SETTING SUN. *1639.*
40 ½ x 53 ¼" (103 x 135 cm).
Musée du Louvre, Paris; Art Resource

Top:
31. Jean-Baptiste-Camille Corot
(1796–1875).
DAUBIGNY WORKING
ON HIS "BOTIN" NEAR
AUVERS-SUR-OISE. *1860.*
9 ⅝ x 13 ⅜" (24.4 x 34 cm).
Present whereabouts unknown.
Photograph, Knoedler Galleries,
New York City

Bottom:
32. Charles François Daubigny
(1817–1878).
THE ARTIST IN HIS FLOATING STUDIO,
from LE VOYAGE EN BATEAU, *1861.*
Etching, 4 x 5 ⅛" (10.2 x 13.1 cm).
Baltimore Museum of Art. The George A.
Lucas Collection of the Maryland Institute,
College of Art, on indefinite loan to the
Baltimore Museum of Art

33. Charles François Daubigny.
Portjoie on the Seine. c.1868.
Oil on wood, 9 ⅝ x 17 ⅜" (24.5 x 44.2 cm).
The Metropolitan Museum of Art, New York City

his work provided. In 1866 Daubigny was elected for the first time to the Salon jury, a position in which his friend Corot had preceded him in 1864. Over the next several years, Daubigny achieved some notoriety as a supporter in official circles of the *"jeune école,"* regularly fighting for their admission to the exhibitions and finally resigning in exasperation from the jury in 1870, a year when none of Monet's pictures was accepted.[89]

Instead of the forest interiors preferred by the Barbizon painters who were his contemporaries, Daubigny, from the 1850s on, was concerned with open landscape scenes and, in particular, with motifs that involved first the sea and then the river. In June 1854 he discovered the sea at Villerville.[90] And in the autumn of 1857 he purchased a small, boxlike studio boat, which he nicknamed *Le Botin* and upon which he worked during the summer months, traveling on the Seine and the Oise with his young son Karl and some of his friends, including Corot (fig. 31). Daubigny documented his own adventures aboard *Le Botin* in a series of etchings that were executed in 1861 and published the following year by Cadart as *Le Voyage en bateau* (fig. 32).[91] His experiences on the rivers were further recorded by his friend and principal biographer, Frédéric Henriet, who described in *Le Paysagiste aux champs* (Paris, 1866) the distractions and difficulties endured by the artist during the course of his intrepid sketching trips. These include a lighthearted account of how Daubigny fell off his boat one day. Absorbed in his work and apparently forgetting where he was, the painter

IMPRESSIONISM AND ROMANTICISM

stepped back—too far—from his easel, *"pour mieux juger de l'effet de son étude."* [92]

After 1857 the river became a major motif for Daubigny. *Le Botin* helped to provide him not only with a new range of subject matter but also with a new point of view from which he could observe and experience nature (fig. 33 and colorplate 25). Daubigny's trips on *Le Botin* allowed him to immerse himself in the environment of the river and completely changed his perceptions of light and space. They unleashed in him, moreover, a fascination already latent in his work with water: its transparency, its luminosity, and its reflective properties were to become now his principal painterly preoccupations.

According to his biographer Henriet, Daubigny painted his full-size pictures from nature. "All his pictures," wrote Henriet, "are, if not finished, at least sketched at the site [*ébauchés sur place*]." [93] Henriet's descriptions of Daubigny's plein-air procedures can help us to understand the ways in which this artist would have provided an early and important role model for his younger followers:

> The *Villerville-sur-mer* of the 1864 Salon was, among others, completely executed on the spot. Daubigny attached his canvas to stakes solidly planted in the ground; and there it stayed, risking the attacks of goats and bulls, and open to the pranks of naughty children. It was not taken down until it was perfectly finished. The painter had chosen a gray sky filled with fat clouds chased by an angry wind. He was constantly on the alert for the right moment and ran to take up his work as soon as the weather corresponded to the impression of his painting. [94]

Daubigny's work out-of-doors, especially on the rivers, helped to raise the light value of his palette and contributed to what many of his contemporaries regarded as the improvisational character of his work. As early as 1852, the critic Grunn had described Daubigny's paintings disparagingly as "rough sketches" (*ébauches*), asking whether the artist feared that he might ruin his work by finishing it. [95] This set the tone for what was to become a recurring criticism of Daubigny's work. Théophile Gautier, for example, wrote in response to pictures exhibited at the Salon of 1861: "It is a shame that Daubigny, this landscapist of such true feeling—so right and so natural—is satisfied with a first impression and neglects details to this point. These paintings are nothing but rough sketches [*ébauches*] and not very advanced sketches at that." [96] But other writers, such as Baudelaire, tempered these criticisms, citing the poetry and the "original sentiment" of Daubigny's pictures as at least partial compensation for their lack of detailed finish. [97]

And, in fact, those who supported Daubigny in the late 1850s and early 1860s were wont to defend him in precisely these, quintessentially Romantic, terms. They stressed the sincerity of his response to nature, the uniqueness of his sensibility, and the authenticity of the emotions that were expressed through his works. In this vein, Zacharie Astruc, a future friend and supporter of the Impressionists', wrote of Daubigny in 1859:

> He is the painter par excellence of simple impressions. He is tender; he is sweet; he is captivating. One feels that he profoundly loves the beautiful freshness, the radiant green plains, these beautiful deep clear waters, their poetic grace so well rendered by his brush. With all this he retains a delicious

naiveté—simple as a child before his subject, adding nothing, removing nothing—strong of heart and eyes; unpretentious by means of the truth; arriving by force of feeling and ardor and by his penetrating passion for his art at a remarkable individuality.[98]

In 1857 Daubigny's friend Henriet had written even more searchingly about the artist's goals and the uniqueness of his achievement in terms that help us to recognize that Daubigny's personal relationship to nature—one that could encompass and even depend upon a commitment to plein-air optical fidelity—was wholly Romantic:

All of Daubigny's aesthetic is contained in one word, and that word is SINCERITY! He knows that the landscape painter is nothing without nature and that he sinks into deep obscurity as soon as he departs from her. But he copies nature with his soul, and not with the cold exactitude of a camera. Hence, the eloquent fidelity of his brush. The model is before his eyes, but it is in his heart that he finds the exquisite sentiment with which he unconsciously impregnates his work and the indefinable emotion that trembles upon his canvas.

Daubigny's great audacity is to be simple; his originality is to have renounced all of the habitual and easy ways of achieving effect. He has replaced the schemes generally used to focus the spectator's eye and to create light by the artifice of contrast with the science of relative tonal values. Daubigny is original because he proceeds directly from nature and does not involve the memory of other painters in his work.[99]

Henriet emphasizes Daubigny's "sincerity" and "originality"—his commitment to a totally personal interpretation of his experiences in nature through the medium of light—and observes that he has "renounced all of the habitual and easy ways of achieving effect," the standard formulas, the academic patterns and recipes for tonal effect and composition that had been invented in the studio and handed down in teaching and practice through generations of conventional landscape painters. Like the Barbizon painters before him in France and the Impressionists after him, Daubigny went directly to nature for the unique effect of light that characterized the moment—his moment—in the landscape, an effect that would both structure his work and enable him to communicate to others what he alone had experienced. "Daubigny is original," writes Henriet, "because he proceeds directly from nature and does not involve the memory of other painters in his work."

Daubigny's influence on the future Impressionists is seen first in the work of Pissarro. Pissarro's *Banks of the Marne at Chennevières* (colorplate 26), painted for the Salon of 1865, is probably related, as Kermit Champa has pointed out, to the open river motifs painted by Daubigny in the late 1850s and early 1860s (colorplate 25), sharing with them a taste for delicacy of tonal nuance and an attentiveness to the reflective properties of the water's surface.[100] In 1866 Pissarro settled in Pontoise. There he found his subjects, as Daubigny had done before him, in the area of the River Oise and in the houses and hills that surrounded the town. Pissarro's four large pictures of the Hermitage at Pontoise, two of

34. Camille Pissarro (1830–1903).
JALLAIS HILL, PONTOISE. 1867.
34 ¼ x 45 ¼" (87 x 114.9 cm).
The Metropolitan Museum of Art, New York City

which were shown at the Salon of 1868, are, in fact, closely dependent on the precedent set by Daubigny in his view of the same subject: the large *Landscape near Pontoise,* painted in 1866, which is also a horizontal view of the motif, with a high horizon and the hillside rising directly in the distance (see figs. 34 and 35).[101]

In Monet's work of the late 1860s and particularly the early 1870s, river views began to replace seascapes as the artist's principle subject, a change that may reflect Monet's increasing contact during these years with Daubigny. In the autumn of 1870, seeking refuge from the invading Prussian armies, Monet and Pissarro went to London, where they encountered Daubigny. The latter demonstrated his continuing friendship and support for them by introducing them to his dealer, Paul Durand-Ruel, who had just opened a gallery in London. Durand-Ruel showed their work there in December 1870 and, from then on, twice yearly in ten more exhibitions, until the London gallery closed in 1875. The first exhibition in December 1870 consisted of one hundred and forty-four paintings,

mainly by members of the Barbizon school, and included one painting by Monet and two by Pissarro. Invariably, the pictures of the Impressionists were shown in London in the company of landscape paintings by already established French artists of the older Romantic generation—including Daubigny, Diaz, Dupré, Corot, Millet, and Rousseau—the native tradition out of which they had come and which, in the early 1870s, was still regarded as the logical context for their work. In fact, it was their affinity to the artists of the Barbizon school as well as to those of the native English landscape school that probably explains, according to the English art historian Alan Bowness, why it was that no one then paid much attention to their work in London, where,

35. Charles François Daubigny.
LANDSCAPE NEAR PONTOISE. *1866.*
44 ⅛ x 63 ⅜" (112 x 161.5 cm).
Kunsthalle, Bremen

by 1870, advanced English art was already entering into its proto-Symbolist stage (with the work of artists such as Rossetti, Burne-Jones, and Whistler) and landscape painting "was out of favour and out of fashion."[102]

During the London sojourn of 1870–1871, Pissarro devoted himself to painting the streets and sites around his home in the new suburb of Lower Norwood (fig. 36), while Monet was attracted to river and park motifs similar to those that had occupied Daubigny on this and on an earlier trip to London (figs. 37–40). In none of these works is any influence from the English landscape school apparent, even though Monet and Pissarro are both known to have visited the museums in London, where much that is relevant would have been available for them to see. More than a hundred oil paintings and watercolors by Turner, for example, including *Rain, Steam and Speed, The Sun of Venice, The Fighting Temeraire* (fig. 3), *Peace—Burial of Wilkie* (fig. 29), and *Fire at Sea*, were on permanent display at The National Gallery, which then had charge of the Turner Bequest. Also on exhibit there were about a dozen works by Constable, including *The Haywain* (colorplate 16) and *The Cornfield*. In addition, the South Kensington Museum (today the Victoria and Albert Museum) was a rich source for English art and included in its 1870 catalogue six major works by Constable and five by Turner.[103]

This experience of English art, in particular of the work of Turner, seems to have made a considerable and enduring impression on Pissarro, even though his own pictures do not directly reflect it and the course of his development was not altered by it. In later years, Pissarro was anxious for his son Lucien to see the Turners in the National Gallery, and in 1898, when the young Matisse visited London on his honeymoon, Pissarro advised him in particular to study the Turners.[104] Still later, when questioned by the English critic Wynford Dewhurst, whose book on the Impressionists appeared in 1904, Pissarro made the

36. Camille Pissarro.
LOWER NORWOOD, LONDON, EFFECT OF SNOW. *1870.*
13 ¾ x 18" (35 x 46 cm).
Reproduced by courtesy of the Trustees of The National Gallery, London

Top:
37. Claude Monet.
HYDE PARK, LONDON. *1871.*
15 ¾ x 28 ¾" (40 x 73 cm).
Museum of Art, Rhode Island School
of Design, Providence.
Gift of Mrs. Murray S. Danforth

Bottom:
38. Charles François Daubigny.
VIEW OF THE CRYSTAL PALACE PARK IN LONDON.
Dated July 1866.
Red chalk, 11 ¹³/₁₆ x 18 ⁹/₁₆" (30. 3 x 47. 2 cm).
Musée Bonnat, Bayonne.
Photograph, Réunion des musées nationaux, Paris

Top:
39. Charles François Daubigny.
THE THAMES AT ERITH. *1866.*
Oil on wood, 14 ¹³/₁₆ x 26 ³/₈" (38 x 67 cm).
Musée du Louvre, Paris.
Photograph, Réunion des musées nationaux, Paris

Bottom:
40. Claude Monet.
THE RIVER BASIN OF LONDON. *1871.*
19 ¼ x 29" (49 x 74 cm).
National Museum of Wales, Cardiff

41. Claude Monet.
WATERLOO BRIDGE, EFFECT OF SUNLIGHT WITH SMOKE. *1903.*
26 x 39 ¾" (66 x 100 cm).
Baltimore Museum of Art. The Helen and Abram Eisenberg Collection

following comments about his and Monet's first visit to London:

> In 1870 I found myself in London with Monet, and we met Daubigny
> and Bonvin. Monet and I were very enthusiastic over the London land-
> scapes. Monet worked in the parks, whilst I, living at Lower Norwood, at
> that time a charming suburb, studied the effects of fog, snow and spring-
> time. We worked from Nature, and later on Monet painted in London
> some superb studies of mist. We also visited the museums. The water-
> colours and paintings of Turner and of Constable, the canvases of Old
> Crome, have certainly had influence upon us. We admired Gainsborough,
> Lawrence, Reynolds, etc., but we were struck chiefly by the landscape
> painters, who shared more in our aim with regard to "plein air," light, and
> fugitive effects. . . .[105]

While Pissarro thus readily acknowledged an affinity between the French Im-
pressionists and the English Romantic landscape school, he nevertheless took
umbrage when Dewhurst subsequently used his statements to paint a picture of
the French Impressionists as derivative imitators and followers of the English

42. Charles François Daubigny.
WINDMILLS AT DORDRECHT. *1872.*
33 1/2 x 57 1/2" (85.1 x 146.1 cm).
The Detroit Institute of Arts. Gift of Mr. & Mrs. E. Raymond Field

landscape painters. In angry and direct response to Dewhurst's published arti-
cles, which preceded his book, Pissarro, in a letter to his son Lucien on May 8,
1903, was defensively motivated to make critical distinctions between the En-
glish and French schools and to trace the roots of both to the French landscape
tradition:

> . . . He [Dewhurst] says that before going to London we had no concep-
> tion of light. The fact is we have studies which prove the contrary. He
> omits the influence which Claude Lorrain, Corot, the whole eighteenth
> century and Chardin especially exerted on us. But what he has no suspi-
> cion of is that Turner and Constable, while they taught us something,
> showed us in their works that they had no understanding of the analysis
> of shadow, which in Turner's painting is simply used as an effect, a mere
> absence of light. As far as tone division is concerned, Turner proved the
> value of this as a method, among methods, although he did not apply it
> correctly or naturally; besides we derived from the eighteenth century. It
> seems to me that Turner, too, looked at the works of Claude Lorrain. . . .[106]

If we bear in mind that lack of originality and personal sincerity were among
the harshest criticisms that could be leveled against a Romantic landscape

43. Claude Monet.
WINDMILL AT ZAANDAM. *1871.*
19 x 28 9/10" (48.5 x 73.5 cm).
Present whereabouts unknown. Photograph, Durand-Ruel, Paris

painter, the vehemence of Pissarro's response to Dewhurst's writings becomes comprehensible. And it may have been a similar fear of being classified as a mere imitator of the English school that also prompted Monet at various times in his career to deny the influence of English painting on his work, a denial that perhaps has been taken at face value too readily and for too long. Certainly, Monet's admiration for Turner in particular, at least during the 1890s and the early years of the twentieth century, is easily established. For example, his American friend, the painter Theodore Robinson, noted in his diary in 1892 that "[Monet] spoke of Turner with admiration—the railway one—and many of the w[ater] c[olor] studies from nature."[107] And later in life, in 1918, Monet once again admitted, although this time more cautiously and even grudgingly: "At one time I admired Turner greatly, today I like him much less. . . .He did not organize color enough, and he used too much of it: I have studied him."[108]

Although Monet had visited London again briefly in 1887, 1888, 1891, and 1898, it was not until September 1899 that he returned there explicitly to paint.[109] On three fall and winter visits to London, the first from September to

IMPRESSIONISM AND ROMANTICISM

early November 1899, the second from February to April 1900, and the third from January to April 1901, he stayed at the Savoy Hotel, where he painted the view of the Thames from the balcony of his fifth-floor room. About a hundred extant canvases from this period deal principally with the motifs of Waterloo Bridge, Charing Cross railway bridge, and the Houses of Parliament, many of them distinguished by a descriptive subtitle that records the particular condition of weather and effect of light under which the scene had been begun (fig. 41 and colorplate 5). Monet continued to work on these canvases back in his studio in Giverny, and he selected thirty-seven of them for exhibition at Durand-Ruel's in May 1904.[110]

As Alan Bowness suggests, the moment in Monet's career when he "admired Turner greatly" may perhaps be associated with the period when he was at work on his London series:

> Here the connection between the two artists is at a very profound level, beyond the question of stylistic borrowing. There is a grand, elemental quality about both of them: land and water, fire and air all merge together into one magnificent colour symphony. I do not think Monet can have seen Turner's paintings of the *Burning of the Houses of Parliament*, but *The Sun of Venice* was hanging in the National Gallery for him to contemplate, a challenge to the French painter to do something comparable. Indeed, the fact that Monet decided in 1908 and 1909 to visit Venice and paint its architecture—his only pictures done away from the Giverny garden in the last twenty years of his life—may be partly due to Turner's example. It is as if Monet wanted to see for himself just what the city on the water was like.[111]

But in the early 1870s, when Monet first visited London, even though the work of Turner was already resonating for him in ways that may have been both conscious and unconscious (colorplates 23 and 24), it was nevertheless not Turner but Daubigny who was still exerting the greatest immediate influence on Monet's development. In 1871 Daubigny and his son Karl went to Holland. It may indeed have been Daubigny who encouraged Monet's trip there in the same year[112]—although Jongkind, who was Dutch, may have already stimulated in Monet a curiosity about the topography of his homeland. Positioning himself on a boat in the middle of the River Meuse, Daubigny made sketches of the windmills of Dordrecht and used these as the basis for his *Windmills at Dordrecht* of 1872 (fig. 42), a picture that is related both in format and subject to Monet's *Windmill at Zaandam* (fig. 43), painted in the previous year.[113] In 1872, after returning to France, Daubigny purchased for his own collection Monet's *The Zaan at Zaandam*.[114] And in 1873 Monet built and began to work on a studio boat, following, of course, upon the example that had been set by Daubigny's *Le Botin* and inspired, in all probability, directly by it (figs. 31 and 32; 44 and 45).

◆ ◆ ◆

Throughout the 1860s and early 1870s, Monet and Pissarro learned their craft through close association with Corot, Boudin, Jongkind, and Daubigny, painters whose view of art and its relationship to nature lay wholly within the French Romantic tradition. Given this association, how are we to deal with the

notion, prevalent in twentieth-century criticism, that Impressionist renditions of nature border in their objectivity upon scientific experiments? The Impressionists, we are told, mechanically recorded their visual sensations of light in nature, devoid of the emotion and personal involvement that had been brought to bear upon such activities by their predecessors and teachers. They are supposed, in other words, to have progressed beyond the example of the older generation by becoming and remaining emotionally detached from what they still so fervently wished to record.

To argue this is not only illogical but historically indefensible, as both the paintings and the letters of Monet in the 1860s clearly show. While Monet was not as prolific or as eloquent with his pen as he was with his brush, there are still ample reflections in his youthful letters of the attitudes and values that he clearly would have imbibed from his Romantic mentors, whom he admired and strove to emulate.

In August 1864, for example, Monet wrote to Bazille from Honfleur, telling Bazille that he was still at Saint-Siméon with Jongkind and Boudin and encouraging him to join them by extolling the beauties of the countryside: "There are winds, beautiful clouds, storms, in short it is a fine moment to see the countryside; there are plenty of effects, and I assure you that I am making full use of the weather."[115] From Paris, in October 1865, he wrote to Bazille exhorting him, when he returned, "not to forget to bring me your effects of this summer [*vos effets de cet été*]."[116] At this point, then, in the traditional, Romantic way, Monet was characterizing the atmospheric states of nature in terms of recognizable luminary "effects"; and he used the term as well to refer to outdoor studies done by the artist in an effort to record these luminary states.

Moreover, for Monet, as for the Romantic generation that preceded and nurtured him, a landscape painting had to result from the artist's unique response to his own personal experience in nature and must not be an imitation of the styles or the responses of others. It is in fact validated as a work of art by the artist's sincerity and spontaneity and by the very authenticity of the emotions that it conveys. Thus, Monet, in 1864, was anxious to reassure Bazille of the originality of a study that he was sending him. Prompted by the same Romantic ideal that would motivate both him and Pissarro, many years later, to deny any influence on their work from the English landscape painters, Monet wrote to Bazille about his study in 1864:

> It is done entirely after nature. You will find there perhaps a certain relationship to Corot, but that is not at all the result of imitation. The motif and especially the calm and vaporous effect are the sole cause. I did it as conscientiously as possible, without thinking of any painting. Besides, you know that that is not my way.[117]

The source of Monet's insistence upon originality and his aversion to imitation lies in the Romantic tradition, and Monet's attitude in this regard can easily be compared with that of Constable, who distinguished between painters "intent only on the study of departed excellence, or what others have accomplished" and those who seek "perfection at its PRIMITIVE SOURCE, NATURE"; or that of Caspar David Friedrich, who urged artists to "study nature after nature and not after paintings."[118]

IMPRESSIONISM AND ROMANTICISM

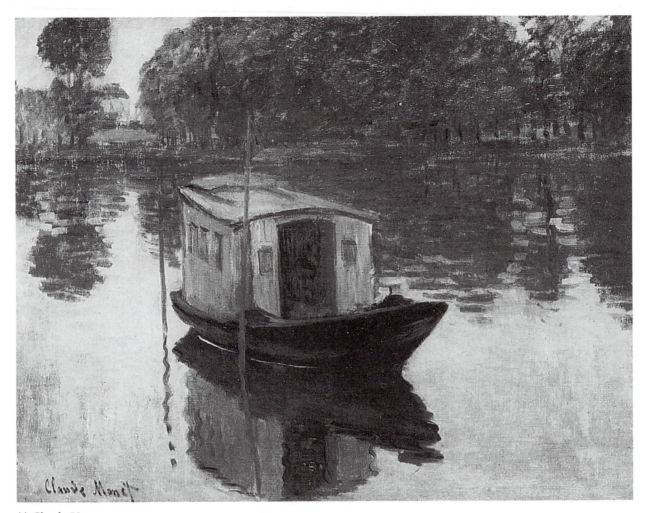

44. Claude Monet.
THE STUDIO-BOAT. *1874.*
19 ⅔ x 25 ⅕" (50 x 64 cm).
Rijksmuseum Kröller-Muller, Otterlo

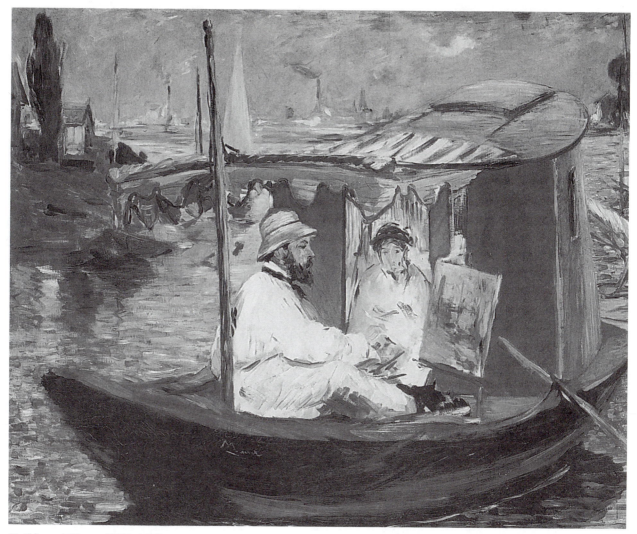

45. Edouard Manet (1832–1883).
MONET PAINTING IN HIS STUDIO-BOAT. *1874.*
31 ⅜ x 38 ⅜" (80. 3 x 98 cm).
Neue Pinakothek, Munich

Similar concerns prompted Monet to complain to Bazille about the distractions of city life that could rob a painter of his individuality. Writing from Etretat in December 1868, he said:

People are too preoccupied with what they see and hear in Paris, no matter how strong they may be. What I do here will at least have the merit of resembling no one, at least I believe so, because it will be simply the expression of what I myself will have personally felt [*ressenti*]. The further I go, the more I regret how little I know; that is what hinders me the most I am sure. The further I go, the more I realize that people never dare to express openly what they feel. It is odd. That is why I am doubly happy to be here; and I think that I will not come to Paris for long periods now, a month at the most each year.[119]

Monet was not alone in decrying the reluctance of people "to express openly what they feel." The critic Thoré-Bürger, who had long implored contemporary artists to risk themselves in honest personal expression, declaring that "the index of talent is personal originality," had also been forced to lament, in his review of the Salon of 1847, that "nothing is rarer than independent, original impressions."[120]

Like his Romantic predecessors and contemporaries, Monet placed a high premium on originality and sincerity—on painting pictures that "will at least have the merit of resembling no one," that will express openly "what I myself will have personally felt"—for therein lay the value and authenticity of a work of art according to the Romantic tradition that had nurtured him. These values and concerns, so like those of Monet's mentors, Boudin, Jongkind, and Daubigny, are further reflected in a comment Monet later made about Jongkind, a comment that reportedly pleased the older artist very much. "One can always profit from looking at the landscapes of Jongkind," said Monet, "because he paints sincerely, as he sees and as he feels."[121]

CHAPTER 3

Effect and Finish:
The Evolution of the Impressionist Style

In the 1860s the Impressionists were the direct heirs to the Romantic landscape painters' responsive attitude toward nature, their emphasis on subjectivity and originality, and their desire to communicate their emotional experiences in nature to the viewers of their works. The vehicle for this communication of emotional experience was understood by painters of both generations to be the "effect"—the characteristic luminary pattern through which nature, at any given moment, creates a mood and weaves a poetic spell for the sensitive observer. It was toward recording these broad tonal harmonies and thereby capturing the emotional states they engendered that the Impressionists, like their predecessors, directed their efforts when sketching outdoors.

The tool used by these artists to preserve their impressions of natural luminary effects was the *pochade*, a particular type of outdoor landscape study *(étude)* devoted to the notation of effect. An established category or procedure of sketching for both conservative and progressive landscape painters throughout the nineteenth century, it was defined late in the century in a manual by the official painter Ernest Hareux as "the general impression of an effect in which every part is jotted down with its respective value, and contributes to the whole."[122] The same writer also observed:

> The most important thing in a picture is the effect. A landscape is not a good one unless we can tell what season of the year and what time of day it represents. To achieve this aim, one must observe constantly and draw one's impressions from nature alone. . . making very small *pochades* with no other object than to capture the exact effect. . . and reproduce a fugitive impression.[123]

Another popular writer of painting manuals of this period, Karl Robert, defined the *pochade* as "a study of a complete theme, done from the point of view of correct values and conveying the impression of a motif that has caught the painter's attention." According to the same writer, the *pochade* served in the execution of the final work as both its base and its complement: ". . . its base, since it is from the *pochade* that you establish the range of values; its complement, since it helps you to remain true to the desired effect as your work proceeds."[124]

Once having captured *en plein air* the fugitive tonal patterns of nature's evocative light, either in the small, separate *pochade* or, more rarely, in the preliminary layer of the final work, called the *ébauche*, artists of the older generation had normally returned to the studio to build a poetic reconstruction of the landscape upon the basic scaffolding of this immediately captured tonal effect—confident of being able to produce paintings that would provide for the spectator emotions analogous to the ones they themselves had experienced in direct, personal communion with nature. But as artists became more and more committed to replacing the standard, formulaic effects of academic painting with those provided by nature, more time was spent working directly outdoors. By the 1860s Daubigny,

for example, was reportedly completing some of his canvases *en plein air*. Gradually, greater emphasis was placed on the immediacy of the optical record, the spontaneity of which was thought to be responsible for preserving the artist's unique response to nature, thus constituting his originality. This connection between artistic originality and immediacy of vision and execution was made explicit by the critic Thoré-Bürger, who wrote appreciatively in 1868 of Jongkind's work: "It delights all who love spontaneous painting, in which strong feelings are rendered with originality. . . .I have always maintained that true painters work at speed, under the influence of impressions."[125]

What has been perceived in the twentieth century as unprecedented stylistic innovation on the part of the Impressionists was regarded, in fact, by many of their contemporaries as a direct outgrowth of this earlier Romantic tradition. In 1891 the English critic P. G. Hamerton argued against assigning profound originality to the movement:

> Impressionism. . . is in reality nothing more than effect-painting, which is the foundation of harmony in landscape and also the necessary condition of the expression of the artist's feeling. Accurate linear drawing of the forms of tangible objects. . . excludes the expression of sentiment and is unfavourable to unity, whilst an effect almost ensures unity of itself, and excites an emotion in the artist which communicates itself to his work.

What was new about the Impressionists, Hamerton proceeded to explain (in negative terms), was "their self-abandonment to the impression of the effect without stopping to consider whether they have knowledge enough to reproduce the entire scene."[126] Echoing here in Hamerton's comments of 1891 are the ambivalent criticisms that had already been directed in the 1850s and 1860s at artists such as Daubigny, who had been praised for his individual and poetic responses to nature but faulted for producing mere sketches—that is to say, for sacrificing drawing and finish (considered to be the "rational" components of the artmaking process) for the sake of the overall effect (the emotional and the intuitive). As Charles Blanc had put it in his review of the Salon of 1866, responding to the work of artists whom he identified as "naturalists" and followers of the Barbizon school: "Make sure that the thing painted creates for you the same impression that would have been created by the thing seen: these are the terms in which certain artists have posed their problem." But what does it matter, he went on to ask, if a collection of "patches" produces *"un effet délicieux?"*:

> With such a manner of understanding art, one risks being left with approximation, with implied execution, debasing the coin of the painter; for in the long run, feeling is not everything, no, not by any means; craft still has its requirements."[127]

Finish and "the requirements of the craft" were concepts over which artists and their critics frequently disagreed during the nineteenth century. The sketch versus finish controversy troubled the French art world throughout this period, but especially during the Romantic era. Figure painters, such as Delacroix, and landscape painters, such as Daubigny, struggled to achieve a correct balance in their work between the free, painterly, and evocative effects of the quick sketch

and the more detailed representation that they and their critics deemed necessary if a simple sketch were to be turned into an enduring and finished work of art. In his journals in the 1850s, for example, Delacroix spoke of "the unfailing effect of the sketch as compared to the finished picture, which is always somewhat spoiled as to the touch," and he analyzed the evocative effects of a sketchlike technique upon the imagination, both of the artist and the spectator. He concluded, nevertheless, that details must be added and that a certain amount of the broad effect of the original sketch must be sacrificed in order to create a truly finished work, in which, as he put it, "the harmony and depth of the expression become a compensation" for the loss of the more broadly evocative effect of the initial sketch.[128] Even Daubigny, whose Salon pictures were frequently criticized for being mere "rough sketches," did not entirely ignore official standards in this respect: there is a clearly visible distinction, in terms of detail and degree of finish, between his Salon works (even when these were finished outdoors) and his *pochades*, which pretended to be no more than effects—simple and direct recordings of natural, luminary phenomena. It has long been thought that the Impressionists were revolutionary and unique for their ability to renounce these arbitrary standards of finish, standards to which even the most avant-garde painters of earlier generations had acceded to some degree. But in this, too, there is ample evidence that they were once again the receptive heirs to the traditions and values of their respected predecessors. Although they would eventually find solutions to the effect versus finish problem that would be more complete and satisfactory in some ways than those of their elders had been, the problem to which they sought solution was nevertheless the same.

On July 15, 1864, Monet wrote to his friend Bazille from Honfleur where he was working:

> In short, I am fairly satisfied with my stay here, even though my studies are far from what I would like. It is really frightfully difficult to do something that is complete in every respect, and I believe that very few people are satisfied with approximations. Well, my friend, I want to struggle, scrape out, start over, for one can do what one sees and understands, and it seems to me, when I am looking at nature, that I am going to do it all, record it all, but then just go ahead and try to do it. . . when you are there in front of the work. . . .

> All of which only proves that we must think about nothing else. It is by dint of observation and reflection that one succeeds. And so let us grind away continually. Are you making any progress?[129]

As his correspondence during this period makes clear, Monet, at this stage in his career, did not regard his studies as complete. To complete them, he knew, would take repeated application, requiring time for "observation and reflection," and this, his letters of the 1860s suggest, is something that he rarely had enough of. About to send Bazille some paintings that he hoped the latter would be able to sell for him, Monet wrote from Sainte-Adresse on October 14, 1864:

> Among the three canvases, there is a simple study [*étude*] that you did not see me begin; it is done entirely after nature. . . .The other two canvases

are of the shipyard that lies below Saint-Siméon, and the road in front of the farm [fig. 24]. These are two of my best studies [*études*]. I am not sending you the studies, however, but two paintings [*tableaux*] that I am in the midst of finishing here after my studies. I hope that they will please you and especially M. Bruyas [the prospective patron].[130]

Two days later, however, from Rouen, he wrote to announce a change in plan:

> Instead of sending you as I had told you copies of my studies, I am sending the studies themselves, which are better by far. I was too busy to do them over, and I want you to have something passable to show.[131]

These and other letters by Monet in the 1860s reflect not a complete and precocious acceptance on his part of the intrinsic and self-sufficient validity of his *études*—even the best of which he referred to, with resignation, as *"quelque chose de passable"*—but a genuine frustration and despondency over not being able to achieve his highest aspiration, the *tableau*, "something that is complete in every respect," and which he seemed to connect, moreover, with the traditional notion of the Salon picture. He continued, despairingly, to make this distinction in his letters as late as 1869, when he wrote to Bazille on September 25 lamenting that he would have nothing to send to the next Salon:

> Winter is coming, a disagreeable season for the unfortunate. And then comes the Salon. Alas! I will not be represented there once again, for I will not have anything ready. I have a dream, a picture [*tableau*] of the bathing area at La Grenouillère, for which I have made some bad sketches [*quelques mauvaises pochades*], but it is only a dream. Renoir, who has just spent two months here, also wants to do this picture.[132]

It has been speculated that Monet subsequently destroyed the "bad sketches" to which he refers in this letter.[133] If that were the case, then the three known pictures by Monet of the motif at La Grenouillère would belong to the category of the more ambitious *"tableau"* of which the artist said he dreamed. But according to the Monet scholar Joel Isaacson, it is most unlikely, at this late date and with winter coming on, that Monet would have had either the time or the opportunity to do these paintings, which show the site as it would have appeared in summer, "crowded with strollers and bathers."[134]

The extant paintings of this subject, then, must indeed be the pictures that Monet referred to as his *mauvaises pochades*. Today, we may no longer be able to share Monet's qualitative assessment of these works; however, we can understand and be enlightened by his classification of them in these terms, as preliminary *pochades*. The Metropolitan Museum of Art's *La Grenouillère*, for example, is such a *pochade* (colorplates 27 and 28). It is a plein-air study in which the artist concentrated on seizing the effect, the broad pattern of nature's light at a particular moment, in order to preserve his immediate impression of—his personal emotional response to—the natural scene. While the canvas is entirely covered, the work is painted broadly and rapidly, with no significant layering of the pigment. As an "effect" it is appropriately limited in color range, but rich in tonal contrast and nuance. Even at a distance, the vehemence of the surface and the

rhythm of the brush strokes have their own forcefulness and character. These bold, graphic strokes are movements of the artist's hand in response to what he has seen; and what he has seen are not consciously identified objects, figures, and details, but rather his sensations of color and tone—what Meyer Schapiro has referred to as Monet's "uninterpreted sensations."

For Monet, his *pochades* were not finished works; they were not yet complete in every respect—products of observation and reflection. Isaacson points to the irony of the fact that "the unsatisfactory sketch, initially rejected by its author as unworthy of his highest aim, became, in the next decade, the hallmark of a new style of painting."[135] But given the evidence of Monet's future progress, we may reasonably question whether such works, despite their essential utility, ever really rose in his estimation—at any time during his life—beyond their original classification as preliminary *pochades*. The old values, certainly, are still reflected in comments Monet made to an interviewer in 1898:

> In the old days we all made *pochades*. Jongkind. . . took notes in water-colour and worked them up into pictures; Corot, when he dashed off his studies from nature, used them to make up the canvases that are so sought after, and in some of these you can see very well what the ingredients were. . . .Landscape painting is simply a matter of impressions, instantaneous ones—hence the label that people have given us, and for which, as it happens, I am responsible. I had sent in a piece of work that I had painted from my window at Le Havre, with a misty sun, and a few masts sticking up in the foreground. . . .They asked me for a title to put in the catalogue, and as I really couldn't call it a view of Le Havre, I replied: "Let's say an impression."[136]

By implication, Monet's *Impression, Sunrise* of 1873 (colorplate 23), which he exhibited at the first independent group show of the future "Impressionists" in 1874, was to his mind a *pochade*. And this is in fact borne out by the physical properties of the work. It is quickly and thinly painted, restricted in color, and obviously designed to capture an effect—albeit an effect very different in character from the one that Monet had set out earlier to capture at La Grenouillère. In the later work, large, tonally similar areas, punctuated by small color accents, describe a pervasive atmosphere of mist. A subtly differentiated evenness of light spreads throughout the scene—what Monet at a later date would refer to as "the envelope, the same light spread everywhere."[137] As a *pochade*, it is a recording of the effect that originally produced, and continues to convey, the artist's impression. But it was not, in Monet's view, a finished work: he "really couldn't call it a view of Le Havre," Monet said, and therefore he decided to call it "an impression."

In the twentieth century, we have come to regard as "complete" many works of art that, in earlier periods, would have been deemed "unfinished." We recognize in these works, which are often rapid sketches of one kind or another, the attainment of a precarious, but precious state of aesthetic and expressive harmony and balance, one that would have been lost had the artist attempted to add further descriptive detail or surface finish to the work. Nineteenth-century viewers were capable of recognizing and appreciating the perfection of these works within their own genre, but were less willing than we to erase all

distinction between the established categories of *étude* and *tableau*. Corot, for example, when shown a work by a student in which an effect had been captured *en grisaille*, is reported to have told the student: "Leave it alone now, or you'll spoil it!" And when the student persisted in wanting to make a painting out of it by adding color, Corot reiterated: "I assure you, do please leave it alone."[138]

Monet, too, recognized that many of his *études* and *pochades*, painted quickly in a single session out-of-doors, were "complete" and successful in their own terms. In the early 1870s, as we have seen, he chose to exhibit works of this type, such as *Impression, Sunrise*. But he presented them, explicitly, as studies and impressions, not as finished paintings. And he continued to make the distinction in kind between works "completed" in a single sitting before nature (the successful *étude* or *pochade*) and those far more difficult and desirable to attain, the work (as he said in his letter of 1864 to Bazille) that is "complete in every respect" a product of "observation and reflection"; in short, the *tableau*. Like earlier generations of Romantic artists, Monet valued the intensity and personal "authenticity" of his initial responses to nature, but he was not averse to tempering these with cooler analysis. Like those earlier Romantics, he too might have found much that was congenial to the spirit of his enterprise in Wordsworth's famous and quintessential description of the Romantic method. "Poetry," wrote Wordsworth, in the preface to the *Lyrical Ballads* (1798), "takes its origins in emotion recollected in tranquillity. The emotion is contemplated until by a species of reaction, the tranquillity gradually disappears, and an emotion, kindred to that which was before the subject of contemplation, is gradually produced and does itself actually exist in the mind."[139]

During the second half of the 1870s, Monet's technique gradually changed and developed in a way that reflects the enduring spirit of this Romantic ideal as well as his own unique coming to terms with the sometimes conflicting demands of the sketch and the finished picture—his personal answer, in other words, to the old effect versus finish controversies of nineteenth-century aesthetics and criticism, which continued to preoccupy him. During these years, which were critical ones for Impressionism as a new Romantic style, the look of Monet's paintings gradually changed as he spent more and more time, *on successive occasions*, before the motif in nature. His pictures, like those in the Gare Saint-Lazare series of 1877 (colorplates 29 and 30), were now built up slowly, over a period of time, made up of layer upon discrete layer of delicately flecked and nuanced, but palpably encrusted pigment. As he returned repeatedly to the motif and to his canvas, searching each day for the recurrence of the effect that had originally moved him, Monet's technique became less a process of getting the masses down broadly, as it had been in his plein-air work of the 1860s (see colorplates 23 and 27) and as it still remained during his first sessions before the motif. Canvases that did not progress far beyond the first, relatively thinly painted and emphatically tonal layer of the *ébauche* (the layer in which the effect was initially recorded) are readily identifiable not only from the 1870s (see colorplates 30 and 32), but from the 1880s and 1890s as well (figs. 46 and 48). More frequently now, from the late 1870s on, as Monet returned "to contemplate his emotion," to reexperience the condition of light, the natural effect that had stimulated his initial impression, his technique of painting became more characteristically a process of elaboration rather than one of reduction. He worked repeatedly over the initial layer of his *ébauche*, noting, with deliberation

and patience, the complexity of his visual and emotional sensations and allowing these to modify and enrich—but not obscure—his first impression (see figs. 46 and 47; colorplates 29 and 30).

Monet described the slow and painstaking nature of this procedure and its goals in a letter that he wrote to his friend and future biographer, Geffroy, on October 7, 1890, while at work on the Grain Stack series:

> I grind away and persist in a series of different effects (of stacks). But in this season the sun goes down so quickly that I cannot follow it. . . . I have become so slow in working that I am in despair; but the further I go, the more I see that it will take a great deal of work to succeed in rendering what I am looking for: "instantaneity," especially the envelope, the same light spread everywhere, and more than ever facile things that come at the first attempt disgust me. I am driven more and more frantic by the need to render what I experience.[140]

The word *instantaneity,* which Monet set off in quotation marks, is highlighted as a word that was not originally his own in application to his art. It derived, in fact, from a recent critical debate in the press between two art critics, Félix Fénéon and Octave Mirbeau, the former hostile, the latter friendly to Monet's work.[141] Fénéon, a supporter and promoter of the "new art" of Georges Seurat, had first applied the word "instantaneity" in a pejorative sense to Monet's work in a review of 1886, implying, by his use of it, that Monet worked automatically and hastily and without cerebral intervention. Mirbeau picked up on the term while writing a catalogue essay for Monet's retrospective exhibition of 1889. Defining "instantaneity" as a positive quality, he wrote:

> M. Claude Monet understood that, in order to arrive at a fairly exact and moving interpretation of nature, what one needs to paint, in a landscape, is not only its general lines, or its partial details, or its localizations of greenery and ground, but the moment that one has chosen in which this landscape becomes characterized: that is, the instantaneity.[142]

While Monet, in his letter to Geffroy, seems to have accepted and endorsed Mirbeau's use of the term as one that was relevant to his art, "instantaneity" was still for him a word that needed to be set in quotation marks, one that had perhaps for his ear too theoretical a ring. This is not surprising, given the remarkable simplicity and consistency of Monet's aesthetic program throughout his career. In the very last years of his life, in fact, Monet wrote to the English art critic Evan Charteris: "I have always had a horror of theories; my only merit is to have painted directly from nature, seeking to render my impressions in front of the most fugitive effects."[143]

In 1890 Monet may well have been discomforted by the fanciness of the term "instantaneity" and may well have felt impelled, if only in private correspondence with Geffroy, to demystify it, by providing his own, fuller, and less ambiguous definition. If, as Mirbeau had argued, "instantaneity" as a procedural ideal referred to the moment, chosen by the artist, in which the "landscape becomes characterized," then, Monet made clear, the visual and emotional agent of this revelation is an effect of light: "the envelope, the same light spread every-

46. Claude Monet.
PORT-DOMOIS AT BELLE-ILE. *1886.*
23 ⅝ x 23 ⅝" (60 x 60 cm). Present whereabouts unknown

where." Along with Mirbeau, who had countered earlier critics' association of Monet's efforts to record the "instant" in nature with a hasty and insufficiently considered execution, Monet placed great emphasis on the idea that to achieve "instantaneity"— to capture the luminary harmony of a moment and thereby to render what he "experiences"— is a slow and deliberate procedure. In this he is echoed, in an equally clear and down-to-earth way, by the words of the American artist Theodore Robinson, who worked with Monet at Giverny at this time. In an article published in 1892, Robinson gave a firsthand account of what was new and what was traditional about Monet's methods and goals:

> Most painters have been struck by the charm of a sketch done from nature at a sitting, a charm coming from the oneness of effect, the instantaneousness seldom seen in the completed landscape, as understood by the studio landscape painter. M. Claude Monet was the first to imagine the possibility of obtaining this truth and charm on a fair-sized canvas with qualities and drawing unattainable in the small sketch. He found it attainable by working with method at the same time of day and not too long, never for more than an hour. Frequently he will be carrying on at the same time fifteen or twenty canvases. It is untrue that he is a painter of clever, large *pochades*. The canvas that does not go beyond the *pochade* state never leaves his studio, and the completed pictures are painted over many times.[144]

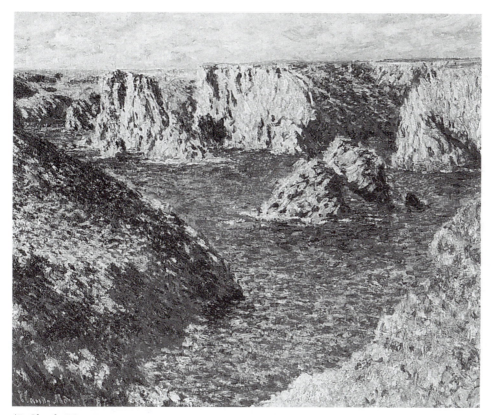

47. Claude Monet.
PORT-DOMOIS. *1886–1887.*
25 ½ x 31 ¾" (65 x 81 cm).
Yale University Art Gallery, New Haven. Gift of Mr. and Mrs. Paul Mellon, B.A. 1929

The "oneness of effect," formerly attainable only in the plein-air sketch, was achieved by Monet in more finished paintings—paintings that go beyond the *pochade*—because, Robinson says, Monet returned to the effect repeatedly at the same time of day and had many canvases in progress simultaneously. He would work on each canvas, Monet himself later told an interviewer, "only when I had my effect, that's all there is to it." In this same interview with the Duc de Trévise in 1920, Monet explained more fully, but with utter simplicity, the origins of his series:

> When I started out, I was like everyone else; I believed that two canvases sufficed, one for "gray weather," one for "sun." Then I was painting some stacks that had impressed me and that made a magnificent group, just nearby here; one day, I see that my lighting has changed: I tell my step-daughter: "Go to the house, if you would, and bring me another canvas." She brings it to me, but a little later, it [the light] is different again: another! and yet another [canvas]! And I worked on each only when I had my effect, that's all there is to it. It's not very difficult to understand.[145]

The amount of time that Monet would spend on any one canvas on any given day was determined by the movement of the sun and could be far briefer than

IMPRESSIONISM AND ROMANTICISM

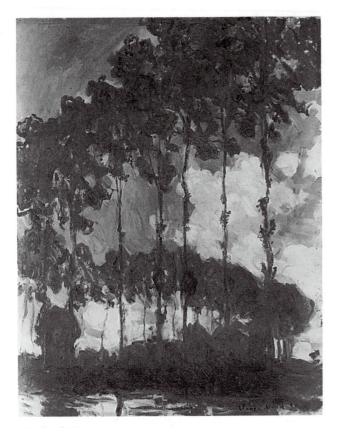

48. Claude Monet.
POPLARS ON THE BANKS OF THE EPTE. *1891.*
(Signed and dated at a later time: Claude Monet 90.)
36 ¼ x 28 ¾" (92 x 73 cm). Tate Gallery, London; Art Resource.

the hour that was specified by Robinson in 1892. Monet later told another interviewer, the American painter Lilla Cabot Perry, that for one of his "Poplar" pictures of the 1890s, "the effect lasted only seven minutes, or until the sunlight left a certain leaf." Perry continued: "He always insisted on the great importance of a painter noticing when the effect changed, so as to get a true impression of a certain aspect of nature and not a composite picture."[146] In his interview with the Duc de Trévise in 1920, Monet described the particular difficulties and frustrations with which he had been confronted while working on his series in London from 1899 to 1901:

> At the Savoy Hotel or Saint Thomas's Hospital, where I established my points of view, I had as many as a hundred canvases in progress—for a single subject. By dint of searching feverishly among these studies [*ébauches*], I had chosen one that did not differ too much from what I saw before me: in spite of all that, I modified it completely. My work over, I noticed, while moving my canvases, that I had overlooked precisely the one that would have best suited me and that I had had right there under my hand. What stupidity! [147]

Monet went on to explain that he might return to work on any given canvas as many as twenty to thirty times, if the right luminary conditions recurred.[148] And these works, as well as others that Monet brought home from his travels, were further retouched in the studio. This practice was not limited to Monet's late works, which were often exhibited as series and therefore retouched by the artist to provide them with coherence and unity as a group. As his letters show, his practice of putting the final touches on his canvases in the studio was well-established by the early 1880s.[149] In a letter of 1886 Monet explained the vital role that this practice played for him in the creative process. Writing to his dealer Durand-Ruel from Belle-Ile on the Breton coast, Monet said:

> You ask me to send you what I have finished; I have nothing finished and you know that I can really judge what I have done only when I see it again at home and I always need a moment of tranquillity [*repos*] before I can give the final touches to my canvases.
>
> I am working steadily, I often have bad weather unfortunately, and for many motifs I am having difficulty in finding the effect again, and I will have much to do once I return to Giverny.[150]

Despite such evidence to the contrary, the idea that Monet presented his sketches as finished works is one that took hold and persisted in the art historical literature throughout much of the twentieth century. Albert Boime, for example, wrote in 1971:

> . . . it is certain that the Impressionists consciously presented their studies as finished works. . . . The simplification of the technical procedure now enabled the artist to achieve his impression of a scene in the same time that formerly permitted only a simple sketch. The Academicians were still calling this a sketch, while the Impressionists called it a respectable work of art.[151]

Ironically, the survival of this notion might be seen in some measure as a tribute to the success of Monet's enterprise. For what he set out to do was not to present his sketches as finished pictures, but to create and present finished pictures in which the most valued qualities of the sketch—the freshness and spontaneity of its execution—would be preserved.

For the Romantics in the nineteenth century, the rapidly executed sketch was the visible embodiment of the artist's "originality" and "sincerity" of emotion. It was both the product and record of what was in fact most personal to the artist: the immediate response of his unique sensibility to an experience in nature. It is this conception of artistic originality that lies behind the concern voiced by so many early nineteenth-century artists over the importance of retaining the first impression (Corot, for example, who wrote, "Never lose the first impression which has moved us") as well as behind their anxious and not always successful efforts to preserve in their studio pictures something of the physical immediacy of the sketches upon which those finished pictures were based.

Monet's uniquely successful solution to this central and long-standing dilemma of nineteenth-century aesthetic theory and practice was to create, deliberately, the look of spontaneity in pictures that had been carefully and thoughtfully developed over dozens of sittings. In recent years, the extensive and careful studies of Monet's technique that have been carried out principally by John House and Robert Herbert have provided enough information about the way in which Monet's pictures were made to allow us to understand how this look of spontaneity was actually achieved.[152] As we have seen, it was the *ébauche*, the quickly and thinly painted first layer of the work in which the effect was recorded, that represented for the Impressionists the most truly spontaneous moment in the creative process and the most meaningfully responsive moment in the artist's interaction with nature. Over the *ébauche*, there followed in Monet's works a deliberate layering of a variety of directional and textural strokes. Between sessions, these were allowed to dry, and they formed a palpable crust over which a final layer of thin, color strokes was added. The main purpose of the intermediate layers of dried impasto was to provide, as Herbert has explained, "a texture of apparent spontaneity."[153] Although finally covered over, as the *ébauche* beneath them had been, the surface irregularities of these textural layers remained to provide an enduringly "spontaneous" foundation for the final layer of color—thus preserving, through many sessions of slow and deliberate work, the illusion of the artist's quick and responsive movements upon the canvas.[154]

In the 1860s and early 1870s, a period when Monet frequently expressed dis-

satisfaction with his work and despaired of achieving his goal of the finished *tableau,* the majority of his canvases were worked very quickly, although isolated instances of overpainting on the dried surfaces do occur. It was not until the mid-1870s, as Monet more regularly disciplined himself to return to work repeatedly on specific effects, that the technique of surface color over dried layers of textural impasto emerged in his work as a recognizable and fairly systematic procedure. In this respect, the decade of the 1870s was indeed crucial for the development of Monet's Impressionist method.

Over a career that encompassed some sixty-five years of careful and intensive plein-air observation, Monet's sensibilities became attuned to ever finer and more discriminating perceptions of even the briefest of nature's luminary and expressive states, and his eye became incredibly sensitive to the complexity of tonal and coloristic elements out of which these states or "effects" might be reconstituted. In later life, he devoted himself to capturing the briefest of effects in quick succession. But even though he had come a long way from the days of his youth, when, as he later said, he had been "like everyone else," and "believed that two canvases sufficed, one for 'gray weather,' one for 'sun'"[155] (echoing, perhaps, Rousseau's advice to his students, that they should always "take two canvases to the motif, one for a morning study, the other for an effect of evening"),[156] the path along which Monet had traveled had been remarkably straight and consistent, linking his earliest as well as his latest works with those of his Romantic predecessors and teachers. For like Rousseau and the other Barbizon painters, Monet, too, was a "Son of Light." Although his procedures had evolved and changed decisively from the mid-1870s on, their raison d'être remained the same: "to render," as the critic Pothey wrote in 1877, "the effect and the emotion that nature produces directly in the heart or in the soul."[157]

The evocative "effect" that Monet and his predecessors had formerly recorded in the separate *pochade* was later captured and preserved by Monet in the *ébauche,* the first, quickly sketched record, on the final canvas, of the plein-air effect that had originally moved the artist and constituted his impression. It came to serve as the literal foundation for Monet's finished work, guiding him as he built and refined, through "observation and reflection," his completed image. Though finally covered by successive layers of textural and coloristic enrichment, it is through the implicit presence of that underlying effect and the emotional experience that it represents that the artist's unique and fleeting first impression—his original emotion—is preserved and conveyed.[158] In Monet's "feverish" but remarkably focused efforts to return to and reexperience his plein-air effects and in the "moment of tranquillity" that preceded his final work in the studio, that original emotion, as Wordsworth would have put it, was "contemplated, until by a species of reaction, the tranquillity disappears, and an emotion, kindred to that which was before the subject of contemplation, is gradually produced and does itself actually exist in the mind."

In terms, then, that were wholly compatible with Romantic aspirations, Monet was able to achieve in the work of his maturity an inspired synthesis between the best qualities of the *étude* and the *tableau.* And in that synthesis, which had for so long eluded his predecessors, he found a solution to the problem that had been a central and crucial one, not only for the practice of landscape painting but also for aesthetic theory in general throughout the nineteenth century.

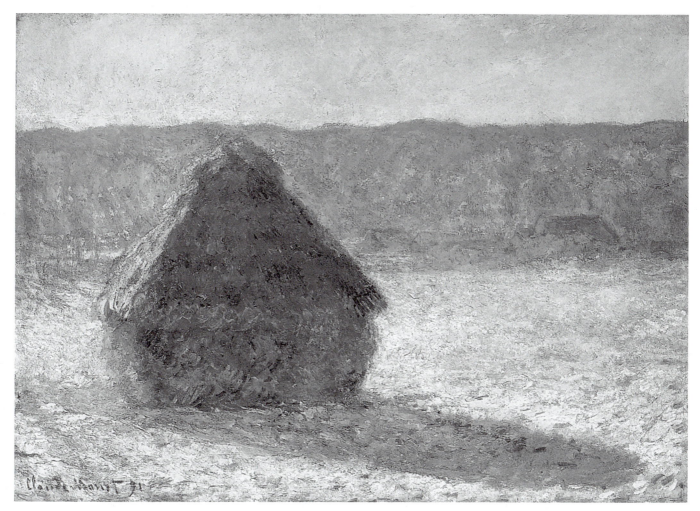

1. Claude Monet.
GRAIN STACK, EFFECT OF SNOW, MORNING. *1891.*
25 ¾ x 36 ⅜" (65.4 x 92.3 cm).
Gift of the Misses Aimée and Rosamond Lamb
in memory of Mr. and Mrs. H. A. Lamb.
Courtesy Museum of Fine Arts, Boston

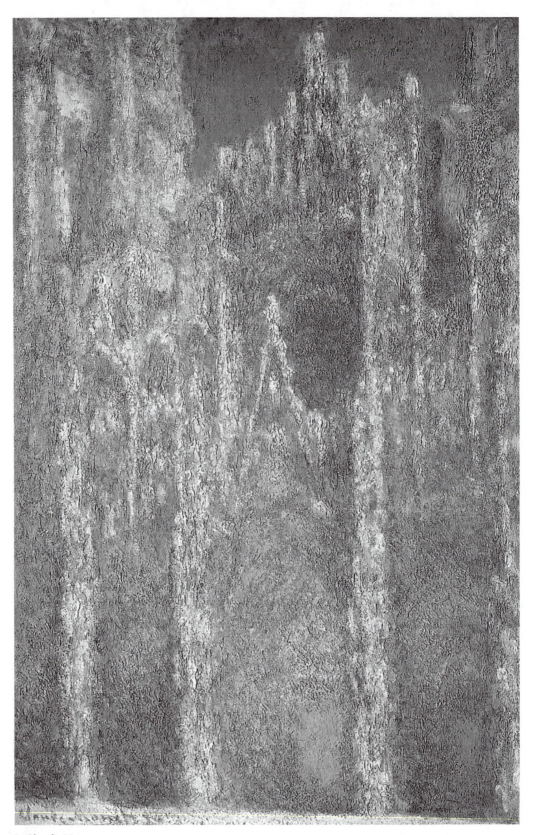

2. Claude Monet.
CATHEDRAL OF ROUEN, EFFECT OF SUNLIGHT. *1893–1894.*
39¹/₂ x 25 ¾" (100.3 x 65.5 cm).
Juliana Cheney Edwards Collection.
Courtesy Museum of Fine Arts, Boston

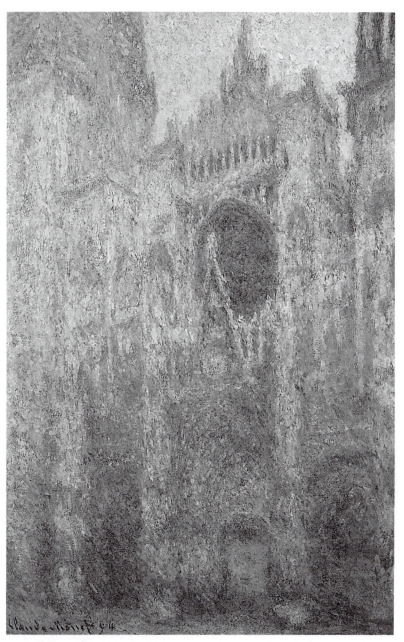

3. Claude Monet.
CATHEDRAL OF ROUEN, WEST FAÇADE. *1893–1894.*
39 ½ x 26" (100 x 66 cm).
National Gallery of Art, Washington, D.C.
Chester Dale Collection

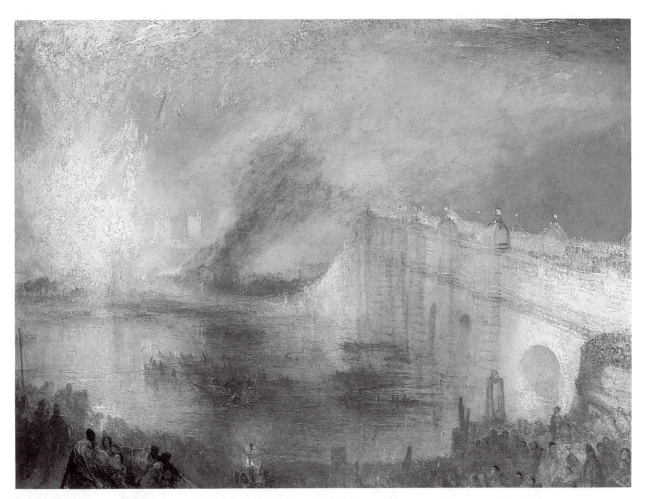

4. J. M. W. Turner.
THE BURNING OF THE HOUSES OF PARLIAMENT. *1834.*
36 ¼ x 48 ½" (92.1 x 123.2 cm).
Philadelphia Museum of Art.
The John H. McFadden Collection

5. Claude Monet.
THE HOUSES OF PARLIAMENT. *1905.*
31 ⅞ x 36 ¼ " (81 x 92 cm).
Musée Marmottan, Paris.
Photograph, Jean-Michel Routhier, Studio Lourmel, Paris

6. Théodore Rousseau.
SUNSET NEAR ARBONNE. *c.1855.*
Oil on wood, 25 ¼ x 39" (64.2 x 99.1 cm).
The Metropolitan Museum of Art, New York City.
Bequest of Collis P. Huntington, 1900

7. Claude Monet.
THE JAPANESE FOOTBRIDGE AT GIVERNY. *1922.*
35 x 36 ¾" (88.9 x 93.3 cm).
The Museum of Fine Arts, Houston.
John A. and Audrey Jones Beck Collection

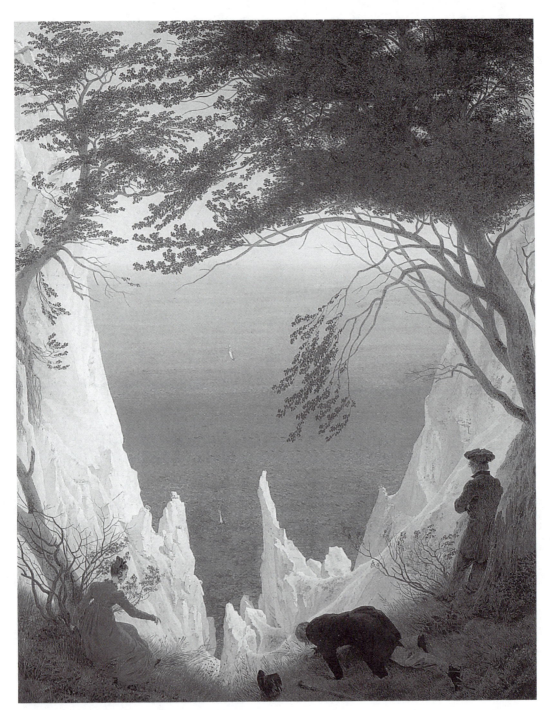

8. Caspar David Friedrich.
CHALK CLIFFS ON RÜGEN. *c.1818.*
35 ⅔ x 28" (90.5 x 71 cm).
Oskar Reinhart Foundation, Winterthur, Switzerland

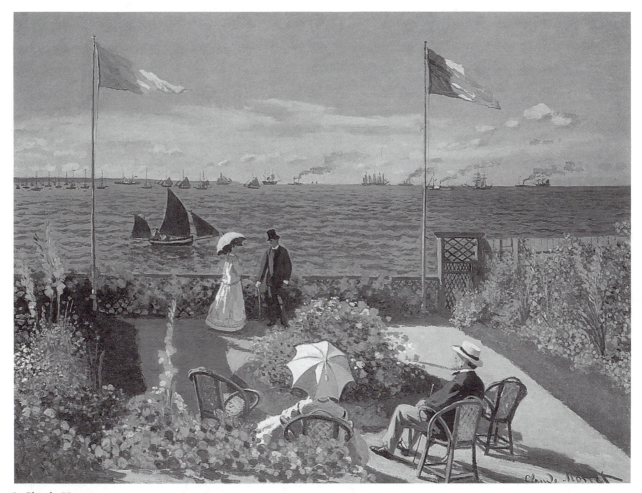

9. Claude Monet.
GARDEN AT SAINTE-ADRESSE. *1867.*
(formerly called Terrace at Sainte-Adresse.)
38 ⅗ x 51 ⅕" (98 x 130 cm).
The Metropolitan Museum of Art, New York City. Purchased with special contributions
and purchase funds given or bequeathed by friends of the Museum, 1967

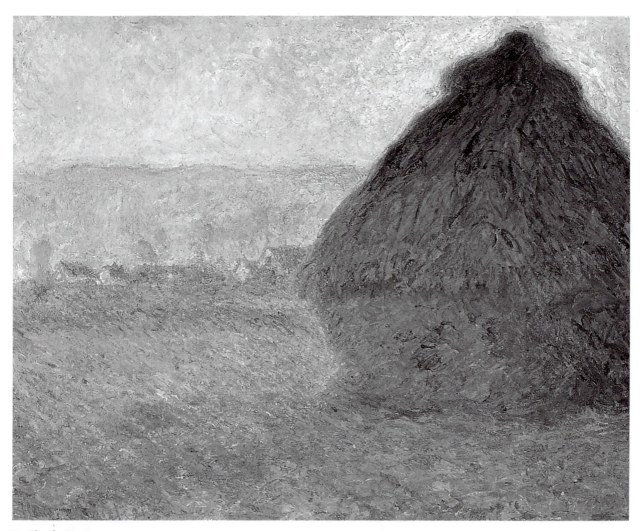

10. Claude Monet.
GRAIN STACKS, SETTING SUN. *1891.*
29 1/2 x 37" (75 x 94 cm).
Juliana Cheney Edwards Collection.
Courtesy Museum of Fine Arts, Boston

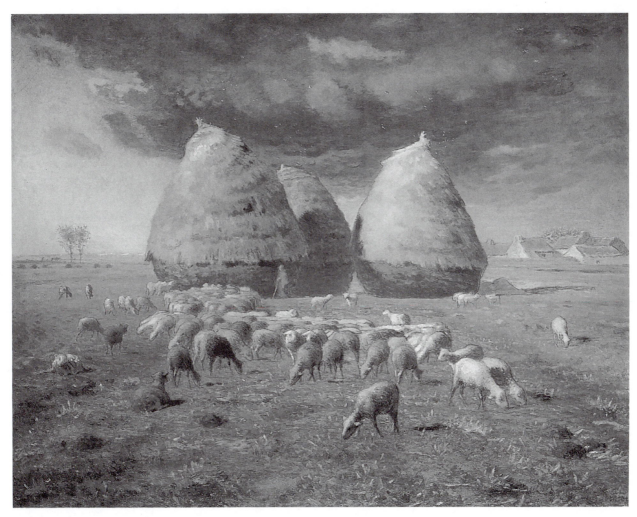

11. Jean François Millet.
GRAIN STACKS—AUTUMN. *1868–1875.*
33 ½ x 43 ⅜" (85.1 x 110.1 cm).
The Metropolitan Museum of Art, New York City.
Bequest of Lillian S. Timken, 1959

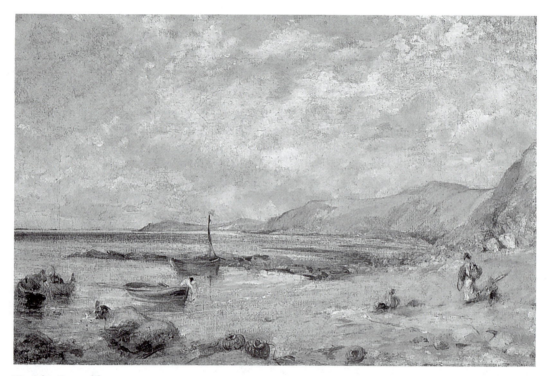

12. John Constable.
WEYMOUTH BAY. *after 1816.*
13 ½ x 20 ⅜" (34.3 x 50.8 cm).
Wadsworth Atheneum, Hartford.
The Ella Gallup Sumner and Mary Catlin Sumner Collection

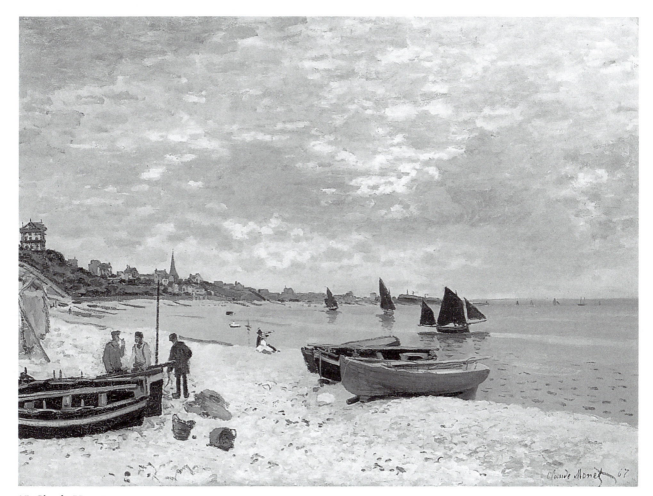

13. Claude Monet.
THE BEACH AT SAINTE-ADRESSE. *1867.*
28 ½ x 41 ¼" (72.4 x 105 cm).
The Art Institute of Chicago.
Mr. and Mrs. L. L. Coburn Memorial Collection.
Photograph ©1988, The Art Institute of Chicago.
All Rights Reserved

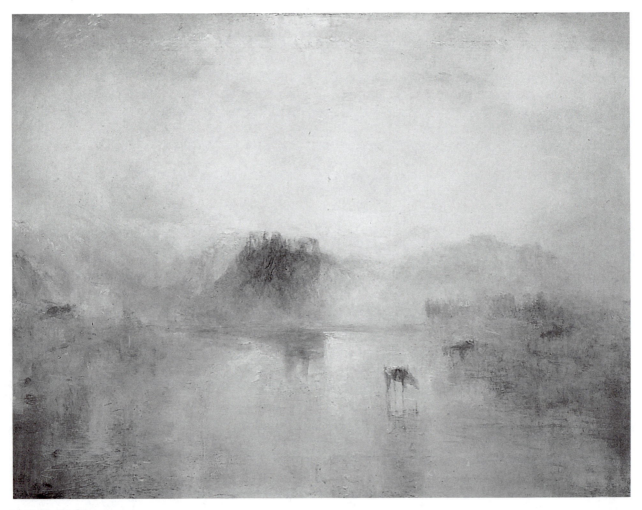

14. J. M. W. Turner.
NORHAM CASTLE, SUNRISE. *c.1835–1840.*
35 ¾ x 48" (90.8 x 121.9 cm).
Tate Gallery, London; Art Resource

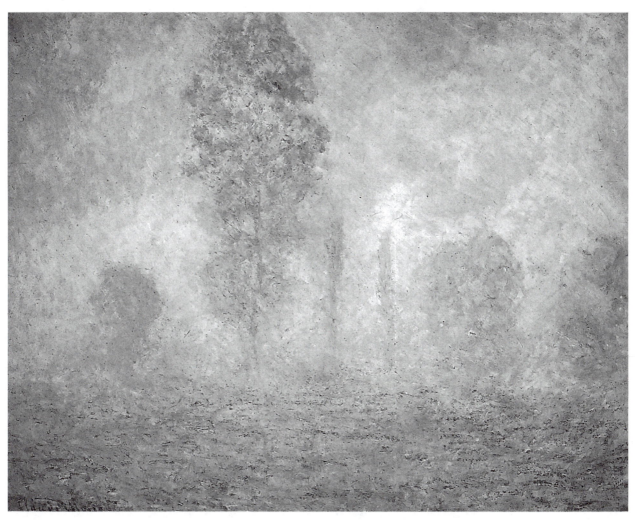

15. Claude Monet.
MORNING HAZE. c.1888.
29 ⅛ x 36 ⅛" (74 x 92.9).
National Gallery of Art, Washington, D. C.
Chester Dale Collection, 1958

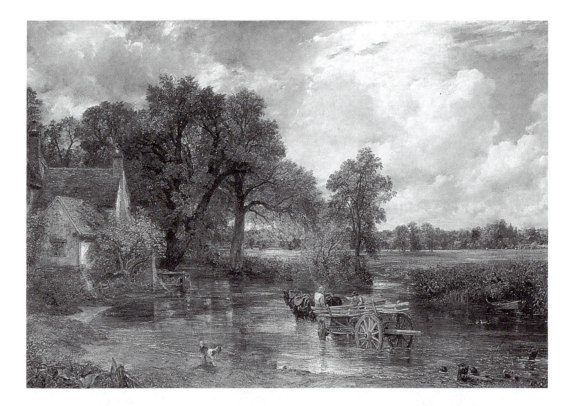

Top:
16. John Constable.
THE HAYWAIN. *1821.*
51 ¼ x 73" (130.5 x 185.5 cm).
Reproduced by courtesy of the Trustees,
The National Gallery, London

Bottom:
17. John Constable.
Full-size sketch for THE HAYWAIN.
c.1820–1821.
54 x 74" (137 x 188 cm).
Reproduced by courtesy of the Trustees,
The Victoria and Albert Museum, London

18. Théodore Rousseau.
ROAD IN THE FOREST OF FONTAINEBLEAU, EFFECT OF STORM. *c.1860–1865.*
11 ¾ x 20 ⅛" (30 x 51 cm).
Musée d'Orsay, Paris.
Photograph, Réunion des musées nationaux, Paris

19. Jean-Baptiste-Camille Corot.
THE HARBOUR OF LA ROCHELLE. *1851.*
19 ⅞ x 28 ¼" (50.5 x 71.8 cm).
Yale University Art Gallery, New Haven.
Bequest of Stephen Carlton Clark, B.A. 1903

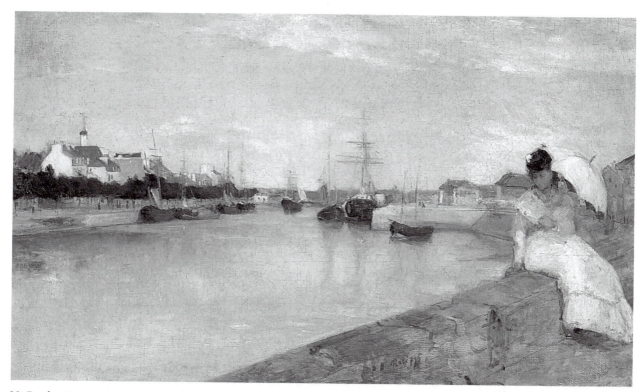

20. Berthe Morisot.
THE HARBOUR AT LORIENT. *1869.*
17 ⅛ x 28 ¾" (43.5 x 73 cm).
The National Gallery of Art, Washington, D.C.
Ailsa Mellon Bruce Collection, 1970

21. Johan Barthold Jongkind.
ENTRANCE TO THE PORT OF HONFLEUR (WINDY DAY). *1864.*
16 ½ x 22 ⅛" (41.9 x 56.2 cm).
The Art Institute of Chicago.
Frank H. and Louise B. Woods Purchase Fund.
Photograph ©1990, The Art Institute of Chicago. All Rights Reserved

22. Claude Monet.
MOUTH OF THE SEINE AT HONFLEUR. *1865.*
35 ½ x 59" (90 x 150 cm).
The Norton Simon Foundation, Pasadena

23. Claude Monet.
IMPRESSION, SUNRISE. *1873.*
(signed and dated lower left at a later time: "Claude Monet, 72").
18 ⅞ x 24 ¾" (48 x 63 cm).
Musée Marmottan, Paris.
Photograph, Jean-Michel Routhier, Studio Lourmel, Paris

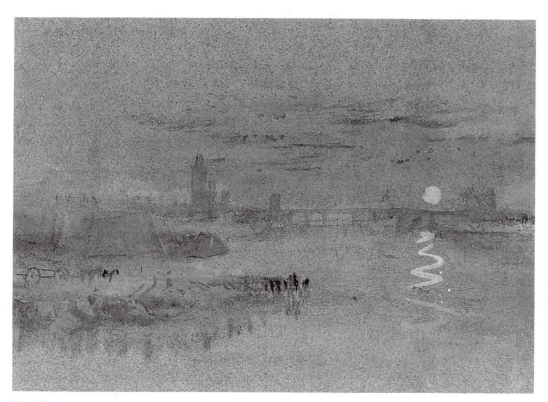

24. J. M. W. Turner.
SUNSET: ROUEN (?). *c.1829.*
Bodycolor on blue paper.
5 ⁵⁄₁₆ x 7 ¹⁄₂" (13.5 x 19 cm).
Tate Gallery, London; Art Resource.

25. Charles François Daubigny.
RIVER SCENE NEAR BONNIÈRES. *1857.*
Oil on wood, 11 ¾ x 21 ⅛" (29.8 x 53.6 cm).
The Fine Arts Museums of San Francisco.
Mildred Anna Williams Collection

26. Camille Pissarro.
BANKS OF THE MARNE AT CHENNÈVIERES. *Exhibited at the Salon of 1865.*
37 ¼ x 56 ¾" (94.6 x 144.1 cm).
National Gallery of Scotland, Edinburgh

27. Claude Monet.
LA GRENOUILLÈRE. *1869.*
29 3/8 x 39 1/4" (74.6 x 99.7 cm).
The Metropolitan Museum of Art, New York City.
Bequest of Mrs. H. O. Havemeyer, 1929.
The H. O. Havemeyer Collection

28. La Grenouillère (detail).
The Metropolitan Museum of Art, New York City

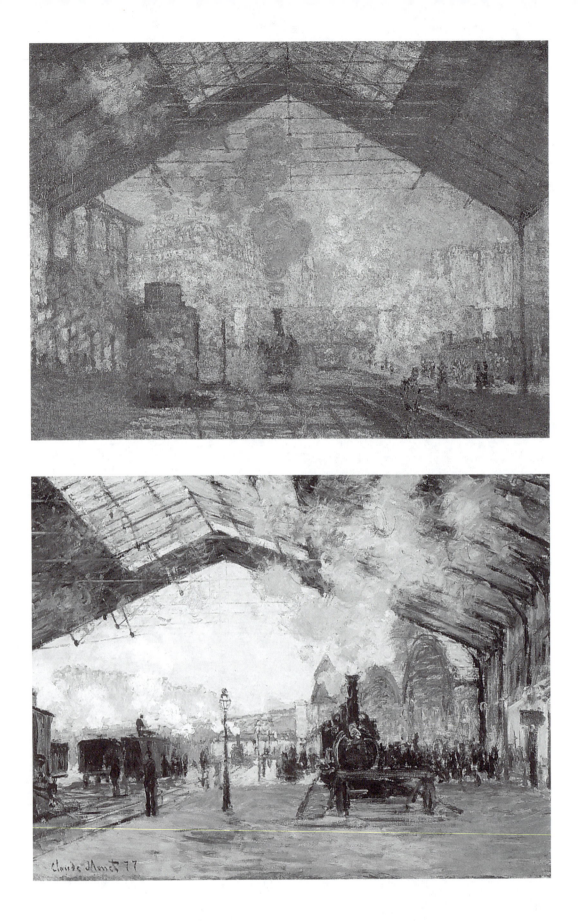

31. THE GARE SAINT-LAZARE (detail).
Musée d'Orsay, Paris

32. THE GARE SAINT-LAZARE (detail).
The Art Institute of Chicago

Top left:
29. Claude Monet.
THE GARE SAINT-LAZARE. *1877.*
29 ½ x 39 ⅜" (75 x 100 cm).
Musée d'Orsay, Paris.
Photograph, Réunion des musées nationaux, Paris

Bottom left:
30. Claude Monet.
THE GARE SAINT-LAZARE. *1877.*
23 ½ x 31 ½" (59.5 x 80 cm).
The Art Institute of Chicago.
Mr. and Mrs. Martin A. Ryerson Collection.

Impressionism and Science

At the heart of the Impressionist enterprise was the Romantic engagement with feeling and subjectivity. In this sense, Impressionist landscape painting was organically connected to what came before it in the nineteenth century, not only in terms of its conceptual framework but even to some extent its iconography, its methods, and its techniques. Yet this continuity with Romanticism and the subjectivity of Impressionism have been consistently denied in later art historical accounts of the movement. How did Impressionism come to be seen by the middle of the twentieth century as an art of "scientific objectivity," devoid of feeling? Why has it been so systematically divorced from its Romantic roots?

Early in the nineteenth century, the Romantic movement in France helped to focus a long-standing uneasiness in Western culture with painterly and coloristic styles in art.[1] This uneasiness in the nineteenth century, I will argue, was fundamentally about gender and about the negative, gender-based stereotypes that were associated not only with color as a "subjective" element in painting but also with what was deemed to be the "passive" and hence feminized attitude taken by the Romantic and Impressionist landscape painters toward their subjects in nature. Out of this uneasiness and out of our own period's need to regender Impressionism has come art history's insistence upon creating a causal link between Impressionism and the positivist science of its period, a science that enshrined the culturally masculinized values of objectivity, materialism, and cerebral detachment.

These rationalizations set in at an early stage in the history of Impressionism's critical reception, concealing the fundamental relationship between Romanticism and Impressionism and the quite normative evolution that had occurred from one to the other. Reestablishing that relationship has necessarily been the starting point and one of the principal foundations for this study. Another part of this process must be a reexamination of the claims that have been made for a historical connection between Impressionism and positivist science, as well as a long overdue reevaluation of the status and influence of positivism itself in the French art world during the second half of the nineteenth century.

Before examining in this new light the contemporary nineteenth-century texts that first posited a relationship between Impressionism and science, we will consider first, as an essential context, the changing faces of science during the eighteenth and nineteenth centuries and science's shifting relationship with art and with nature during this period.

"Romantic" versus "Normal Science" in the Eighteenth and Nineteenth Centuries

According to the canonical view, the creation of modern science and the establishment of its heuristic assumptions was the work of a succession of scientists from the sixteenth to the early eighteenth century, from Copernicus and Galileo to Bacon and Newton. The mechanical world view, popularly associated with the name of Newton and the ideas set forth in his *Principia* of 1687, tried to explain all phenomena on the model of the machine. It posited a mechanistically determined nature consisting of particles in motion, external to human beings and functioning like a "great engine" or "clock"—a world in perpetual motion whose history is causally determined and hence preordained in accordance with natural laws that operate uniformly at all times and in all places. This mechanical philosophy was dualistic. It reduced nature to particles of dead matter and created a separation between mind and matter and between human beings and nature. It thus stood in direct opposition to an older world view and mode of scientific inquiry based on Aristotelian philosophy, in which a divine intelligence was seen to be at work in nature, a nature that was both alive and meaningful in human and ethical terms.[2]

Newtonian science enjoyed widespread acceptance throughout much of the eighteenth century, especially in France, where its precepts were popularized early in the century in a treatise by Mme du Châtelet and Voltaire and where its mechanical and mathematical explanations of phenomena provided an important foundation for French Rationalism and the Enlightenment. Nevertheless, awareness of the philosophical dilemma created by the scientific revolution (the need to reconcile the causality that was required as a secure foundation for modern science with the free will required for ethics) is amply reflected in the philosophical texts of the eighteenth century, particularly in the system devised in the 1780s by the German philosopher Immanuel Kant, who endowed nature with rationality and attempted to reinstate it as the guiding force that gives human reason its direction and its purpose.[3]

By the late eighteenth century mounting distrust for the Cartesian and Newtonian mathematical model of the universe and discomfort with the estrangement between humans and nature that it fostered found increasing expression, particularly in Germany, where a profound antipathy toward Newton was not uncommon on the part of poets such as Goethe and philosophers such as Hegel and Schelling. And it was in Germany that new, Romantic systems of thought, which admitted the subjectivity of cognition, evolved. The most influential of these was Schelling's *System der Naturphilosophie* (1798–1799), which helped to generate and support a new Romantic science at the turn of the century.[4] Among the scientists most notably influenced by Schelling's *Naturphilosophie* were the German J. W. Ritter and the Dane H. C. Oersted. Oersted was the discoverer of electromagnetism. His collected writings were translated into English later in the nineteenth century under the title *The Soul of Nature*, a title that eloquently expresses some of the metaphysical assumptions of the new science. The close link that existed in Germany between science and philosophy in the late

eighteenth century is in part explained by the fact that the sciences were usually taught in German universities at that time, atypically, in the faculty of philosophy. As the historian of science D. M. Knight has pointed out: "They were not therefore taught as 'normal science,' but as genuine natural philosophy involved with a world-view and abounding in generalisations."[5]

The Romantics turned against the causal and empirical paradigm of Baconian and Newtonian science—the "normal science" (to borrow the now widely accepted terminology of Thomas Kuhn) of the sixteenth and seventeenth centuries—and adopted a new paradigm, one that substituted a sweeping organicism for the mechanical and mathematical model that had governed the practice of science in preceding centuries. Essential to Schelling's *Naturphilosophie* was the belief that since the human mind is a part of nature, the laws of human reason must reflect those of nature. As a result, in the science that was practiced by adherents of *Naturphilosophie* in Germany, the power of human reason and speculation was privileged over the tradition of Baconian experimental and descriptive science, which now played a far less central role in Germany than in other national schools of science. Knight explains:

> In *Naturphilosophie*, the great generalisation which the reason supplied was that force rather than matter was the underlying reality which men of science must investigate. In place of the materialism associated with eighteenth-century Rationalism and Enlightenment, in which everything —even thought—was accounted for in principle in terms of matter and motion, Schelling and his disciples saw a world of forces. This was a world of flux, in which solid objects or persons only endured like waterfalls or columns of smoke do, through the perpetual flux of their material particles. . . . The material particles were unimportant or even imaginary; our hand seems to encounter solid particles when we press it on the table, but really as Oersted remarked we encounter only forces.[6]

The primacy and unity of force that reason seemed to dictate was established during this period both inside and outside Germany by scientists such as Volta, Davy, Berzelius, Herschel, Ritter, and Oersted, who demonstrated in a variety of ways the interconvertibility of various forces of nature—including electricity, magnetism, heat, light, and chemical affinity.[7] But it was in Germany in particular that Romantic scientists, with their philosophical vision of an organic universe, fully challenged the mechanical materialism of the Rationalists. For the German scientists who were disciples of Schelling's *Naturphilosophie*, nature was characterized by continuity. Polarities were not seen as simply in opposition to one another but in a relationship of dialectical synthesis. "In the world of the Romantic scientist," writes Knight, "there is nothing cold and inanimate. We seem to encounter brute matter, but really we meet living forces. . . materialism was viewed by Romantics in Germany and in England as a particularly French kind of intellectual pox."[8]

The scientific affinity in Germany for *Naturphilosophie* represents in part a nationalistic rejection of late eighteenth-century French rationalism and materialism. It may have grown as well out of a desire for continuity with the chemical philosophy of the early eighteenth century. Then, a "dynamical chemistry," which emphasized the forces that modify matter, had been close to the main-

stream of thought in chemistry and had been viewed as more fundamental than mechanics. By the end of the eighteenth century, however, the quantification of chemical affinities, as developed by the French chemist Lavoisier, had become a standard part of the practice of chemistry in most countries. But it was rejected as irrelevant by the devotees of *Naturphilosophie* in Germany, who continued to pursue chemistry as a dynamical science.[9]

In the Romantic period, as Arthur O. Lovejoy showed in the 1930s, the earlier, static conception of "the great chain of being" was replaced by a more dynamic and evolutionary concept. The way was prepared for later evolutionary philosophies, which saw "higher," or more perfect, forms evolving from "lower," or less perfect, ones, completely reversing the assumptions of earlier Western philosophic systems, which had seen the world as the creation of a Supreme Being and all lower or imperfect forms deriving from higher ones.[10] The Romantic followers of *Naturphilosophie* restored to nature (formerly reduced to particles of dead matter by the mechanical philosophy of the seventeenth-century scientific revolution) a central role in the historical and temporal unfolding of the world—an imperfect world, but one that was no longer viewed as causally determined and in which there could now exist room for hope and progress. Among the radical results of this concept of an organic and evolving universe were Romantic historicism and introspection. "The explanation of an organic product, of an organic being," wrote Friedrich Schlegel, "must be historical, not mechanical."[11]

National styles of science are not monolithic; they are a function of period as well as place.[12] The *Naturphilosophie* that briefly dominated science in Germany at the very beginning of the nineteenth century lost much of its influence there as the century progressed. Newtonianism fused with Darwinianism to produce German materialism, and experimental physiologists such as Johannes Müller (who wrote his *Handbuch der Physiologie* in 1833) and psychologists such as E. H. Weber increasingly applied the laws of physics and mechanics to organic phenomena, extending the mechanical philosophy and its power of explanation to new domains. Openly rejecting the speculative and metaphysical brand of Romantic science that had been widespread in German universities during his youth and relying instead on the principles of mechanics and mathematics, Müller (1801–1858) pioneered the use of experimental methods in physiology and exerted a formative influence on the next generation of German scientists. Many of the most prominent German scientists of the second half of the nineteenth century were in fact his students and followers, including Ernst Haeckel (1834–1919), Ernst Wilhelm von Brücke (1819–1892), and Hermann von Helmholtz (1821–1894), each of whom did important experimental work in the field of physiological optics. In France, the mechanical philosophy based on Newtonian science was bequeathed by the French encyclopedists of the eighteenth century to the positivists of the nineteenth century and remained the dominant mode of scientific discourse there throughout this period. The experimental method was applied to medicine and physiological research most notably by Claude Bernard (1813–1878), whose empirical rationalism was nevertheless tempered by philosophical concerns. The work of contemporary German scientists such as Haeckel, Brücke, and Helmholtz was also widely known and respected in France throughout the second half of the century.

In both France and Germany, nevertheless, the legacy of Romantic science continued to produce sporadic confrontations with normal science, particularly

IMPRESSIONISM AND SCIENCE

toward the end of the nineteenth century. The most notable of these occurred in 1883, when the German physicist Ernst Mach published the first edition of his *Mechanics (Die Mechanik in ihrer Entwickelung historisch-kritisch dargestellt)*.[13] Mach's work was essentially a critique of Newtonian dynamics, which he viewed as presenting only one model among many of what our senses can tell us about nature. Reviving the philosophical tradition of Locke, Hume, and Kant in an era when few men of science were interested in philosophy, Mach advanced the "phenomenalist" theory that knowledge is made up of complexes of individual sensations and that science, rather than fixing a material reality, can only provide conceptual models that help us trace our sensations. Mach's phenomenalist approach to a theory of knowledge and its ultimate subjectivity found few adherents in the mainstream scientific community of his period. But it provided an important philosophical alternative that was congenial to the arts and to those who theorized about them and their relationship to science during this period.

CHAPTER 5

Science and the Arts

Throughout much of the seventeenth, eighteenth, and nineteenth centuries, art and science were widely viewed as complementary activities. "The arts have this in common with the sciences," wrote Le Bossu in 1675, "that like the latter they are founded on reason."[14] And in France during its classical seventeenth century and early in the eighteenth century, the faith in reason prompted by the scientific revolution did indeed become a major support for art and poetry as well as for science and philosophy, promoting in both a quest for universal laws and fostering among artists the notion of a normative aesthetic—the idea that all artists can and should achieve a universal ideal through imitation or idealization.

In England during the first half of the eighteenth century, Sir Isaac Newton's description of the refraction of light into colors and the return of colors to light—first published in the *Opticks* in 1704 and then quickly popularized—became a major source of inspiration for a whole generation of poets, who prided themselves on being "scientific" and "philosophical" and who almost deified Newton in their poetry.[15] As Alexander Pope, leader of the English neoclassical school of poetry, put it in one of his typical couplets:

Nature, and Nature's Laws lay hid in Night.
God said, *Let Newton be!* and All was *Light*.

But even among poets and artists who were not programmatically wedded to the classical ideal during this period, empirical and mechanical science could serve as a positive inspiration, providing heightened access to natural phenomena and a new rational support for aesthetic experience. These poets, too, credited Newton and his "Science of Colours" with restoring color to poetry and praised him, as did Pope, for flooding the world metaphorically with light. Nature poets like the proto-romantic James Thomson, author of *The Seasons*

(1726–1730), were inspired by Newton's discovery of the fluid interrelationship between light and color to create for poetry a new "symbolism of the spectrum." This supplemented the prevailing Miltonian poetic equation between God and light with a more complex symbolism in which light was associated with the heavens and sublimity, while color—which both derived from and returned to light—was associated with the terrestrial world. Such imagery had a continuing impact on English Romantic poetry during the early nineteenth century, when Shelley, for example, wrote:

Heaven's light forever shines, Earth's shadows fly;
Life, like a dome of many-coloured glass,
Stains the white radiance of Eternity. . .
 Adonais, LII (1821)

In the early eighteenth century, the interest of English poets in the work of Newton had not been mathematical but aesthetic. He had given them a new self-consciousness about the processes of vision and perception and thereby heightened their responsiveness to the impressions of their senses. In the words of the literary historian Marjorie Nicolson, he had "given the world new beauty with new truth."[16]

Later in the century, the English poet William Blake once again invoked the name of Newton, along with those of Bacon, Descartes, and Locke, but in a far different spirit. For according to Blake, science was the enemy, not the inspiration, of poetry and art. Blake was not alone in scorning the mechanical science that was favored in England and in France during the second half of the eighteenth century. His attitude toward the "normal science" of his period, however, was not, as it has frequently been called, a harbinger of a general "romantic reaction against science."[17] For contrary to popular belief, Romantic art was not an art of pure fantasy and imagination. Rather, much of it was generated by an inspired fusion between empirical data and personal response. In this process of fusion, science and its discoveries often played an important and an accepted role.

For Romantic poets and painters of a slightly younger generation than Blake's, science would soon come to mean not the mechanical philosophy of Bacon and Newton but rather the ideas that emanated from Germany around the year 1800, at a time when chemistry and the biological and geological sciences briefly took precedence over physics and mechanics in the scientific world. It was the speculative organicism of the new Romantic science—which an important segment of the scientific world in this generation considered to be superior to Newtonian physics—that sparked the interest and enthusiasm of the Romantic poets and painters; and it was from this "revolutionary" science that they derived inspiration. On the relationship between science and poetry in the modern world, for example, William Wordsworth wrote in the preface to the second edition of the *Lyrical Ballads* (1800) that "the remotest discoveries of the chemist, the botanist, or mineralogist will be as proper objects of the poet's art as any upon which it can be employed." The poet, he predicted, "will be ready to follow the steps of the man of science. . . carrying sensation into the midst of the objects of the science itself."

When organicism replaced the mechanical philosophy, individual imagination joined and tempered reason as the accepted pathway to higher truths. Notions

IMPRESSIONISM AND SCIENCE

49. Théodore Géricault (1791–1824).
THE INSANE WOMAN (*MONOMANIE DE L'ENVIE*).
1822–1823. 28 ⅜ x 22 ¾" (72 x 58 cm).
Musée des Beaux Arts, Lyon

of an unchanging universe and an unchanging human nature were increasingly abandoned by poets and painters as well as by philosophers and scientists during this period. Instead of searching for the timeless and universal, they placed new value upon the temporal, the personal, and the introspective. But in rebelling against mechanism, Romantic artists, like the scientists of their period, did not reject reason. We might say, rather, that they dethroned and deconstructed reason, assigning at least an equal value to the intuitive processes of the imagination and individual feeling. Nor did they ignore observation. Rather, they used it as a stimulus for the imaginative and creative dimensions of reason, thus emphasizing the unity of intellectual and creative life.

During the late eighteenth and early nineteenth centuries, the dynamic spirit of the new science, with its emphasis on organicism and synthesis, held considerable fascination for Romantic artists in many parts of Europe, and there were many instances of collaboration between artists and scientists during this period.[18] One well-known product of such a collaboration is the series of *Portraits of the Insane* by Théodore Géricault (fig. 49), thought to have been undertaken at the instigation of the prominent French psychiatrist Etienne Jean Georget. Known for his diagnostic descriptions of the physiognomic manifestations of a variety of mental disorders, Dr. Georget may have commissioned these works to serve either as teaching aids or as guides to illustrations (which never appeared) for subsequent editions of his book *On Madness (De La Folie)* of 1820.[19] In these haunting, close-up portraits is to be found a typically Romantic combination of the recording of what was then regarded as scientific fact with the crucial leavening of the artist's peculiar empathy and insight, so that what Géricault seems to have painted are not only the faces but also the souls of his disturbed subjects.

It was common for artists during the Romantic era to take an active layman's interest in science and even to make use of its lessons and discoveries as an aid in their work. From the late nineteenth century on, however, the scope and nature of that interest have often been exaggerated in the literature in order to support the notion of a predominantly positivist and materialist orientation among artists in France during this period. Eugène Delacroix's interest in complementary color relationships is a case in point. Delacroix's self-conscious concern with this issue is clearly reflected in his *Taking of Constantinople by the Crusaders* of 1840 (fig. 50), where the three complementary color pairs are displayed—almost as the keynote for the entire work—on the three standards the crusaders bear. In his treatment of shadows in this picture, moreover, Delacroix avoided black (which does not exist in the spectrum) and replaced it instead with neutral tones that result from a mixture of complementary colors.

Such practices and concerns have long been used to ascribe to Delacroix an active interest in science and scientific method in general and a dependence in particular on the findings and theories of the French chemist Eugène Chevreul, whose work on the simultaneous contrast of color was first published in a form accessible to the general public in 1839. On a sheet of studies (1839–1840) for

the *Taking of Constantinople* for example, Delacroix had drawn and annotated a color circle, presumed to have been modeled upon the example of Chevreul, who had plotted, simply and graphically, the relationship between the three primary colors and their complements.[20]

Of course, artists before Delacroix and Delacroix himself in his earlier work had made effective use of complementary color schemes, not so much in response to a scientific theory but simply because they would have noticed, through their own empirical observations, that certain colors do in fact take on greater luminosity and brilliance when placed in proximity to one another. Recent scholars have in fact determined that Delacroix's active interest in Chevreul's work did not develop until about 1850 and that the annotated color wheel and color

50. Eugène Delacroix (1798–1863).
Taking of Constantinople by the Crusaders. *1840.*
161⅜ x 196" (410 x 498 cm).
Musée du Louvre, Paris. Photograph, Réunion des musées nationaux, Paris

triangle that appear in Delacroix's notebooks in the 1830s were derived from a popular painting manual of that period.[21] Given his established taste and practice as a colorist, the appeal to Delacroix of these devices as a simple aid to the observation and organization of complementary color is easy to understand. And his later interest in the ideas of Chevreul may well have encouraged him to become more analytical in his thinking about color. But it is important to keep in mind that Chevreul's analyses of color—prompted by his work as head of the dye laboratories at the Gobelins tapestry factory—had been designed to alert artists and craftspeople to "anomalous" optical effects (such as the simultaneous contrast of colors) so that they might succeed in preserving "true" or normative hues in their work. Romantic artists such as Delacroix, on the other hand, ultimately used the scientist's observations to a different end, controlling and exploiting these optical anomalies in personal and expressive ways.

In England in the early nineteenth century, John Constable's cloud and sky studies (figs. 51 and 52), many of them painted between 1821 and 1822, bear eloquent witness to the fascination that the scientific observation of nature — what the period referred to as "Natural Philosophy"—might hold for the Romantic artist. Constable was interested in the work of contemporary meteorologists, and he also took an occasional interest in anatomy, botany, and geology, interests that he saw as complementary to his art.[22] "Painting," he wrote in 1833, "is a science, and should be pursued as an enquiry into the laws of nature." "Why, then," he asked, "should not landscape painting be considered as a branch of natural philosophy, of which pictures are but the experiments?"[23] In a letter of 1835, he observed: "After thirty years I must say that the sister arts have less hold on my mind in its occasional ramblings from my one pursuit

51. John Constable (1776–1837).
CLOUD STUDY. *c.1822.*
Oil on paper, 18 ⅞ x 23 ¼" (48 x 59 cm). Inscribed on verso: "31st Sep. 10–11 o'clock morning looking Eastward a gentle wind to East." The Visitors of the Ashmolean Museum, Oxford. Gift of Sir Farquhar Buzzard, 1933

[i.e., painting] than the sciences, especially the study of geology, which more than any other, seems to satisfy my mind."[24]

Constable's cloud studies are more accurate meteorologically than any painted before his time. They record the actual shapes and movements of clouds and often bear written notations of the precise day, hour, and weather condition under which they had been observed. In one notation, describing the type of cloud he had painted (fig. 52), Constable used the nomenclature that had recently been developed by the meteorologist Sir Luke Howard. Howard, whose "Essay on Clouds" had appeared in 1818, was the first to classify cloud formations on the basis of their visible shapes. Again, it is easy to see how Howard's work would have interested Constable as an aid to observation and understanding and as a parallel in science to his own passionate concern for the description of natural phenomena. But it is not necessary to argue, as has been done, that Constable was directly inspired to do his cloud and sky studies by this scientist's work.[25] Rather, Constable's motivation can be sought more profitably in his long and consistently held belief in the important expressive and unifying role that is played by the sky and the effects that derive from it in the total composition of a landscape. Constable's studies of the clouds and the skies are not only

52. John Constable.
CLOUD STUDY. *c.1822.*
Oil on paper, 4 ½ x 7" (11.4 x 17.8 cm).
An inscription on the back has been read as "cirrus"; it is obscured by a later inscription that reads: "Painted
by John Constable, R.A." By courtesy of the Trustees of The Victoria and Albert Museum, London

documents of meteorological accuracy, which record the actual shapes and movements of the clouds, they are also documents of Romantic feeling, charting the changing moods of the sky and of the artist who responds to them. "It will be difficult," Constable wrote in a letter of 1821, "to name a class of landscape in which the sky is not the keynote, the standard of scale and the chief organ of sentiment. . . . The sky is the source of light in nature, and governs everything."[26]

Although reason may not have been preeminent in the philosophy of Romanticism, the movement, as we have seen, was not antirational. As Constable put it, sublimity for the Romantic painter was not the result "of inspiration but of long and patient study, under the direction of much good sense."[27] And this view was one that he shared with many other painters and poets of his period. Coleridge, for example, defined "the two cardinal points of poetry" as "the power of exciting the sympathy of the reader by a faithful adherence to the truth of nature, and the power of giving the interest of novelty by the modifying colours of the imagination."[28] And for Coleridge, too, science played an important part in this creative equation.[29] Coleridge scorned, as we might expect, the mechanical science that continued to be favored as normal science in England and France during his lifetime, associating it with atheism, materialism, and all the ills of

contemporary society. Angered, for example, by the increasing acceptance among scientists of what he called "the atomistic scheme" (the concept of the chemical atom developed by Dalton in England and LeSage in France), he wrote in 1817: "I persist in the belief. . . that a few brilliant discoveries have been dearly purchased at the loss of all communion with life and the spirit of Nature."[30] Rejecting philosophies that separated science from metaphysics and theology and that compartmentalized intellectual life, he was naturally drawn toward the more organic and "dynamic" spirit of philosophy and the physical sciences in Germany, where he had studied in the late 1790s. He enthusiastically embraced Schelling's *Naturphilosophie* and viewed nature as the unified but ever-evolving product of a rational and living history.

Far from rejecting science, then, Romantic poets and painters distinguished, according to their own lights, between good and bad forms of scientific inquiry. For the majority of them (with the exception of Blake), "truth to nature," in terms consonant with the new dynamical sciences, was not a deterrent but rather a prerequisite both for the expression of personal emotion and for the attainment of transcendental experience. The importance of scientific revelation for the Romantic artist in this regard has been explained by the English art historian Hugh Honour:

> Scientific observation was still consonant with religious and artistic attitudes of mind. . . Constable imagined Wilson, whom he regarded as the greatest English landscape painter, "walking arm in arm" with Milton, the supreme Christian poet, and Linnaeus, the great naturalist, and it was probably his ambition to combine their achievements. His studies from nature could satisfy the most exacting botanist, yet convey very strongly a feeling of reverential love.[31]

But it was most particularly in Germany during the first half of the nineteenth century that art was regarded by Romantics "as the crown of science" and both were seen as a path to the Divine.[32] In his *Nine Letters on Landscape Painting*, first published in 1831, Carl Gustav Carus, who was a trained physiologist and natural philosopher as well as a painter and man of letters, urged that modern landscape painters be trained in natural science so that they might have access to the original source of nature and, through it, a clearer understanding of their own relationship to the natural world and to God. Taking Goethe as his inspiration, Carus wrote:

> The eye must learn to conceive the forms of natural phenomena not as an arbitrary, indefinite, lawless and therefore senseless matter, but as something determined by the primal life of the Divine, in accordance with eternal laws and perfect reason. . . . If a powerfully and beautifully striving soul is not already leading the eye to such a conception then it can be done only by the intervention of science.[33]

Like his Romantic brethren in other countries during this period, Carus regarded light as the "most spiritual" of all the natural elements and urged that the landscape painter be instructed in "the laws of sight, the different refractions and reflections of light, the origins of colour. . . so that, along with his natural

feelings of joy and pleasure he may not undertake his work without a feeling of reverence and indeed of worship."[34]

In France, unlike Germany, England, and the United States during the nineteenth century, science and art became increasingly unfriendly to, rather than supportive of, traditional religious beliefs, even in the unorthodox and highly personalized forms that these had taken during the early Romantic period. At the same time, fundamental to the intellectual and cultural climate of France throughout much of this century was a widespread enthusiasm for science as well as an optimistic belief in its power to benefit society at all levels.

These attitudes derived much of their authority and impetus from the positivist philosophy of Auguste Comte, as it was enunciated in his six-volume work, *Positive Philosophy* (1830–1842). Comtean positivism may be said to reflect the unbroken authority in nineteenth-century France of mainstream, Cartesian, Baconian, and Newtonian science and the eighteenth-century French Rationalism these had helped to inspire. According to Comte, "positive" knowledge depended upon empirical science: it had to be acquired through the senses and it had to be based upon observation and experiment. All aspects of human experience, according to Comte and his followers, could be subjected profitably to scientific inquiry, which, in the modern world, would ultimately replace theology and philosophy in an inevitable progression and evolution of the human mind.[35] With its insistence that science could solve all problems, including those in the moral and spiritual realm, positivism was essentially anticlerical in its thrust and was thus aligned with the political Left in France during the nineteenth century.[36] Its attitudes were also consonant with those of artists and critics, particularly those of the Realist and Naturalist schools, who shared that political alignment. Among these, for example, was the writer and critic Jules Castagnary, a longtime supporter of Courbet's, who, in his Salon review of 1863, described the Naturalist school as "truth bringing itself into equilibrium with science."[37]

Comte's ideas, successfully popularized at every level of French culture during the Second Empire by his disciple Emile Littré and others, affected to some extent all fields of knowledge and cultural endeavor in nineteenth-century France. The emphasis in art criticism during this period on "positive experience" obtained through the senses as the basis of creative art, as well as a concomitant interest in the functioning of the human eye as the chief organ of cognizance, were very much in keeping with the influential tendencies of Comtean positivism. The attitudes and concerns of the art critics were in turn paralleled and substantiated by the findings of contemporary scientists and philosophers. For example, in writings published shortly after his death in 1865, Pierre Gratiolet, professor of physiology and comparative anatomy at the Sorbonne, identified individual sensations as the prime determinants of human action, and in this regard he spoke of "sensation" as an experience that could be localized in the area of the retina.[38]

But while this emphasis on empirical or "positive experience" might be said to have provided a common denominator for art and science throughout the nineteenth century in France, the predilection of science for what was regarded as "dispassionate" and "objective" observation presented a problem of increasing magnitude for artists and critics, especially as science itself—and here I refer to the "mechanical" scientific paradigm that prevailed in France—threatened to acquire something of the status of a religion. Far from accepting this new

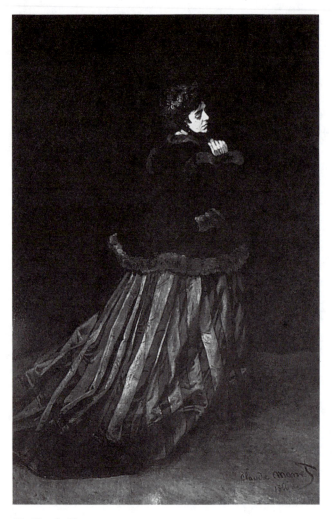

53. Claude Monet.
CAMILLE OR WOMAN IN A GREEN DRESS. *1866.*
91 x 59 ½" (231 x 151 cm). Kunsthalle Bremen

religion in all its ramifications (as the Realists, Naturalists, and Impressionists are said to have done[39]), French artists and critics during the nineteenth century were, on the contrary, both conscious and wary of its limitations and of the threat that it might pose to traditional artistic values. While they praised science along with their contemporaries as a universal good, they struggled at the same time to find a way of harmonizing art and science as complements—so that science would enhance and not destroy the expressive and individualistic conception of art and the artist that continued to dominate their century's aesthetic philosophy.

It is only with this struggle and this effort to reconcile conflicting values in mind that I believe we can fully understand Emile Zola's famous dictum, "A work of art is a corner of the universe viewed through a temperament." This often-quoted definition of a work of modern art was offered by the Naturalist novelist and critic at the conclusion of one of his reviews of the Salon of 1866. Surprisingly enough, this article, entitled "The Realists in the Salon," was not a defense of the positivist position with which Zola is usually identified. Instead, it was purposefully cast as an indictment of a programmatic, positivist Realism, a point of view from which Zola clearly wished to dissociate himself. "I seek in art," he declared, "men, new and powerful temperaments," and then he went on to explain:

They take nature and they give it, they transmit it to us through their particular temperaments. Therefore each artist will give us a different world and I will willingly accept all these different worlds providing each is the living expression of a heart. I admire the worlds of Delacroix and of Courbet. Faced with this declaration, no one, I believe, can stick me into any one school.

Only, here is what happens in these days of psychological and physiological analysis. Science is in the air, in spite of ourselves we are being pushed towards the close study of objects and happenings. Similarly each of the strong individual talents that now reveals itself finds itself developing in the direction of Reality. The movement of the age is certainly towards realism, or rather positivism. I am, therefore, forced to admire men who appear to share a certain relationship, this is a relationship to the time in which they live.

But if tomorrow a different genius were born, a spirit moving in a different direction, with the power to show us a new earth, his own, I promise him my applause.[40]

Dismissing those artists at the Salon for whom reality "consists of the choice of a vulgar subject," Zola turned to a work in the exhibition by Monet, a full-length portrait of the artist's future wife, Camille Doncieux (fig. 53), and wrote:

Ah yes! here is a temperament, here is a man amidst a crowd of eunuchs. Look at the neighboring canvases, see what a poor showing they make next to this window opened on nature. Here is more than a realist, there is a delicate and strong interpreter who knew how to give every detail without falling into dryness. . . .

Therefore, no more Realism than any other thing. Let us have truth, if you will, life, but above all different hearts and hands, giving different interpretations of nature. The definition of a work of art cannot be other than this; a work of art is a corner of the universe viewed through a temperament.[41]

"The movement of the age," Zola wrote, "is certainly towards realism, or rather positivism," and this, for him, meant little more than an injunction to artists, in Baudelarian terms, to be of their own time. Although science pushes us, "in spite of ourselves," he observed, "towards the close study of objects and happenings," the true artist, Zola makes clear, is not an impassive recorder of empirical phenomena, but an individual, a temperament, who sees and interprets the world through the filter of his unique personality.

As the authority of science and an increasingly materialist conception of its relationship to the social order gained ascendancy in France during the nineteenth century, a conflict of values between "intuitive" art and "rational" science—and a desire to prevent the former from being submerged by the latter—was crystallized for many artists and writers, even for those of the "Realist" and "Naturalist" persuasion, as Zola's impassioned comments make clear. For the writers and critics who followed Zola over the next two decades, the measurable truths and proofs of empirical science might be useful as a means of explaining works of art and could even be used to justify or validate artistic styles. But for them, as for Zola, science could never explain or replace the essential component in art of "temperament" or individual creativity.

It can be said, then, that there emerged in nineteenth-century France a new conflict of values between art and science—that is to say, between art and the rationalist science that prevailed as normal science in France during this period. And given the prestigious position that this form of science occupied in the intellectual life of France at the time, there resulted, inevitably, an effort to reconcile their potentially opposed demands. This effort is nowhere more apparent than in the criticism that was written in the 1870s and 1880s by the supporters of Impressionism, some of whom, as we shall see, tried to use science as a means of explaining and justifying this visually new form of Romantic art to a bewildered and stubbornly hostile public.

IMPRESSIONISM AND SCIENCE

The Optical as a Path to the Personal: The Writings of Duranty, Martelli, and Laforgue

"The eye, which is the window of the soul,
is the chief organ whereby the understanding
can have the most complete and magnificent
view of the infinite works of nature."[42]
—Leonardo da Vinci

In the 1870s Impressionist pictures were often criticized for being unnatural as well as unfinished. Among the standard complaints leveled against them in the press were that they were "discolored," "formless," and untrue to human vision and "reality," as these were understood by eyes accustomed to the drawing and linear perspective of post-Renaissance pictorial representation. Moreover, the Impressionists' heightened use of colors at the blue, indigo, and violet end of the spectrum—a result of their work outdoors—was particularly distressing to many critics of the period, who could explain this lapse from the "reality" of studio painting only as a symptom of retinal dysfunction, and therefore accused the Impressionists of suffering en masse from diseases of the eye.[43]

An important vein in the early literature written in defense of Impressionism seems to have been designed to counter such criticisms and to do so, moreover, by showing that Impressionism was far truer both to the appearances of nature and to the operations of the human eye than any earlier style of painting had been. To accomplish this, a few of the early defenders of Impressionism invoked in support of their argument what was for the nineteenth century—and especially for the supporters of Realism—the sacred authority of science. In the 1870s and early 1880s the writers who advanced a scientific rationale for the style of Impressionism at length and with any seriousness were relatively few, considering the importance that this association was to have for later Impressionist criticism. The principal texts are in fact only three: by Edmond Duranty in 1876, Diego Martelli in 1879, and Jules Laforgue in 1883. All three linked the expressive and individualistic paintings of the Impressionists with a standard of truth to optical reality and conformity to the laws of natural science. And in so doing, all three attempted to create for these paintings a manner of viewing and understanding that might reassure a wider public, which had been understandably distressed by the loose drawing and broken brushwork of the Impressionist style.

Edmond Duranty and Impressionism

The first writer to introduce the authority of science and the standard of "objective truth" into the critical dialogue surrounding Impressionism in the

1870s was Edmond Duranty. A Naturalist novelist and champion of Courbet in the 1850s, Duranty had enjoined artists, in his short-lived periodical *Realisme* of 1856, to paint things and events of their own time and not visions of past ages. Among artists active in the 1870s, Duranty was ideologically most in sympathy with Degas, who shared his concern for depicting modern life. But Duranty's interest in the modern school embraced landscape as well as genre and figure painting, and in 1876 he published a booklet that was the first of its kind to consider at length all these new currents in art.

The booklet, whose appearance in April 1876 coincided with the second group exhibition of the artists we now call the Impressionists, was entitled *La nouvelle peinture: à propos du groupe d'artistes qui expose dans les galeries Durand-Ruel*.[44] In it, Duranty did not use the words "Impressionist" or "Impressionism"; nor did he refer to any of these artists by name. Nevertheless, he discussed the new painters as a group and defined their innovative contributions in three areas: in the handling of color, drawing, and the new point of view they assumed in relation to their subjects. It was in his discussion of color that Duranty was most directly concerned with the plein-air landscape painters in the group, and it was here that he sought to justify and explain their innovations in terms of the verities of popular science. About these landscape painters whom we now call the Impressionists, Duranty wrote:

> In the realm of color, they have made a real discovery, the origins of which cannot be found elsewhere, not among the Dutch, not in the clear tones of fresco painting, nor in the light tonalities of eighteenth-century art. They are not simply concerned with the fine and supple play of color that results from the observation of the most delicate values in tones that either harmonize or contrast with one another. Their discovery here consists precisely in having recognized that full light decolors tones, that sunlight, reflected from objects, tends, by virtue of its brightness, to restore them to that luminous unity that blends its seven prismatic rays into a single colorless radiance, which is light.
>
> From intuition to intuition, they have gradually succeeded in decomposing the solar glare into its rays, into its elements, and in reconstituting its unity by means of the general harmony of the spectral hues that they spread on their canvases. From the point of view of optical delicacy and the subtle interpenetration of color, the result is altogether extraordinary. The most learned physicist would find no fault with their analyses of light.[45]

It is this fuller understanding of the nature of light, an understanding expressed in the technique of their paintings, that distinguishes the Impressionists, Duranty concludes, from all earlier artists, and in particular from the earlier Romantics. The latter, he explains, had depended heavily upon light and dark contrasts to create the illusion of light and in their studies they "knew only the orange strip of sun setting above darkened hills, or white impastoes tinged with chrome yellow or rose lake, sprinkled amidst the bituminous opacities of the forest floor. No light without bitumen, without prussian blue, without the contrasts which they used to say made the tone appear warmer and lighter."[46] In contrast

to this, Duranty presents the Impressionist technique as a response to the real sensory experience that can be shared by everyone who has traversed the countryside in summer:

> . . . and has seen how the hillside, the meadow, the field, vanish, so to speak, in a light-filled reflection that they receive from the sky and send back to it; for this is the law that engenders light in nature: aside from the particular blue, green, or composite ray which each substance absorbs, and over and above this ray, it [light] reflects both the ensemble of all the rays and the color of the vault that covers the earth. Now, for the first time, painters have understood and reproduced, or tried to reproduce, these phenomena; in some of their canvases, one feels light and heat vibrating and palpitating; one experiences a luminous environment which, for painters trained outside of and in opposition to nature, is something without merit or importance, much too bright, too clear, too crude, too explicit.[47]

In order to counter those who would dismiss as unnatural the surprising new look of Impressionist pictures, their surfaces covered with scatterings of small touches of clear color, Duranty stresses the power of these pictures to duplicate and evoke the character of real, scientifically definable, sensory experience. And to support this, he invokes the familiar Newtonian concept of prismatic color, implying that the Impressionists' handling of pure color to create the illusion of light is consonant with this established and popular scientific understanding of colors as the prismatic components of white light. The analogy is one that is meant to lend credence to Duranty's contention that Impressionist pictures, despite their unusual appearance, are nevertheless true to nature.

In our contemporary literature, the most extensive discussion of Duranty's *La Nouvelle Peinture* is by Marianne Marcussen, whose two articles on "Duranty and the Impressionists" appeared in 1978 and 1979, respectively.[48] In the second, Marcussen establishes (by reference to books listed in Duranty's possession at the time of his death in 1880) the range of popular, scientific writing with which the critic was familiar; and she provides an overview of the positivist intellectual milieu in France that prompted contemporary commentators on both art and science at that time to seek correspondences between the "laws" of science and those of art.[49] Within this cultural context, she characterizes Duranty as a writer and critic who "has no taste for subjective judgments," and who, instead, "privileges analytic explication."[50] She cites his use of terms that are also found in the popular literature of the natural sciences, terms such as *"décoloration"* and *"prismatique,"* as keys to defining what she calls "the scientific objective of the Impressionists."[51]

Yet despite Duranty's often-quoted claim that "the most learned physicist would find no fault with their analyses of light," nowhere in *La Nouvelle Peinture* does he ever suggest that the goals or procedures of the Impressionists are in any way comparable to those of objective scientists. He does not suggest that the Impressionists created their paintings as demonstrations of scientific precepts, and he expresses no distaste for subjectivity in art. He stresses, on the contrary, that the Impressionists made their discoveries about light and its reproduction through paint *intuitively*. He acknowledges their expressive intentions and

speaks, for example, of the importance of painting a landscape "entirely at the site, not after a study that is brought back to the studio and from which the first feeling [*le sentiment premier*] is gradually lost."[52] Elsewhere in his discussion, he emphasizes the importance of capturing a scene under a single and consistent moment of illumination, so that everything in the scene can partake "of the same feeling [*sentiment*]."[53] Above all, Duranty values these, by traditional standards, roughly finished works ("*ces tentatives*") as expressions of the artist's originality and as symptoms of the desire "to escape from the conventional, the banal, the traditional" in society.[54] In this, he says, the Impressionists resemble Constable; and in almost two pages of aphorisms drawn from the writings of the older English artist—whose ideas, Duranty says, are representative of the thinking of many contemporary Frenchmen—Duranty presents the Romantic artist's scornful view of the painter who seeks the path to easy recognition through imitation of the old masters, as opposed to the artist who copies no one and "whose only ambition is to render what he sees and what he feels in nature."[55]

Duranty's characterization of the Impressionists, as artists who want to be true to the appearances of nature—with a truth that could rival the standards of objective science—but who, at the same time, seek to convey their personal feelings and responses and to be original, is a characterization that holds within it no contradiction. For in these passages from *La Nouvelle Peinture* Duranty is not describing artists who have sacrificed the subjective aspirations of an earlier Romantic art to the objective norms of a scientific method. Instead, they are artists who—like their predecessors—have come to regard truth to nature as a path to the most intense and personal kind of artistic expression.

This characterization of Impressionism as an art that is at once subjective and objective is found again in the writings of Diego Martelli and Jules Laforgue, critics who, like Duranty, also turned to the teachings and to the authority of science for a justification of the Impressionists' style. They did so, however, in terms that were both scientifically and philosophically far more sophisticated than Duranty's pioneering critical efforts.

Diego Martelli and Impressionism

Diego Martelli was a close personal friend and supporter of the Italian painters known as the Macchiaioli, artists who were active in Tuscany from the mid-1850s through the first decade of the twentieth century, a period that parallels the active careers of many of the French Impressionists. The aesthetic that was shared by these Italian painters and from which their name derives is associated primarily with their activities in Florence during the late 1850s and early 1860s. Following the example of the Barbizon painters, whom they admired, they turned at that time to landscape and rural subjects, and they began to make their painted studies outdoors, in order to capture the natural luminary "effects" that were to become the expressive and structural foundations for their pictures. At first, they were referred to by the press in Florence as the "*Effettisti*," and they were not given the name "*Macchiaioli*" until 1862, when a hostile critic seized upon the multiple meanings of the word *macchia*—which could be used to mean effect, sketch, or patch—to emphasize and ridicule what

IMPRESSIONISM AND SCIENCE

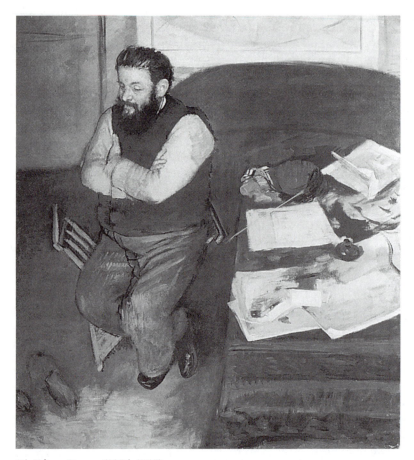

54. Edgar Degas (1834–1917).
PORTRAIT OF DIEGO MARTELLI. *1879.*
42 ⅜ x 39 ⅜" (108 x 100 cm). National Galleries of Scotland, Edinburgh

he considered to be the unfinished character of their pictures, a result, he said, of their excessive emphasis on "effect."[56]

Perhaps the most intelligent and perceptive of the critics in the circle around the Macchiaioli, Diego Martelli was locally prominent in Tuscany as an art critic, journalist, and man of letters. By the 1870s he had already begun to acquire an international reputation as a critic and writer on contemporary Italian art.[57] In April 1878 he went to Paris for the opening of the World's Fair and stayed for about a year, serving as correspondent for several Italian publications. During three earlier trips to Paris, in 1862–1863, in 1869, and again in 1870, Martelli had written appreciatively about the artists whom he and his Italian friends most admired, artists such as Rousseau, Troyon, Decamps, Corot, Millet, and Courbet. During the sojourn of 1878–1879, however, Martelli discovered and responded enthusiastically to the Impressionists. He was initially introduced into their circle by such mutual friends as the engraver Marcellin Desboutin, who had lived for a period in Tuscany, and by Federico Zandomeneghi, an Italian painter who began to exhibit with the Impressionists in 1879. At the popular weekly dinner parties given by Giuseppe De Nittis, a Neapolitan artist who had emigrated to Paris via Florence in 1867, Martelli met not only the painters but also several of the writers, including Zola, Duranty, and Edmond de Goncourt, who were part of the Impressionists' circle.[58]

During this visit to Paris, Martelli became particularly well acquainted with both Manet and Degas. The latter, in fact, painted two portraits of him during the year that he spent in the French capital (fig. 54).[59] But his closest personal friendship was with Camille Pissarro, and it appears to have been most directly through this artist that Martelli gained his exposure to the Impressionists and their work.[60]

Martelli was anxious to share his own newly acquired enthusiasm for Impressionism with his Florentine friends, and in September 1878 he persuaded Pissarro to send two of his canvases to Florence for inclusion in the next exhibition there of the Society for the Promotion of the Arts (the annual *Promotrice*; figs. 55 and 56).[61] Through his letters to his friends at home, moreover, he tried to prepare in advance a favorable reception among the artists for Pissarro's

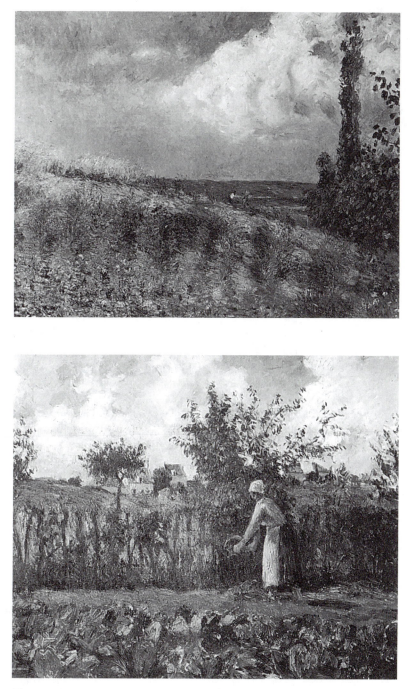

Top:
55. Camille Pissarro.
LANDSCAPE, VICINITY OF
PONTOISE. *1877.*
23 ⅝ x 28 ⅜" (60 x 72 cm).
Galleria d'arte moderna, Florence.
Bequest of Diego Martelli.
Photograph, Gabinetto fotografico,

Bottom:
56. Camille Pissarro.
IN THE KITCHEN-GARDEN. *1878.*
17 ¾ x 21 ¼" (45 x 54 cm).
Galleria d'arte moderna, Florence.
Bequest of Diego Martelli.
Photograph, Gabinetto fotografico, Florence

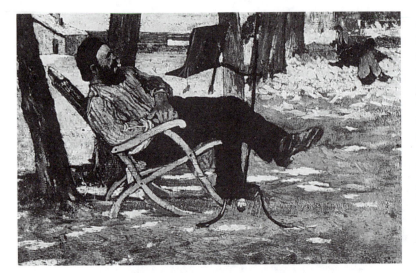

57. Giovanni Fattori (1825–1908).
DIEGO MARTELLI AT CASTIGLIONCELLO. *1867.*
Oil on wood, 8 x 5" (20 x 13 cm). Giacomo and Ida Jucker Collection, Milan

canvases. Emphasizing the concerns that he felt the two groups of artists shared in common, he wrote: "I hope that it will not be without benefit for you all to see the unusual means by which these artists seek to capture effect, but that it will give rise to many discussions among you."[62]

But despite Martelli's efforts, Pissarro's canvases were not sold, and the reception accorded them in Florence, even among the progressive artists there, was cool indeed. For example, Giovanni Fattori, one of the Macchiaioli, was shocked by the absence of conventional drawing and tonal modeling in these paintings. Fattori's attachment to drawing, seen for example in his portrait of Martelli painted a decade earlier (fig. 57), helps to explain the Italian artist's aversion to Pissarro's work and why he remained unmoved by Martelli's attempts, in subsequent correspondence, to convince him of the basic similarity between the goals of the Impressionists and those of the Macchiaioli.[63]

Upon his return to Italy in 1879, Martelli was invited to deliver a lecture before a cultural group, the Circolo filologico in Livorno, and he took this as an opportunity to continue his proselytizing activities on behalf of the Impressionists. The lecture that he delivered there, entitled *"Gli Impressionisti,"* was published in Pisa as a pamphlet in 1880 but has never been translated or reprinted in its entirety outside of Italy. Of particular interest to us here are the passages in which Martelli offered his audience a new philosophical and physiological rationale for the technique of Impressionism. After distinguishing astutely between the peculiar modernity of artists like Manet and Degas as opposed to that of the "real" Impressionists, Martelli explained:

> *Impressionism* is not only a revolution in the field of thought, it is also a revolution in the physiological understanding of the human eye. It is a new theory which depends upon a different mode of perceiving the sensation of light and of expressing impressions. The *Impressionists* did not construct their theories first and then adapt their paintings to them after the fact, but, on the contrary, as is always the case with real discoveries, the paintings were born out of the unconscious processes of the artist's eye, which, when considered later on, gave rise to the reasoning of the philosophers. . . .
>
> Until now, drawing has generally been believed to be the firmest, most certain and positive part of art. To color was conceded the unpredictable magic of the realm of the imagination. Today, we can no longer reason in this manner, for analysis has shown us that the real impression made upon

the eye by objects is an impression of color; and that we do not see the contours of forms but only the colors of these forms.

Even if we accept this train of thought, however, drawing need not be renounced, for the revolutions of science, which take place not for secondary ends but with a view to the highest aims, do not destroy that which is good. Drawing, therefore, is simply conceived by the *Impressionists* in another way, and takes on a different meaning and function.

Drawing no longer belongs to the sense of sight alone but is transferred in part to the sense of touch and exists as the graphic and mathematical expression of our quantitative judgments. The sense of the solidity of an object is not produced by the eye; the sense of distance would not exist for us if we were unable to measure it with our steps, and if you could imagine a human body endowed with all of the faculties except touch, you would readily understand that such an individual could live only in a world of harmonies and colors and would be deprived entirely of the world of measurements and lines. Drawing, then, as drawing, is the mathematical expression of quantity and is positive only in so far as it limits and defines in the algebraic sense of the word. In the same way that algebra is the abstraction of numbers, using letters to represent quantities so that movement and reciprocal relationships can be studied, so drawing is the abstraction of forms, the limits and boundaries of which are isolated from the light that envelops them and from the color that clothes them. Drawing in chiaroscuro is the intermediary link between drawing and painting, for he who draws in chiaroscuro must not only indicate the masses of shadow with black and the masses of light with white, but must grasp and use the full range of half-tones that separate white from black. Thus he adopts a full palette, with an infinite range of combinations at his disposal, and, consequently, he paints. Since human beings have the ability to abstract mentally one object from another, but have not in reality the ability to abstract and fix one sensation for the reason that all sensations are linked and are essentially complex, it follows then that, having linked in our brain the boundaries of objects with their colored appearance, we imagine that we see the contours of things, but in reality we do not see them.[64]

Martelli was addressing an audience that he had reason to believe would object to the unconventional technique and "unrealistic formlessness" of Impressionism. He therefore tried to show them that Impressionist pictures were in fact true to reality—not the reality of what we think we see, but the reality of what the human eye is physically able to experience. He set out, in other words, to justify the Impressionist technique as a parallel to the physiological and psychological nature of perception itself.

In defense of the way in which the Impressionists achieved their effects with juxtaposed flecks of color instead of drawn contours, Martelli drew an analogy between this mode of painting and the nature of the optical experience, as this experience had been explained by a philosophical and scientific tradition that stretched back to the early eighteenth century. By asserting that "we imagine

that we see the contours of things, but in reality we do not see them," or again, that "analysis has shown us that the real impression made upon the eye by objects is an impression of color; and that we do not see the contours of forms but only the colors of these forms," Martelli was making use of a position associated with the English philosopher George Berkeley, who had written in "An Essay Towards a New Theory of Vision" in 1709:

> All that is properly perceived by the visive faculty amounts to no more than colours, with their variations and different proportions of light and shade. . . .What we strictly see are not solids, nor yet planes variously coloured: they are only diversity of colours. And some of these suggest to the mind solids, and others plane figures, just as they have been experienced to be connected with the one or the other.[65]

These ideas about vision and perception, which were familiar and widely known by the early nineteenth century, were applied to art, most notably by Goethe, who wrote, in 1810, in the preface to his *Theory of Colors*:

> We now assert, extraordinary as it may in some degree appear, that the eye sees no form, inasmuch as light, shade and colour together constitute that which to our vision distinguishes object from object, and the parts of an object from each other. From these three, light, shade and colour, we construct the visible world, and thus, at the same time, make painting possible.[66]

During the nineteenth century, the philosophical notion that "matter" is merely a conventional concept was given further scientific sanction by developments in the fields of physics (for example, atomic theory) and of physiological optics and perception. In the latter area, the German physiologist and physicist Hermann von Helmholtz, who denied any correspondence between sensations and the things they are supposed to denote, developed in detail the theory that our perceptions are merely signs or abstract symbols for external objects, symbols that we order in relation to our experience so that we may be able to adjust our actions to our environment.[67] In this context, matter or substance—that is, the "form" of "objects" in external reality—becomes a convenient but fictitious way of describing relationships between sensations that, by definition, are sensations of light and can be differentiated by us perceptually only in terms of intensity and color.[68] By the 1870s Helmholtz's complex work had become absorbed into the current literature on popular science in Europe. His *Handbuch der Physiologischen Optik* was translated into French in 1867. In 1870, when the French literary critic and philosopher Hippolyte Taine wrote his book *De L'Intelligence*, he based his discussion of vision and perception on the work of Helmholtz.[69] Helmholtz's writings themselves were readily available to the interested layman in the form of short, popular lectures, which were collected and published in many translated editions. One of these, a lengthy essay by Helmholtz that was translated into French under the title *"L'Optique et la peinture,"* appeared in a volume entitled *Principes scientifiques des beaux-arts* (Paris, 1878), a book that Martelli owned and that he probably acquired during the year he spent in the French capital.[70]

To what extent can Martelli's unusual and scientifically up-to-date justification of Impressionism — unprecedented on this level of sophistication in the earlier French literature on these artists — be said to reflect the tenor of thought then current in the circle of Impressionist supporters with whom he mixed in Paris in 1878? Helmholtz's research on the physiology of perception was readily available in Paris and may already have been known to Duranty (and to Martelli as well) through the writings of Taine as early as 1870. Nevertheless, as we have seen, Duranty did not directly address any of the issues raised by that research in his discussion of Impressionism in 1876.

On the other hand, we know that Martelli's interest in a Berkeleian philosophy of perception and its application to the critical interpretation of contemporary painting predated his 1878–1879 visit to Paris and his discovery there of Impressionism. In a lecture he delivered before the Circolo filologico in Livorno in 1877, well before his departure for Paris, Martelli had in fact called upon this same general philosophy of perception in order to explain and justify the stylistic proclivities of the Macchiaioli. Describing the events that had taken place in Florence in the late 1850s, he told his audience: "the *macchia* was found in opposition to form . . . it was said that form did not exist, and since, in light, everything appears as the result of colors and chiaroscuro, the effects of nature should therefore be obtained solely by means of patches [*macchie*], either of color or of tone."[71]

Martelli's interests, then, were certainly shared by other writers and critics in the Impressionists' circle in the 1870s, and his thinking must have been greatly stimulated by theirs during the year that he spent among them. Nevertheless, the terms in which Martelli forged a critical justification for Impressionism were unique. He had brought with him to Paris a prior knowledge of the science and philosophy of perception, as well as a predisposition to regard line and form, in the conventional artistic sense, as perceptual illusions unrelated to the reality of optical experience. It was this predisposition that must have been the catalyst for his surprisingly precocious openness to Impressionism when he first encountered this unconventional style in Paris in 1878.

As Martelli was very careful to point out when he discussed the compatibility of the Impressionists' style with the nature of the optical experience, this compatibility was a wholly fortuitous and unplanned one. The painters themselves had proceeded empirically, not as pseudo-scientists or philosophers, but simply as painters who were remarkably attentive to their visual sensations. These parallels with the theories of philosophers and scientists, Martelli insisted, were discovered only later on, by those, like himself, who studied and thought about the implications of the Impressionists' work: "The Impressionists," he wrote, "did not construct their theories first and then adapt their paintings to them after the fact, but, on the contrary, as is always the case with real discoveries, the paintings were born out of the unconscious processes of the artist's eye, which, when considered later on, gave rise to the reasoning of the philosophers." A similar point would be made a few years later by Jules Laforgue, another critic who came to the defense of the Impressionists in the early 1880s.

Jules Laforgue and Impressionism

In addition to Duranty and Martelli, the only other writer in the nineteenth century who brought an interest and knowledge of science to bear significantly and originally upon his analysis and defense of Impressionism was the French poet and critic Jules Laforgue (1860–1887). Educated in science and philosophy as well as in art and literature, Laforgue, in 1880, at the age of twenty, became an assistant to Charles Ephrussi, the erudite writer and soon-to-be-editor of the *Gazette des Beaux-Arts*. A supporter of the Impressionists who owned an impressive collection of their paintings, Ephrussi regarded Impressionism as a "system which necessitates a very special organization and training of the visual faculties," in order that the artist may be able to "seize the least quiver of light, the least particle of color, the least tint of shadow."[72] It was Ephrussi who introduced Laforgue to the Impressionists' work.

Also important for the development of Laforgue's aesthetic philosophy was the work of his friend Charles Henry, the brilliant and influential young scientist and aesthetician. Like his teacher, the physiologist Claude Bernard (1813–1878), Henry rejected the conventional view of science as the mere recording of fact, for a view, more congenial to the arts, that recognized the contributions of imagination and emotion. The "psychophysical" aesthetic that was being developed by Henry during the years of his friendship with Laforgue emphasized the primacy of the individual's state of consciousness in defining the nature of physical reality: it was an aesthetic designed to bridge what Henry perceived to be a gap between the two basic modes of understanding—natural philosophy or science (objective understanding) and art (subjective understanding)—and it may have helped to form some of the attitudes that support Laforgue's approach to the Impressionists and their art.[73]

In an essay on Impressionism written as a review of a small exhibition held at the Gurlitt Gallery in Berlin in October of 1883, an essay that was published for the first time posthumously in 1902–1903, Laforgue, like Martelli, used current, popular scientific knowledge about the way in which the human eye works (based largely on the theories of Helmholtz and Thomas Young) in order to justify the absence of conventional drawing and perspective in Impressionist paintings and to demonstrate that what the Impressionist artist painted was in fact simply what he saw. The following passages are from Laforgue's essay:

Physiological Origin of Impressionism: The Prejudice of Traditional Line.
It is clear that if pictorial work springs from the brain, the soul, it does so only by means of the eye, the eye being basically similar to the ear in music; the Impressionist is therefore a modernist painter endowed with an uncommon sensibility of the eye. He is one who, forgetting the pictures amassed through centuries in museums, forgetting his optical art school training—line, perspective, color—by dint of living and seeing frankly and primitively in the bright open air, that is, outside his poorly lighted studio, whether the city street, the country, or the interiors of houses, has succeeded in remaking for himself a natural eye, and in seeing naturally and painting as simply as he sees. Let me explain. . . .

Line is an old deep-rooted prejudice whose origin must be sought in the

first experiments of human sensation. The primitive eye, knowing only white light with its indecomposable shadows, and so unaided by distinguishing coloration, availed itself of tactile experiment. Then, through continual association and interdependence, and the transference of acquired characteristics between the tactile and visual faculties, the sense of form moved from the fingers to the eye. Fixed form does not originate with the eye: the eye, in its progressive refinement, has drawn from it the useful sense of sharp contours, which is the basis of the childish illusion of the translation of living nondimensional reality by line and perspective.

Essentially the eye should know only luminous vibration, just as the acoustic nerve knows only sonorous vibration. The eye, after having begun by appropriating, refining, and systematizing the tactile faculties, has lived, developed, and maintained itself in this state of illusion by centuries of line drawings; and hence its evolution as the organ of luminous vibration has been extremely retarded in relation to that of the ear, and in respect to color, it is still a rudimentary intelligence. And so while the ear in general easily analyzes harmonics like an auditory prism, the eye sees light only roughly and synthetically and has only vague powers of decomposing it in the presence of nature, despite the three fibrils described by Young, which constitute the facets of the prisms. Then a natural eye—or a refined eye, for this organ, before moving ahead, must first become primitive again by ridding itself of tactile illusions—a natural eye forgets tactile illusions and their convenient dead language of line, and acts only in its faculty of prismatic sensibility. It reaches a point where it can see reality in the living atmosphere of forms, decomposed, refracted, reflected by beings and things, in incessant variation. Such is this first characteristic of the Impressionist eye.[74]

The Impressionist, according to Laforgue, is an artist who has managed, unconsciously, to isolate and to recover the primitive workings of the human eye, as that eye would have functioned before it had been compromised by learned responses—i.e., by the tactile knowledge of form and by the conceptual illusion of line, fixed contours, and linear perspective. The Impressionist, for Laforgue, "has succeeded in remaking for himself a natural eye, seeing naturally and painting as simply as he sees." His technique of painting and notation is totally in harmony with "the unconscious processes" (to borrow Martelli's phrase) of that natural eye, which is also, Laforgue wrote (combining an eighteenth-century, proto-Romantic yearning for a return to a state of nature with nineteenth-century Darwinism), "the most advanced eye in human evolution, the one which until now has grasped and rendered the most complicated combinations of nuances known."[75]

But this faithfulness to optical experience, which is both simple and complex at the same time, is not an end in itself for the Impressionists according to Laforgue; rather, it is a means to a higher end. The eye, in Laforgue's view, is central to the optical arts not only because it is the essential channel of communication between the artist and his environment, but also because it is the channel by means of which the work of visual art is born from the artist's "brain" and from his "soul." This process, Laforgue made clear, is not a dispassionate or a

coolly objective one, for these "impressionistic notes," he wrote, had been "taken in the heat of sensory intoxication."[76] What the Impressionist achieves by being true to the workings of his natural eye is not a simple, objective recording of an Absolute Reality. The latter, in fact, is a concept that Laforgue emphatically rejected. In terms that would have been equally congenial to the adherents of *Naturphilosophie* in the late eighteenth century and to the Phenomenalists of the late nineteenth, Laforgue stressed instead the constant flux that occurs both in nature and in the artist's optical and emotional state, as he is bombarded by the innumerable, almost imperceptible stimuli and distractions that come from his environment. Laforgue explained how these can modify even the briefest of the artist's experiences in nature, making it impossible for him ever to record a fugitive, external "reality":

> So, in short, even if one remains only fifteen minutes before a landscape, one's work will never be the real equivalent of the fugitive reality, but rather the record of the response of a certain unique sensibility to a moment which can never be reproduced exactly for the individual, under the excitement of a landscape at a certain moment of its luminous life which can never be duplicated.[77]

Citing the same possibility of moment-to-moment variation in the sensibility and experience of each individual observer who stands before an artist's work, Laforgue concluded:

> Subject and object are then irretrievably in motion, inapprehensible and unapprehending. In the flashes of identity between subject and object lies the nature of genius. And any attempt to codify such flashes is but an academic pastime.[78]

The Impressionist, then, in attempting to be true to the rapidly altering experiences of his or her eye, was not trying to achieve, according to Laforgue, a recording of an objective reality. For, as Thoré-Bürger had written of the Barbizon painters in the 1840s, and as Laforgue would have agreed, the transitory character of nature had taught artists that faithful imitation of the visual world is a physical impossibility.[79] (It was also, one might add, an increasingly undesirable aesthetic goal for nineteenth-century artists, who faced in this area the competitive edge of photography and were being forced, increasingly, to redefine themselves in relationship to it.) No matter how brief the sitting, wrote Laforgue, "one's work will never be the real equivalent of the fugitive reality." What it can be, however, is "the record of the response of a certain unique sensibility to a moment which can never be reproduced exactly for the individual, under the excitement of a landscape at a certain moment of its luminous life which can never be duplicated."

The work of art, in other words, could be for the Impressionists what it was for their earlier Romantic predecessors—a record of what the artist has felt during a particular succession of moments as a result of what he has seen. The Impressionist, Laforgue tells us, seeks not to record external reality, but instead to grasp from moment to moment and to express that which is most personal to himself: his own unique experience of the external world, as that experience has

been filtered and mediated by the operations of his own, thoroughly individual eye: "There do not exist anywhere in the world," Laforgue asserted, "two eyes identical as organs or faculties."[80] And in what is surely one of the quintessential statements of Romantic individualism, one that forms a bridge between Laforgue's century and our own, he wrote:

> Each person is, according to his moment in time, his racial milieu and social situation, his moment of individual evolution, a kind of keyboard on which the exterior world plays in a certain way. My own keyboard is perpetually changing, and there is no other like it. All keyboards are legitimate.[81]

The critical supporters of Impressionism in the 1860s, 1870s, and 1880s responded to their positivist milieu by trying to find a justification in the current scientific mainstream for an art that was in many ways still rooted in an earlier, Romantic philosophical and scientific tradition. As we have seen, however, theirs was frequently a desperate effort to negotiate and circumvent—rather than to mindlessly embrace—the positivist spirit of their age. In Laforgue's writings of the early 1880s is revealed a need, similar to Zola's in the 1860s, to reconcile the lessons of "rational" science with the traditional values of "intuitive" art. For Zola, a work of art had been "a corner of the universe viewed through a temperament," with a clear emphasis placed upon the last term. For Laforgue, the answer to this long-standing dilemma was to be found in the scientifically demonstrable uniqueness of the individual human eye, a uniqueness upon which he eloquently insisted. In Laforgue's defense of Impressionism, there was thus a wedding of empirical science's emphasis upon truth to experience with the happy realization that "experience," in terms that were finally being sanctioned by science itself, is never something that is singular or absolute but always something that is personal and variable, a matter of the unique sensibility, or physiology, of each human eye—of which, Laforgue reminds us, there are not two, anywhere in the world, that are "identical as organs or faculties."

The optical, then, not only for the Impressionists but also for their scientifically oriented apologists, had become by the 1880s (as it had been for their Romantic predecessors) a path to the personal. Unlike the paradigm of the positivist scientist in the nineteenth century, who saw himself in archetypically dualistic terms as separate and apart from nature, the Impressionists were artists who regarded process as primary and who saw their own originality as dependent upon maintaining a personal and interactive relationship with the natural world. Impressionism was thus clearly not—as our own century has insisted—aligned with or dependent upon positivism's conception of the goals and procedures of an objective mechanical science. Rather, it was an art that may be said to have challenged the epistemology and the paradigms, the priorities and assumptions of that "normal" science of its period in essential ways.

Impressionism and Neo-Impressionism

Mistaken connections between Impressionism and positivist science that prevail in the critical literature of the twentieth century may be traced in

58. Georges Seurat (1859–1891).
SUNDAY AFTERNOON ON THE ISLAND OF LA GRANDE JATTE. *1884–1886.*
81 x 120 ¾" (206 x 307 cm).
The Art Institute of Chicago. Helen Birch Bartlett Memorial Collection, 1926.
Photograph ©1990, The Art Institute of Chicago. All Rights Reserved

part to a confusion or failure to distinguish adequately between Impressionism and its scientifically based offshoot, Neo-Impressionism, a confusion that took hold fairly early in the general art historical literature. Since Neo-Impressionism, as its name implies, was closely linked with Impressionism as a historical phenomenon, some of the initial confusion between the two, at least on the popular level, is understandable. The works of Seurat and his followers were first seen together, in fact, at the eighth and last group exhibition of the Impressionists in 1886. In his review of this exhibition—a version of which Seurat later described as "the exposition of my ideas on painting"[82]—Félix Fénéon, the critic who gave the Neo-Impressionists their name, presented the work of these artists as a systematic and scientifically based extension and improvement upon the goals and methods of the Impressionist painters whom they thus superseded. The basis of Neo-Impressionism, according to Fénéon, was the theory and practice of optical mixture, the advantages of which, he claimed, had already been discovered by the Impressionists as they sought to capture sunlight on their canvases. The Impressionists, he said, had "made separate notations, letting the colors arise, vibrate in abrupt contacts, and recompose themselves at a distance." But their use of this principle had been haphazard and irregular and not, we may infer from Fénéon's discussion, consciously invoked. Of the Impressionists, Fénéon wrote:

> They thus proceeded by the decomposition of colors; but this decomposition was carried out in an arbitrary manner: such and such a streak of impasto happened to throw the sensation of red across a landscape; such and such brilliant reds were hatched with greens. Messieurs Georges Seurat, Camille and Lucien Pissarro, Dubois-Pillet, and Paul Signac divide the tone in a conscious and scientific manner. This evolution dates from 1884, 1885, 1886.

Proceeding "in a conscious and scientific manner," Fénéon tells us, the Neo-Impressionists, following their leader Seurat, had consistently applied their pigments in separate small touches and in dosages that were "complexly and delicately measured out," and they had thereby succeeded in eliminating the impurities and dullness of color that still resulted in Impressionist pictures from pigmentary mixtures carried out intentionally on the palette or accidentally, through haste, on the canvas itself. The separate spots of color on Seurat's can-

vases constituted an important improvement upon the Impressionists' technique, according to Fénéon, because they could recombine consistently in the eye of the beholder as optical mixtures of colored rays of light, thus producing color sensations that—according to the findings of scientists like Rood and Chevreul, whom Seurat had read—would be far superior in luminosity to those derived from conventional palette mixtures.

In re-creating this experience of luminosity, Seurat availed himself of still another optical phenomenon that he had learned about from contemporary science. Observed by the German physicist Heinrich Dove and described in *Modern Chromatics* (1879) by the American physicist Ogden Rood, this phenomenon, known as "luster," is essentially an optical vibration that occurs optimally for the viewer of a Neo-Impressionist painting only at the correct viewing distance from the canvas: that distance at which the eye struggles toward but does not yet entirely achieve a complete synthesis of the separate spots of color. Of the role that this phenomenon plays in the viewer's experience of Seurat's painting *Sunday Afternoon on the Island of La Grande Jatte* (fig. 58), which was shown at the Eighth Impressionist Exhibition, Fénéon wrote:

> The atmosphere is transparent and singularly vibrant; the surface seems to flicker. Perhaps this sensation, which is also experienced in front of other such paintings in the room, can be explained by the theory of Dove: the retina, expecting distinct groups of light rays to act upon it, perceives in very rapid alternation both the disassociated colored elements and their resultant color.[83]

To create his complicated system of incomplete optical mixture, Seurat had drawn inspiration from a variety of scientific and theoretical sources, as well as from what he described, in a letter to Fénéon, as "Delacroix's precepts" and "the intuitions of Monet and Pissarro."[84] Delacroix's ideas about color had reached Seurat largely through a positivist filter, via the writings of Charles Blanc, the prominent critic, historian, and Beaux-Arts administrator, who believed that social and artistic progress could be achieved in the modern age, as in the Renaissance, through science. It was Blanc who first advanced the now disputed idea that Delacroix had been deeply influenced by the color theories of Chevreul.[85]

Along with "the intuitions of Monet and Pissarro," these "precepts" of Delacroix's provided Seurat's supporters in the 1880s and 1890s with a historical pedigree as well as a justification for the Neo-Impressionist style, and this approach culminated with Paul Signac's influential book *From Delacroix to Neo-Impressionism* (1898–1899), which was widely read among avant-garde artists and critics at the turn of the century. "If Neo-Impressionism results directly from Impressionism," Signac wrote, "it also owes much to Delacroix . . . It is the fusion and the development of the doctrines of Delacroix and of the Impressionists, a return to the tradition of the one with every benefit of the others' contribution."[86] Following Blanc, Signac associated the "tradition" of Delacroix with a color theory and practice that were presumably influenced and shaped to a significant extent by the precepts of science, in particular the work of Chevreul. The "contribution" of the Impressionists is defined as "simplification of the palette" and "decomposition of the tints into multiple elements." But

59. Camille Pissarro.
APPLE HARVEST AT ERAGNY. *1888.*
23 x 28 ½" (58.5 x 72.5 cm). Dallas Museum of Fine Arts. Munger Fund Purchase

the Impressionists, Signac makes clear, had been guilty of ignoring science; they had not submitted their intuitive discoveries to scientific "laws."[87] Thus, like Fénéon before him, Signac used the Impressionists essentially as foils, pointing out the faults of their haphazard empirical procedures so that the virtues of the consistent and scientifically sanctioned methods of Seurat and his followers could be more readily perceived and appreciated.[88]

While few in the nineteenth century would have confused the empirical approach of the Impressionists with the scientific orientation of the Neo-Impressionists, the association of Impressionism with "divided color" and "optical mixture" that is to be found first in the writings of Fénéon and then of Signac, is an association that had a profound influence upon later criticism and that eventually succeeded in blurring this crucial distinction between the two groups. Instead of keeping firmly in mind that "divided color" and "optical mixture" were interests that had been superimposed upon Impressionism by the Neo-Impressionists in an effort to provide themselves with historical antecedents, many early twentieth-century scholars and critics eventually came to regard these as the legitimate and conscious concerns of the Impressionists

60. Camille Pissarro.
THE ARTIST'S GARDEN AT ERAGNY. *1898.*
29 x 36 ⅜" (73.6 x 92.3 cm).
National Gallery of Art, Washington, D. C. Ailsa Mellon Bruce Collection, 1970

themselves. Even popular misconceptions about Seurat's methods and techniques—as, for example, the idea, already current in the 1890s, that optical mixture required Seurat to restrict his (in reality quite varied) palette to just the three primary colors[89]—eventually attached themselves to Impressionism as well. Thus, by the 1930s, several widely used general textbooks in the United States were explaining the luminosity of both Impressionist and Neo-Impressionist pictures as the result of a scientifically prescribed optical mixture, induced by the consistent and conscious juxtaposition of small touches of only the three primary colors.[90] This explanation of the optical mixture sought by Seurat and his friends was of course grossly oversimplified, and its patent absurdities were officially exposed and debunked in 1944 by the art historian J. Carson Webster in his now classic article, "The Technique of Impressionism: A Reappraisal."[91] But as a simple, albeit incorrect, way of understanding the logic behind the application of Seurat's *petit point*, one which could easily be extended to the broken brushwork of the Impressionists as well, this was an explanation that long held appeal for the popular imagination.

141

IMPRESSIONISM AND SCIENCE

The early twentieth century's confusion between Impressionism and Neo-Impressionism may have been further complicated by the fact that Camille Pissarro, one of the core group of Impressionists in the 1870s and early 1880s, was for several years in the late 1880s an adherent of Neo-Impressionism (see fig. 59). Pissarro was the only one of the original Impressionists who tried to adopt Seurat's pointillist technique and divisionist method, and he was the only one among them who defended it. Introduced to Seurat in October 1885, Pissarro, who had recently begun to grow dissatisfied with his own work, was quickly won over by these younger "progressive" painters and their style.[92] He soon began to refer to his former associates as the "romantic impressionists," in order to distinguish them, disparagingly, from the members of the emerging new school, whose specifically scientific proclivities the older Impressionists seem to have both feared and scorned.[93] In particular, it was the apparently impersonal attitude of Seurat and his followers toward the execution of their works that proved most offensive to the Impressionists, whose continuing attachment to a romantic conception of originality and spontaneous self-expression in painting was seriously and understandably threatened by the "mechanical" aspects of Seurat's *petit point*.[94] It was therefore only as the result of Pissarro's strenuous intervention on their behalf that the Neo-Impressionists were invited to participate in the Impressionist Exhibition of 1886. It was also at his insistence that the works of Seurat and Signac, along with recent pictures by himself and his son Lucien, were exhibited together as a group in a separate room at that exhibition. Pissarro's victory, however, was hard won. Considerable dissension resulted from his efforts to include Seurat and Signac in this exhibition, and it was finally to open without the participation of some of the earlier mainstays of the Impressionist group, including Monet, Renoir, Sisley and Caillebotte.[95]

Pissarro's own excursion into Neo-Impressionism proved to be short-lived. He soon began to chafe under the restrictive rigors of Seurat's method, and in 1889 he complained to Fénéon of the difficulty he was experiencing with a "technique which ties me down and prevents me from producing with spontaneity of sensation."[96] By 1890 he had rejected Seurat's systematic divisionism and returned to his earlier plein-air Impressionist pratice(see fig. 60). In a letter of 1896 to Henri van de Velde, who had been one of Seurat's Belgian followers, Pissarro explained his rejection of Seurat's doctrine and its narrowly scientific base in terms that fully justify his earlier reference to himself and his older friends as the "romantic impressionists." It is with Pissarro's own words, then, that we may, at this juncture, rest our case:

> I believe that it is my duty to write you frankly and tell you how I now regard the attempt I made to be a systematic divisionist, following our friend Seurat. Having tried this theory for four years and having now abandoned it, not without painful and obstinate struggles to regain what I had lost and not to lose what I had learned, I can no longer consider myself one of the neo-impressionists who abandon movement and life for a diametrically opposed aesthetic which, perhaps, is the right thing for the man with the right temperament but is not right for me, anxious as I am to avoid all narrow, so-called scientific theories. Having found after many attempts (I speak for myself), having found that it was impossible to be true to my sensations and consequently to render life and movement, im-

possible to be faithful to the so random and admirable effects of nature, impossible to give an individual character to my drawing, I had to give it up. And none too soon![97]

<p style="text-align:center">◆ ◆ ◆</p>

In the early nineteenth century, as we have seen, Romantic artists regarded truth to nature as a prerequisite for personal expression, and they aligned themselves with the Romantic philosophy and organic science of *Naturphilosophie*. The landscape painters of the Impressionist movement grew out of this Romantic tradition and all that science had meant to it—but in a place and at a time when a very different conception of "good" or "normal" science prevailed, one that was in many ways anathema to their own pursuits. In the positivist intellectual climate of nineteenth-century France, artists, critics, and the public-at-large were encouraged to seek correspondences between the "laws" of science and those of art. They were bombarded with books and essays (Taine's *De L'Intelligence*, Blanc's *Grammaire des arts du dessin*, Brücke's *Principes scientifiques des Beaux-Arts*, Helmholtz's *L'Optique et la peinture*) designed to provide them with a knowledge of the most recent scientific research into the physiological and psychological nature of sensory perception. The authors of these books, particularly those who were scientists, proceeded upon the assumption that the more artists and the public can be made to know about the universal processes of vision and perception—the more they know, in other words, about the way the human machine functions in this regard—the closer art may come to rendering the universal, objective "truth" about what all people really see.[98]

Ironically, the ultimate intention of many of these popularizing treatises was to engender a normative aesthetic. The scientists who wrote them were thereby offering artists and laymen a recipe for placing art and science on the same rational footing—at the cost, however, of purging art of its subjective and intuitive elements. By thus endeavoring to recast artists in their own image, these positivist scientists were displaying an understanding of art's mission that was very different from that of the positivist philosophers. Comte and Littré, the original architects of that philosophy, had assigned to the scientist—and to the scientist only—the primary task of observing and recording the factual world, while they had assigned to the artist the complementary but subordinate task of imaginatively idealizing and "perfecting" what is thus observed. Positivist philosophy permitted art its subjectivity, but again at a cost—the cost of its relative status in a society that valued the empirical and the objective above all else.

The real issue at stake in art's struggle to come to terms with positivism—and in efforts made by Impressionism's supporters to avoid the extremes of binary classification for the movement as either "subjective" or "objective"—was the shifting and unstable status of subjectivity in nineteenth-century French culture. The problem this created for art's relationship to science was further complicated by the gendered associations that not only "science" and "art," but also "objectivity" and "subjectivity" carried with them throughout this period. The pivotal role played by gender in the critical reception and interpretation of Impressionism is the subject to which we now turn.

The Gendering of Impressionism

The role played by visual representation in the social production and consolidation of gender difference, has been a major issue in the writings of many recent feminist art historians. They have analyzed the social and psychological systems that produce normative notions of sexuality and gender difference, and they have emphasized the roles these play in generating works of art.[1] My focus in this study is also on the socially constructed category of gender, not as it operates on the processes of artistic production, however, but on those of reception and interpretation—on the power of gendered cultural discourses to impose meaning not by shaping and determining artistic intentions but by altering subsequent cultural readings of them. The separation of Impressionism from Romanticism in the twentieth-century literature and its strained and artificial attachment to a positivist science have been the result, I will argue, of the movement's feminine gendering in the nineteenth century and the twentieth century's increasingly pressing need to regender this most valued of modern art movements as masculine.

While a few critics in the 1870s and 1880s used the then fashionable language of contemporary science to explain and justify some of the unusual features of the Impressionist style, none, as we have seen, ever characterized Impressionism as an art of impassive optical imitation ruled by scientific objectivity. Instead, each of those critics emphasized the subjective and expressive nature of the Impressionists' goals. Later misconceptions may have been due in part to an oversimplification of what Comtean positivism and the so-called scientific spirit of the nineteenth century actually meant to artists and critics in nineteenth-century France—a failure on the part of later historians, in other words, to distinguish adequately between the operations of "Romantic" and "normal" science and their continually shifting impact on art and art theory throughout this period. Also, a confusion between Impressionism and its scientifically based offshoot, Neo-Impressionism, took hold fairly early in the general art historical literature of the twentieth century (even though the first critical supporters of Neo-Impressionism in the 1880s and 1890s had used the new movement's self-conscious concern with science to distinguish it from Impressionism and to assert its superiority).

This blurring of distinctions between Impressionism and Neo-Impressionism was supported by the rhetoric of the Symbolists, a competing group of artists and theorists who emerged in France in the 1880s and 1890s. Although the Symbolists vociferously rejected Impressionism's reliance on the material world of nature, it has lately been argued that differences between these two groups are not as clear-cut as was once believed.[2] Nevertheless, the Symbolists' efforts to establish themselves as a recognizable entity distinct from the Impressionist movement—a process that involved the casting of Impressionism as the inferior "other"—have reinforced the tendency of later historians to write the history of

this period in dualistic terms, as a narrative of conflict in which the Symbolists' scorn for science implied—and eventually, in the literature, "proved"—the Impressionists' abiding attachment to it.

During the twentieth century, a period when "objectivity" has not generally been valued as a criterion for avant-garde art, the presumption of an alliance between Impressionism and positivist science has been stubbornly maintained in the critical literature, even though the effect of such an alliance on Impressionism as *art* has often been judged in negative rather than positive terms. And when the subjective and expressive elements of Impressionism have been recognized at all—as in George Heard Hamilton's 1959 essay on Monet's Cathedrals[3]—they have been associated exclusively with the 1890s Symbolist ethos and kept rigidly isolated not only from the orbit of "true" (i.e., impassive and objective) Impressionism but also from its presumed opposite, Romanticism.

Although this critical position is not justifiable historically, its persistence becomes comprehensible when the intersecting relationships between art and science, art and nature, and science and nature are understood in their larger historical framework as gendered relationships, and when the status that has been accorded or denied to artistic subjectivity in the modern era is further analyzed as a function of those gendered relationships.

<div style="text-align:center">

CHAPTER 7

The Gendering of Art, Science, and Nature in the Nineteenth Century

</div>

That "Nature is to Culture as Female is to Male" has been a recognizable formulation in Western thought for many centuries.[4] The ancient and hierarchic oppositions on which this construct is based have been the subject of many recent studies in the fields of cultural history and anthropology, and they are acknowledged, both within the orbit of feminist scholarship and outside of it, to have exerted a long and powerful influence on the shaping of Western society and thought.[5]

In the Western philosophical tradition, the gendering of nature as female can be traced back to the writings of Plato (the *Timaeus*) and Aristotle (*On the Generation of Animals*). It was Aristotle who divided the cosmos into the heavens, presumed to be immutable and perfect, gendered as male, and the earth, subject to generation and decay, gendered as female. To explain human procreation, Aristotle made a further, qualitative distinction in the terrestrial realm between passive, inert, female "matter" and active, shaping, male "form."[6] These dualisms have had an ongoing and profound impact on every aspect of Western culture. For nature, gendered as female and regarded as passive but also as mysterious and secretive, has served as the primary object of scrutiny and investigation not only for the sciences—characterized as "active" and "objective" and thus gendered as male—but also for art, whose gendered identity in relation both to female nature and male science has been less secure and has undergone constant

revision and permutation.

Over the course of the last decade, the role of gender ideology in the evolution of modern science has been emphasized in the writings of such scholars as Evelyn Fox Keller, Carolyn Merchant, Brian Easlea, and Sandra Harding, among others.[7] They have explored the polarization of masculine and feminine that attended the "birth" of modern science in the seventeenth century, especially as that polarization is reflected in the gendered language that was used by the new, "mechanical" scientists and philosophers to describe the values and aims of their enterprise. Special attention has been focused on the rationalist philosophy of René Descartes, which reduced nature to the level of dead, mechanically interacting matter and rejected the organic cosmos of antiquity and the middle ages (when the female Earth had been viewed as passive and receptive but nonetheless as a living organism). Descartes and the mechanical philosophers aimed at gaining control of the great world machine, thus becoming, in Descartes's words, "masters and possessors of nature."[8] Cartesian rationalism, referred to by some recent writers as "the Cartesian masculinization of thought" and characterized as an active "flight from the female," was based on mathematical measurement and objectivity.[9] As a cognitive style, it stressed intellectual transcendence and detachment, the clear separation of mind from matter, of the knower from the known. It was a scientific mode of interrogating the natural world that might restore man, in the words of Francis Bacon, to his once God-given "dominion over creation" and thereby inaugurate "a truly masculine birth of time."

In the writings of Bacon in the early seventeenth century, the desire for domination over nature emerges as the guiding principle and the central project of the new science. And it is in a series of striking metaphors to be found in Bacon's writings that the gendered basis of the "Scientific Revolution" is most fully revealed.[10] "Let us establish," Bacon wrote, "a chaste and lawful marriage between Mind and Nature."[11] In his writings, nature is the bride who is to be tamed and subdued by the male, scientific mind. In an early work entitled *The Masculine Birth of Time* (1603), Bacon speaks in the voice of the mature scientist addressing his son. He criticizes and dismisses the scientific contributions of the ancients and declares: "I am come in very truth leading to you Nature with all her children to bind her to your service and make her your slave."[12] The scientific quest is seen by the mechanical philosophers as a virile, masculine adventure, and Bacon's language, as recent writers point out, is the language of aggression and sexual domination. The marriage between mind and nature, Bacon says, is one that will give rise to a "race of Heroes and Supermen."[13] Nature is to be unveiled, exposed, and penetrated even in her "innermost chambers." And the inventions of the scientific mind, he writes, do not "merely exert a gentle guidance over nature's course; they have the power to conquer and subdue her, to shake her to her foundations."[14]

The language of seventeenth-century science and philosophy was redolent with metaphors of aggresion, sexual penetration, and conquest. These survived into the nineteenth century (and beyond) and were commonly found in the discourse of science, as for example in the words of the British geologist Adam Sedgwick, who in 1845 described the methods of science as those designed to put "nature to the torture, and wring new secrets from her,"[15] or in the words of the German physiologist Emil du Bois-Reymond, who in 1879 defined natural

science as "the mastery and exploitation of Nature by man with a view to increasing his own power, comfort and enjoyment."[16]

Art, too, bears eloquent witness to the gendered relationship between nature and science that survived throughout the nineteenth century. A statue by Louis Ernest Barrias (1841–1905), for example, made in 1899 for the Conservatoire National des Arts et Métiers and then placed on exhibition at the medical faculty in Paris, carries the inscription "Nature Unveiling Herself Before Science" (fig. 61). The statue personifies nature as a beautiful young woman, her breasts bared and her hands raised to remove the veil that still covers her head. Cogently analyzed by Ludmilla Jordanova in her study of the role of the biomedical sciences in the social construction of gender difference during the nineteenth century, the image implies, in Jordanova's words, "that science is a masculine viewer, who is anticipating full knowledge of nature, which is represented as the naked female body."[17]

During the Renaissance the medieval view of nature as the creation of God and therefore superior to man-made art was superseded. The idea that the artist is one who can perfect and thereby surpass nature was advanced by Renaissance theoreticians such as Leon Battista Alberti. The classical revival supported artists' new, humanistic claims to creative genius, turning art into the rival and the adversary of nature. As art aligned itself with rational science, there emerged the view that art, like science, can master and transcend nature by discovering her secrets. Brunelleschi's invention of one-point perspective and the practice of this system, as that practice was presented by artists themselves during this period, clearly exemplify these ambitions and make explicit the gendered dualities that served to naturalize them. Among Albrecht Dürer's illustrations to "The Treatise on Measurement," for example, there is a well-known woodcut in which a semidraped female model serves as the object for the male artist's perspectival investigation (fig. 62). This female figure, as Mary D. Garrard has pointed out, can be readily understood as the personification of female Nature.[18] She is viewed by the male artist depicted within the work (as well as by Dürer and by the beholder of the print, who is also assumed to be male) from a fixed distance. Thus measured and framed by the rational devices of perspective construction, she, Nature, has become both literally and metaphorically the passive female object of the controlling male gaze.

More than at any time since the Renaissance virilization of art, Romantic landscape painters in the nineteenth century defined themselves as social outsiders in relation to this paradigm. Taking a "passive" and responsive rather than an aggressive and controlling attitude toward their subjects in nature, they risked and inevitably invited—both for themselves and for art in general—stereotypical feminization. No longer did they necessarily conceive of themselves as the rivals and adversaries of nature, as artists in the Renaissance had done when they proudly struggled to join the liberal arts and sciences. Nor did they necessarily see themselves as the adversaries of science, at least not of the "revolutionary" science—the science that postulated an organic universe in which humans are not separated from nature—that emerged among the disciples of Schelling's *Naturphilosophie* in Germany and that briefly challenged the

61. Louis Ernest Barrias (1841–1905).
NATURE UNVEILING HERSELF BEFORE SCIENCE. *1899.*
Marble and polychrome Algerian onyx on gray granite pedestal, 78 ¾ x 33 ½ x 21 ⅜" (200 x 85 x 55 cm).
Musée d'Orsay, Paris.
Photograph, Réunion des musées nationaux, Paris

62. Albrecht Dürer (1471–1528).
ARTIST AND MODEL: DEMONSTRATION OF PERSPECTIVE. *WOODCUT*.
From Dürer's Treatise on Measurement, *2nd edition, 1538.*
Photograph courtesy of the Library of Congress

mechanical materialism of the Rationalists.

But even during the early years of the nineteenth century, when the mechanical philosophy of orthodox Baconian and Newtonian science was modified and in some instances temporarily replaced by a more organic philosophy, the gendered dualities that had traditionally described the scientific enterprise survived in force. Thus, in 1802 Sir Humphry Davy, a pioneer in the field of electrochemistry, could describe the modern chemist as one upon whom science had bestowed "powers which may be almost called creative; which have enabled him to modify and change the beings surrounding him, and by his experiments to interrogate nature with power, not simply as a scholar, passive and seeking only to understand her operations, but rather as a master, active with his own instruments."[19]

It was partly in response to such attitudes in general and to Davy's writings in particular that the English Romantic novelist Mary Wollstonecraft Shelley conceived her famous science-fiction fantasy *Frankenstein, or the Modern Prometheus* (1818).[20] The ideas of its protagonist, the scientist Victor Frankenstein, and his attempt to create a new species from dead organic matter were in fact inspired by some of the most advanced electrochemical experiments of this period, in particular the work of Galvani and Volta, who had put forth the theory that muscular motion is caused by electrical stimulation.[21] Mary Shelley, daughter of the pioneering feminist theoretician Mary Wollstonecraft (author in 1792 of *A Vindication of the Rights of Woman*), herself delivered a precocious feminist critique of modern science in *Frankenstein*, exposing, as Anne K. Mellor has observed, the gendered assumptions upon which that science was founded and challenging its efforts to manipulate and usurp the procreative powers of a nature gendered as female. "I pursued nature to her hiding place," says Frankenstein. But his unnatural method of reproduction produces a destructive monster, and the Romantic novelist thus portrays both the hubris of the male scientist, who sees his enterprise in terms of a gendered warfare and competition with nature, and the penalties that humans must inevitably incur for violating nature.[22]

The Romantic period, referred to by literary and cultural historians as an "Age of Feeling," saw a widespread reevaluation of the socially constructed feminine attributes of emotion, intuition, and empathy and an effort on the part of male writers and artists to appropriate for themselves this traditionally feminine domain of feeling and sensibility. The contradictions inherent in this enterprise have recently been explored by feminist literary critics such as Alan Richardson and Christine Battersby, who point to the ultimate inability of the Romantic poets to escape conventional notions of gender even as they sought to define their own subjectivity through contact with the feminine and its culturally defined attributes. Richardson sees the apparent efforts of the Romantic poets to challenge the rigid gender definitions of the early nineteenth century as an effort, in fact, to "colonize the feminine," to assimilate it and thereby to exclude the female herself from the domain of the Romantic creator. The Romantic ideal of androgyny, he points out, was not uncomplicated, for it perpetuated the traditional distinction between the rational male and the sensible female (which early feminists like Wollstonecraft had attempted to discredit), thus offering a further refinement of patriarchal domination rather than a dismantling of it.[23]

The Romantic ego, English literary critics now argue, was "potently male, engaged in figurative battles of conquest and possession, and at the same time capable of incorporating into itself whatever attributes of the female it desired to possess."[24] This was true not only of Byron and Shelley in England but also of Baudelaire in France. Baudelaire, whose ideal of the quintessential artist was the male flaneur, defined "Woman" for the artist as "a kind of idol, stupid perhaps, but dazzling and bewitching." And he praised the painter Eugène Delacroix for a "duality of nature," which he described as "an immense passion, reinforced with a formidable will."[25] As a Romantic artist, Delacroix appropriated the attributes of the feminine—colorism, emotion, imagination—but placed these in the service of a figurative language that subjected nature and the female other to possession and objectification (the Delacroix of the Moroccan harem and the lion hunt, of the *Death of Sardanapalus* [fig. 63] and the *Massacre at Chios*). In this equation, moreover, masculine reason continued to be privileged as the component that was necessary for determining what Baudelaire called "extreme genius." Even though Delacroix was "passionately in love with passion," Baudelaire tells us, he was nevertheless "coldly determined to seek the means of expressing it in the most visible way." For him, nature was "but a dictionary," whose elements the artist of genius will not simply imitate, but will instead adjust in accordance with his own conception, and in so doing will "confer upon them a totally new physiognomy."[26] "Now this is the principle from which Delacroix sets out," Baudelaire wrote, "that a picture should first and foremost reproduce the intimate thought of the artist, who dominates the model as the creator dominates his creation."[27]

While Delacroix and Baudelaire might assume the pose of the Romantic, feminized creator, their attitudes toward reason and nature were nevertheless stereotypically masculine. This strategy helped to preserve a socially acceptable identity for the male artist during the Romantic era. But for critical posterity the extent to which Romantic artists committed themselves to the appropriation of sensibility as a masculine virtue has rendered the efficacy of their counterbalancing assertions of masculine rationality tenuous in the extreme. And in the larger and more simplistic, dualistic patterning of art history, Romanticism (in

63. Eugène Delacroix.
DEATH OF SARDANAPALUS. *1827.*
155 ½ x 195" (395 x 495 cm).
Musée du Louvre, Paris.
Photograph, Réunion des musées nationaux, Paris

contradistinction, for example, to Neoclassicism) has been consistently assigned a feminized cultural identity and role.

Here we must pause to make a further distinction, as Baudelaire himself in fact did, between Romantic painters of the human figure such as Delacroix and painters of the same period who devoted themselves to the landscape. The latter were described by Baudelaire (with evident scorn for these artists "whose specialty brings them closer to what is called inanimate nature") as "those who have no imagination" and who therefore "just copy the dictionary."[28] To the gendered dualities of male and female, culture and nature, then, it would appear that Baudelaire might have added that of figure painting and the painting of landscape. For as the scientific model suggests, the extent to which an art form may be feminized or virilized by its relationship to nature depends entirely upon how

that relationship and the goals of the artist are posited. The distinction to be made is between an attempt to "capture" nature, in the active and aggressive sense of controlling and conferring upon it, in Baudelaire's words "a totally new physiognomy," or, as we have seen in the practice of many of the Romantic and Impressionist landscape painters, an effort not to "capture nature herself," but simply to fix upon canvas the source in sensory perception of an individual artist's unique, but thoroughly responsive experience.

The gendered basis of this distinction between landscape and figurative schools of Romantic painting in France persisted throughout the nineteenth century and became a familiar part of the discourse surrounding the diverse group of artists who banded together in the 1870s and 1880s to show their works to the public, the artists who soon became known as the "Impressionists."[29] A critic writing about an exhibition of Impressionist painting in New York City in 1886, for example, spoke of the "masculine principle" that informed the figure paintings of Manet, Degas, Renoir, Caillebotte, and Seurat, while he found the "feminine" in the landscapes of Monet, Boudin, Sisley, and Pissarro. "The tenderness and grace of Impressionism are reserved for its landscapes," he explained, and "for humanity there is only the hard brutality of naked truth."[30]

Why was Impressionist landscape painting regarded as a feminine art? The gendered distinction offered by the American critic may be partly explained by the preference of the artists he designates as feminine for depicting the tranquillity of rural and suburban settings, their attraction to a domestic iconography, and their relative lack of interest in socially problematic subjects (even Pissarro's images of peasant laborers had become sentimentalized and neutralized as political statements for viewers by the end of the century because of their, by then, nostalgic visual associations with the Barbizon school).

But the perception of the feminized character of this branch of Impressionist painting was widespread, and it had to do not so much with the subjects but rather with the techniques that these artists employed, techniques to which many critics of the period objected in clearly gendered terms. Berthe Morisot's paintings, for example, were consistently praised by critics of her period for qualities that these same critics objected to in the work of her male colleagues. These qualities included the quickness and fluidity of her brushwork, what appeared to be her exclusive concern for superficial sensation rather than for draughtsmanship and compositional structure, and her responsive and imitative facility. These characteristics, as the art historian Tamar Garb has shown, were part of the nineteenth century's cultural construction of femininity in general and its notion of a "feminine art" in particular.[31] As one French writer of the period put it: "The masculine esthetic is an esthetic of form, the feminine esthetic is an esthetic of movement."[32]

During the nineteenth century "scientific" descriptions (later disproved) of differences in the size and formation of the male and female brain and nervous system formed the basis for commonly held ideas about the "natural" mental and emotional capacities of men and women. A convenient summary of many of these popular assumptions is provided by the lengthy and then authoritative essays to be found under the heading *"Femme"* in the *Larousse Grand Dictionnaire universel du XIXe siècle* and in the *Grande Encyclopédie*. In the latter, for example, Henry de Varigny wrote of the male brain:

The frontal lobes—where it is agreed that the organ of intellectual operations and superior psychic functions is situated—are dominant; they are much more beautiful and voluminous amongst the most civilized races. With women, it is the occipital lobes which are the most developed and have more importance, and it is in them that physiology situates the emotive and sensitive centers. This, moreover, corresponds well with the psychological characters of the two sexes, the masculine sex having more intelligence whilst women are gifted with a great sensibility.[33]

In nineteenth-century France, women were widely considered to be physiologically less capable of rational thought than men and also to be more given to emotionalism and superficiality. Also biologically determined, it was believed, was woman's "natural" bent toward humility and obedience, a condition that explained her lack of originality, determined her imitative rather than creative abilities, and inevitably undermined any effort that she might make as an artist. As one writer put it:

> The female sex possesses a remarkable talent for translation, adaptation, interpretation. In the domain of imitation, she is inimitable. . . . Her natural inclinations lead her less toward invention than toward imitation. Where receptivity dominates, originality is weak. The mental qualities of woman are those that produce good disciples rather than great masters.[34]

For art critics in late nineteenth-century France, the Impressionist paintings of Berthe Morisot, with their emphasis on surface, their fluid color and brushwork, and their light and airy drawing, seemed to be a perfectly natural and highly appropriate expression of the artist's femininity. And for many of these critics, the validity of Impressionism (*"cet impressionnisme chatoyant, cet art si féminin"* wrote Camille Mauclair[35]) could only be argued in terms of the separate and "inferior" set of standards that the culture maintained for its conception of *"l'art féminin."* Garb explains:

> For such critics, it was deemed appropriate for women artists alone to practise "impressionism" as it was capable of so directly expressing their facile and superficial natures, their excitablility and innate propensity towards "nervousness." The implication was that for men to work within an "impressionist" mode was an abdication of their natural gifts, their innate powers of reason and intellectual abilities, which carried with them a duty to a more restrained and deliberate art.[36]

But within the orbit of Romantic and Impressionist painting and theory, the same elements of style that were used by some critics to denigrate Impressionism as a superficial and imitative, that is to say "feminine," art were understood very differently—indeed, in an almost diametrically opposed way. For the artists and their friendly critics, as we have seen, the characteristic lightness and fluidity of Impressionist brushwork, for example, expressed particular meanings and positive intentions on the part of these artists and were in fact signifiers, as they had been for their Romantic predecessors, of the Impressionists' spontaneity and creative originality. These competing forms of interpretation of

the same phenomena inevitably came into conflict with one other, and that conflict was framed and further exacerbated by the equivocally gendered—but essentially feminized—position that positivist philosophy helped to create for art and for the artist in France throughout much of the nineteenth century.

For Auguste Comte, founder of the positivist movement in France, and for his disciple Emile Littré, the methodology of the experimental sciences, based on observation and the empirical verification of external phenomena, provided the model for all human knowledge. Surprisingly enough, however, in the realm of art, positivist philosophy did not advocate direct observation alone. As Richard Shiff points out, positivism admitted subjectivity and idealization into the realm of art:

> . . . the most prominent positivistic thinkers believed that the direct observation and recording of external phenomena were the tasks of the scientist, whereas the artist should instead apply his imaginative vision to this world of fact. According to both Comte and Littré, art has its origin in fact but departs from it; the artist must imaginatively "idealize" and "perfect" what he observes. Thus art becomes inspirational and leads to the betterment of society. As Comte wrote, "art is always an ideal representation of what exists, destined to cultivate our instinct for perfection."[37]

But rather than content ourselves with the observation that positivism created a more flexible place than was once thought for art and its values, for the purposes of the present discussion we need to ask the question: exactly what kind of place was being assigned to art by positivism, in terms of the values that positivism itself espoused?

When viewed in these larger terms, it becomes clear that positivism maintained a "double standard" for art and science, a double standard that created for the male artist a position as "stereotypical female" in the culture at large.[38] For even though positivism cast itself as objective and value-free, it was in reality value-laden. In the realm of human knowledge, it privileged what was mathematically provable or observationally reproducible, and it placed all other modes of cognition and experience in a lesser realm of subjectivity and emotion. That art might act as an inspiration to society, that it might, in Comte's words "cultivate our instinct for perfection," is astoundingly like another, admittedly gendered view that flourished throughout the nineteenth century, the male view of woman as moral exemplum, which Comte and his positivist philosophy were instrumental in advancing. According to Comte, woman is as "naturally" inferior to man as art is to science. In his *Cours de philosophie positive* (1839), he spoke of "the relative inferiority of Woman":

> . . . unfit as she is, in comparison, for the requisite continuousness and intensity of mental labour, either from the intrinsic weakness of her reason or from her more lively moral and physical sensibility, which are hostile to scientific abstraction and concentration. This indubitable organic inferiority of feminine genius has been confirmed by decisive experiment, *even in the fine arts, and amidst the concurrence of the most favourable circumstances.*[39]
> [emphases mine]

In Comte's ideal society, however, women (the "Sympathetic" sex), though inferior and subordinate to men (the "Active" sex), can nevertheless serve an essential "moderating function" in the moral realm:

> It is indisputable that women are, in general, as superior to men in a spontaneous expansion of sympathy and sociality, as they are inferior to men in understanding and reason. Their function in the economy of the family, and consequently of society, must therefore be to modify by the excitement of the social instinct the general direction necessarily originated by the cold and rough reason which is distinctive of Man. . . .of the two attributes which separate the human race from the brutes, the primary one indicates the necessary and invariable preponderance of the male sex, while the other points out the moderating function which is appropriate to Woman.[40]

In the first volume of his *Système de politique positive* (1848), Comte elaborated on this role for woman, who was to be protected and provided for by man, and whose life was to be rendered "more and more domestic. . .so to fit her more completely for her special office of educating our moral nature."[41] Thus confined and placed on a pedestal, she was ultimately to replace the Church and become for man the central object of worship in positivism's new "religion of humanity."

The doctrine of female moral superiority and the doctrine of the "separate spheres" were of course essential to the social construction of gender difference in the nineteenth century, as numerous writers have observed. Susan Bordo, for example, writes: "The nineteenth-century celebration of a distinctly feminine sensibility and morality. . . functioned in the service of pure masculinized thought by defining itself as a separate entity." Exalting the feminine within its own sphere, she observes, assured "the exclusion of feminine modes of knowing, not from culture in general, but from the scientific and philosophical arenas, whose objectivity and purity needed to be guaranteed."[42] Bordo's analysis accords well with the view of art and its relationship to science that was promoted by positivist philosophy in the nineteenth century, a view that might be stated as "Male is to Female as Science is to Art." By clearly separating the roles that were to be played by art and science within nineteenth-century French culture and society, positivism was instrumental in establishing a gendered hierarchy that contributed to art's cultural feminization in France throughout much of the century.

This cultural hierarchizing of art's role in relation to science and the similar hierarchizing within art itself of style and its elements based on gender must be taken into account in any effort to situate and explain the nineteenth century's association of Impressionism with the feminine. But also, and even more fundamentally I believe, the characterization of Impressionist landscape painting in particular as a feminized form of art is one that depends upon the very special and inherently Romantic attitude toward nature that guided its conception, an attitude that was embodied and communicated by the unorthodox techniques that the Impressionist painters used.

From the Renaissance on, drawing and perspective had helped to masculinize art by giving form (gendered as male in the Western philosophical tradition) to passive matter (gendered as female). Far more than any other style of paint-

ing that preceded it, Impressionism was an art that broke form into particulate matter. The absence in these traditional terms of "form"—of drawing and perspective—in Impressionist painting in general and in Impressionist landscape painting in particular feminized the movement, as we have seen, for many contemporary observers.

When did the approach to painting landscape in the Western tradition change from structuring space with perspective in the Renaissance manner to this Impressionist mode of fixing upon canvas sensations of light as agents of feeling and affect—that is, to Monet's "uninterpreted sensation," expressed by the artist as the wish that he had been born blind so that he would not "know" the forms of things in external nature? The authority of Renaissance perspective, of course, had not been continuous and had not gone unchallenged during the intervening centuries. But it was still alive in France during the nineteenth century in the academic circles that the Impressionists challenged. In the works of those earlier French artists who provided Monet with both precedent and inspiration, however, an alternative tradition had already been established. In the landscapes of Claude Lorrain, for example, the sun is often placed at the vanishing point in the background of the work, so that its energy seems to radiate forward, breaking down or obscuring forms and measurable spaces in the foreground (fig. 30). But it was not until the Romantic and Impressionist era that this change may be said to be definitive, particularly in the works of artists such as Turner and of course Monet himself (figs. 28 and 29; colorplates 14, 15, 23, and 24).

During the period of Romanticism and Impressionism landscape painting progressively dissociated itself not only from the conventions of Renaissance perspective as a representational system but also from the centered and singular vision that the system had traditionally posited—the vision of the constitutive male subject who views the world of nature from a position of mastery. For a nineteenth-century artist to escape the assumed universality of the perspective system might be seen by us today as tantamount to challenging, among other things, the gender-inflected network of cultural and social values that perspective, as a traditional system of representation, both expressed and reinforced. Viewed in this manner, it becomes newly interesting to consider why it was that so many nineteenth-century artists gravitated to the new spatial systems suggested by Japanese prints and by photography, with their high points of view that randomized and marginalized visual experience and that ultimately had the effect of deconstructing the control of the male gaze.[43]

The feminist art historian Griselda Pollock has argued that the decentered compositional and spatial strategies of Impressionism continued to exclude the female, for it was the flaneur whose experience defined the point of view of the modern artist in the nineteenth century, and the flaneur's social freedom to roam the boulevards and cafés of modern Paris would have defined him (and the artist) as exclusively male.[44] Such judgments can only be relative, however. For the unusual spatial structures and points of view that were adopted by Impressionism clearly opened up to painters such as Berthe Morisot and Mary Cassatt—as well as to the male artist/flaneur—new possibilities for representation that helped them, as women artists, to renegotiate the limitations that were placed upon them in the nineteenth century by their female identity. Thus the young woman who sits virtually centered in the foreground of Berthe Morisot's

64. Berthe Morisot (1841–1895).
LAKE IN THE BOIS DE BOULOGNE (SUMMER DAY). *1879.*
18 x 29 ⅝" (45.7 x 75.3 cm).
Reproduced by courtesy of the Trustees, The National Gallery, London.

Lake in the Bois de Boulogne (Summer Day) (fig. 64) nevertheless resists the objectification that such centering might normally impose—or rather the artist resists it for her by blending her with the sparkling and irregular surface of the water (flattened and brought close by the picture's high horizon) and by resolutely deflecting the viewer's gaze to the landscape through the woman at the left, who is actively engaged in its contemplation and enjoyment. Mary Cassatt's *Woman and Child Driving* (fig. 65) presents a familiar Impressionist composition in which three figures are tightly but asymmetrically massed at the right and a horse and carriage are cut off as they meet the frame. This composition vividly conveys the sensation of literal movement while it underscores through the forward movement into time and space the demeanor of the middle-class woman, who is the active subject of this painting. Accompanied by a little girl, representative of the next female generation, the woman sits assertively but not without trepidation in the driver's seat. That her position may metaphorically depart from or even carry with it a veiled challenge to the normal social order of things is a suggestion made inescapable by the presence of the oddly passive and faceless young man who sits behind her in the carriage. But it is a position that is at the same time potentially normalized by the slice-of-life point of view that the artist has chosen to present.

For the Impressionist landscape painters in particular, however, such new points of view and spatial constructions inevitably assisted in developing a rela-

65. Mary Cassatt (1845–1926).
WOMAN AND CHILD DRIVING. *1881.*
35 ¼ x 51 ½" (89.5 x 130.8 cm).
Philadelphia Museum of Art. W. P. Wilstach Collection

tionship between the artist and the natural world that was very different from
the one of gendered possession and mastery that earlier spatial and composi-
tional systems had supported. In the case of Monet, a correlation might be made
between his progressive abandonment of perspective and the controlling posi-
tion it posited for the artist and his growing understanding of the responsive
character of his mission as an artist who paints the landscape—even when dur-
ing his later years he painted the constructed landscape of his own gardens at
Giverny, "those demonstrations of nature," as his friend, the statesman Georges
Clemenceau called them.[45] For what conspicuously distinguished Monet, both
as a gardener and as a painter of landscape, was the clear understanding and ad-
mission on his part that he could ultimately have no control over nature; that he
could not "capture" nature, but could only support her "demonstrations" and
give form to an "impression" that nature evokes; that even though he was a
unique individual, it was nevertheless nature that made him feel and experience,
thus enabling him to give expression to his individuality. As Lilla Cabot Perry
reported of Monet:

He always insisted on the great importance of a painter noticing when the effect changed, so as to get a true impression of a certain aspect of nature and not a composite picture, as too many paintings were, and are. He admitted that it was difficult to stop in time because one got carried away, and then added: "*J'ai cette force-là, c'est la seule force que j'ai.*" ["I have that strength; it is the only strength I have!"][46]

Thus there existed during the second half of the nineteenth century two competing forms of critical discourse that affected the gendering of Impressionism. On the one hand, the absence of conventional drawing and spatial organization in Impressionist landscape painting clearly served, in traditional terms, to feminize the movement for many of its contemporary detractors. But at the same time, during the second half of the nineteenth century, the science of physiological optics was discovering that there are in fact no forms or lines in nature. Science itself, in other words—that ultimate representative of masculinized reason and objectivity—appeared to be reversing the familiar stereotype and revising the terms of the traditionally gendered relationship between line and color, the basic elements of artistic representation and style. As the supporters of Impressionism were quick to realize, the discoveries of contemporary science in this realm could be used to sanction Impressionism's unorthodox manner of imaging nature in terms that were accessible to the positivist mainstream of thought in France during the Third Republic but which did not do violence to the original intentions of these still-Romantic painters of nature. If the patchy and sketchy technique of the Impressionist painter could now be justified in scientific terms as true to human vision in general and at the same time as the product of a physiologically unique eye, this was an art that could now suddenly be seen both as universally objective as well as subjectively expressive.

But the objectivity with which Impressionism might now be credited could at the same time be equated with passivity in relation to nature. It was essentially for this, as we shall see, that the Symbolists criticized Impressionism. For in their efforts to supplant Impressionism in the avant-garde at the end of the nineteenth century, it was the Symbolists, I shall argue, who reintroduced and reinforced the rhetoric of mastery as the key to a newly regendered relationship between art and nature.

Impressionism and Symbolism

"Monet is only an eye; but good God what an eye!"[47] This often repeated description of Monet attributed to Cézanne by later biographers cannot, we now know, be taken uncritically as a reflection of Cézanne's independent concerns and opinions. For like other equally famous and misleading sayings (such as the injunction to "redo Poussin after nature") that have entered the literature either from Cézanne's letters written in response to his young admirers or from the latter's often unreliable recollections of conversations with the Master of Aix in the years just prior to his death in 1906, such statements are often far less a reflection of Cézanne's own views and interests than those of his interlocutors.[48] These disciples included painters and writers such as Emile Bernard, Maurice Denis, and Joachim Gasquet, younger men who were politically conservative and who had been imbued in the 1890s both with the rhetoric of Symbolism and with a resurgent taste for neoclassicism and neo-Catholicism. In their contacts with Cézanne, they were often intent upon "redoing" him after their own aesthetic program, a program based on the rejection of nature and, not coincidentally, the denigration of Impressionism. But what is in fact remarkable and striking from a reading of Cézanne's letters is not the extent to which his admirers succeeded in winning Cézanne over to their own views but the extent to which he resisted and countered the program they placed before him—by asserting over and over again his attachment to and dependence upon nature. Writing to Emile Bernard, for example, he explained one of the reasons why he valued their correspondence:

> I am able to describe to you again, rather too much I am afraid, the obstinacy with which I pursue the realization of that part of nature, which, coming into our line of vision, gives the picture. Now the theme to develop is that—whatever our temperament or power in the presence of nature may be—we must render the image of what we see, forgetting everything that existed before us. Which, I believe, must permit the artist to give his entire personality whether great or small.[49]

When Cézanne called Monet "only an eye," we may safely conjecture that he was not expressing an independent opinion but was responding to the opinion of others. In the first part of his statement—"Monet is only an eye"—he seems to have been repeating a typical, Symbolist-inspired assessment of Monet, while in the second—"but good God what an eye"—he was answering and qualifying that assessment, reversing the terms of the argument and turning the Symbolist criticism of Monet into what, in Impressionist terms and according to Impressionist values, can only be seen as a homage. Although the Symbolists may have attempted to absorb Cézanne into their own discourse, their rejection of Impressionism was not his.

According to Richard Shiff, however, "symbolism and impressionism, as understood around 1890, were not antithetical."[50] Shiff has in fact charted and analyzed in great depth the very real and significant affinities and continuities in

theory and expressive goals that existed between the Impressionists and the Symbolists. And he has also described the latter's often contradictory pronouncements on Impressionism, which were occasionally appreciative (especially in regard to the late work of Monet and Cézanne, which was already being reinterpreted by the Symbolists to reflect, in part, their own values), but were more often derogatory, made in an apparent effort to dissociate and distinguish themselves from the baser, "naturalist" practices of their predecessors. While my intention is not to replicate these arguments, I will nevertheless address some of them here in order to frame my objections to this conflation of Impressionism and Symbolism and to support my own very different conclusions about these movements' relationship and its significance for modernist practice.

While there were important areas of overlap and even confusion of identity between the two movements in the 1890s, the Symbolists cannot be regarded—and indeed did not regard themselves—as simply extending the Impressionist enterprise. The differences involved were not merely critical fabrications but were derived from and spoke directly to the gender-based hierarchizing of art and science that had long existed in the positivist milieu of nineteenth-century France. To help unravel these differences and measure their meaning, I propose here to examine the literature of Symbolist art criticism and theory as a gendered discourse, and to ask, on the model of Foucault, what were the power relationships that prompted this discourse and how was the discourse then used to support or to alter those power relationships?

It was the Symbolist critics in the 1890s who first began to redefine Impressionism for posterity. They developed and helped to propagate some of the mythic ideas about Impressionism that have remained with us throughout the twentieth century, the most influential of which have been the image of the Impressionist painter as a passive recorder of optical sensations and the notion of Impressionism's objectivity and affinity with science.

Although the theory of Symbolist painting was not the invention of one person, it can be argued that it was set down and articulated most fully in the writings of the Symbolist poet, novelist, and art critic Albert Aurier (1865–1892), whose pronouncements and attitudes were pivotal to the development of the movement's identity. An early supporter of Van Gogh and Gauguin's, Aurier published influential essays on these painters in 1890 and 1891, respectively, essays in which he developed a basic theory and definition of Symbolism in painting. Shiff sums up that theory:

> This was the essence of "symbolism in painting": to direct pictorial means toward the expression of "Ideas" rather than the representation of objects. Aurier wrote in his essay on Gauguin that the artist's technical devices, through simplification and reduction to elements of line and color, should become "signs . . . the letters of an immense alphabet with which the man of genius alone can spell." The critic's sense of the "Idea" was Neoplatonic and mystical—an essence, a universal and eternal truth that might be known through the contemplation of its sign or symbol.[51]

An Impressionist, according to Aurier, was an artist who sought to render "an exclusively sensory impression," generated from without, while the Symbolist sought to give form to internalized ideas, to emotions generated from within,

and in so doing to reveal the essence of objects. In defense of Gauguin, Aurier further argued that the greatest art is inspired by an artist's inner mystical vision and not by a transient and external material reality.[52]

The driving forces behind Aurier's Symbolist aesthetic, it may in fact be argued, were his deep contempt for external material reality—i.e., for nature—and his equally vehement aversion to positivist science and its promotion of a materialist mentality. Aurier saw science as the enemy and the rival of art, responsible for its impoverishment in the modern world. "The limits of art," he wrote, "shrink back as science widens its domain."[53] But the twentieth century, he predicted, would be "the century of Art, of joy, of truth, following upon the century of Science, of despair, of falsehood."[54] Despite his rejection of science and the scientific method, Aurier had nevertheless absorbed many of its habits of thought, particularly its propensity for categorization and dualistic opposition and struggle. In her study of Aurier (written as an appreciation of his contributions to modernist art theory and not as a feminist critique), Patricia Mathews points this out and notes: "Aurier uses analogies of battle and combat to describe the reaction of the new artists against the old: 'In vain, exclusively materialistic art. . . struggles against the attacks of a new art.' He sees the history of art in terms of the rivalry of naturalism and idealism as well."[55]

Aurier's contempt for "detestable nature" as he termed it,[56] his hierarchic subordination in the Neoplatonic tradition of matter to spirit, his aversion to sensuality in both life and art,[57] and his deeply misogynist and typically fin-de-siècle distaste for what he called "the bestiality and dirty tricks" of women[58] all helped to generate and shape his influential conception of a Symbolist art of painting.

Aurier's attitudes toward nature and science in particular have a direct bearing on an issue that was to become recurrent and consuming for art critics during the 1890s: the issue of whether an artist is to be seen as one who controls and acts upon nature (the Symbolist) or as one who is instead acted upon by nature—a passive observer and recorder of the sensations that are generated by an external natural world (the Impressionist). In the broader arena of nineteenth-century French culture, the very concepts of art and nature were gendered, and their various manners of interrelationship were understood in gendered terms. The art of the Impressionist landscape painters was regarded as a feminized art, because it was thought that the Impressionists were merely receptive to nature, that they attended passively to their immediate physical and emotional experiences before "her."

In the 1890s the Symbolists virilized art by reimposing a masculinist mode of possessing female nature upon the theory and criticism of avant-garde painting. A classic statement of this gendered attitude, as it came to be used to distinguish the Symbolists from the Impressionists, is provided by the critic Octave Mirbeau. Writing about Van Gogh in 1891, Mirbeau said of this artist:

> [He] did not allow himself to become absorbed into nature. He had absorbed nature into himself; he had forced her to bend to his will, to be molded to the forms of his thought, to follow him in his flights of imagination, to submit even to those distortions [*déformations*] that specifically characterized him. Van Gogh had, to a rare degree, what distinguishes one man from another: style. . . that is, the affirmation of the personality.[59]

In the 1890s much emphasis was placed upon an artist's personal style and handwriting—"what distinguishes one man from another" according to Mirbeau. In order to affirm his personality, the artist has "to bend [nature] to his will." The Impressionists, on the other hand, were increasingly perceived in the 1890s as artists who had allowed themselves "to become absorbed into nature," who did not impose their will upon her, and who thus did not express their individual personalities through a readily identifiable and accentuated style. So quickly did this attitude take hold and affect critical judgment and vision in relation to Impressionist painting that by 1908 even a presumably sensitive observer such as Henri Matisse could write of the Impressionists (in a pronouncement that can only cause amazement today): "The Impressionist painters, Monet, Sisley especially, had delicate, vibrating sensations; as a result their canvases are all alike. The word 'impressionism' perfectly characterizes their intentions, for they register fleeting impressions."[60]

It was Roger Fry who organized the first group exhibition of works by artists whom he called the "Post-Impressionists" and whose lineage he traced back to Manet (that is, to the "masculine" side of Impressionism). In the introductory essay to the catalog of that show, which opened at the Grafton Galleries in London in November 1910, Fry and Desmond MacCarthy codified the notion of opposition and conflict between Impressionists and those who followed them, as that notion had been promulgated by the Symbolists. "The Post-Impressionists," Fry and MacCarthy declared, "consider the Impressionists too naturalistic."[61] And for these writers as well the issue of whether an artist's stance before nature is an active or a passive one was key:

> The impressionists were artists and their imitations of appearances were modified, consciously or unconsciously, in the direction of unity and harmony; being artists they were forced to select and arrange. But the receptive, passive attitude towards the appearances of things often hindered them from rendering their real significance.[62]

Shiff cites and acknowledges the relatedness of the statements by Mirbeau and by Fry and MacCarthy. But he dismisses the importance of the distinction they make. "It is too insecure a footing," he says, "on which to stand very long."[63] According to Shiff, the central questions for the Symbolists—given the concern they shared with the Impressionists for expressing their own subjectivity—were these: "Under what circumstances will the expression of a particular temperament result in an art of universal import? When does the subjective truth of the individual's impression or sensation become an objective truth known to all?"[64] Shiff considers the technique of Impressionism to be objective because it was designed to appear naive and to communicate; if such communication with the viewer occurs, he reasons, then the Impressionist is painting a universal rather than a personal truth, a truth recognizable to all others. Hence, what is for Shiff an essential distinction between Impressionism and Symbolism collapses.[65]

In his desire to demonstrate continuity between Impressionism and Symbolism, Shiff (who is more interested in constructing theories of artistic expression than in the historical reconstruction of artistic intention) sets out to prove, through the manipulation of theory, that the art of the Impressionists, like that of the Symbolists, is not merely "the expression of a particular temperament"

but "an art of universal import." And in so doing, he falls into the masculinist discourse of Symbolism itself. An example of this is his analysis (and I believe distortion) of comments made by Monet's friend Gustave Geffroy for an exhibition of the artist's Grain Stack series in 1891. Geffroy noted, Shiff reports, "that, like an impressionist, Monet 'gives the sensation of the ephemeral instant' and is the 'anxious observer of minutes.' He is a 'subtle and strong painter,' Geffroy concluded, 'instinctive and delicately expressive—and he is a great pantheistic poet.'" Shiff then presents the following interpretation of Geffroy's remarks:

> In other words, this painter *reveals* the spirit or emotion of the totality of nature; he *captures* universal, permanent truths, as well as particularized, transient ones.[66] [emphases mine]

Shiff is right in wanting to discard as irrelevant the traditional and simplistic dichotomy that has been used to distinguish Impressionism from Symbolism—the distinction between an objective art that is tied to the world of appearances and a subjective art that expresses inner feeling. But he is incorrect in trying to deny essential difference between the two aesthetic points of view, difference that the Symbolists themselves insisted upon. Both groups of artists, as their contemporaries often recognized, incorporated aspects of the subjective and the objective into their practice. And as Shiff observes, the Symbolists were not averse to criticizing the Impressionists for being too objective on the one hand and too subjective on the other.[67] To separate themselves from the Impressionists, the Symbolists stressed the "objective" and "scientific" side of Impressionism, describing these artists as mere imitators of surface appearances. But they also criticized the Impressionists for an excessively personal subjectivity, one that resulted in an inability to generalize. These traits of mind and personality, of course, were regarded as gendered in nineteenth-century France. As we have seen, they were essential to that culture's construction of both femininity in general and its notion of what constituted a feminized form of art in particular. For Camille Mauclair, who described Impressionism in 1896 as a "feminine art," it was precisely this fatal inability to generalize that had in fact led to Impressionism's demise. "Having accomplished," he wrote, "by the sheer force of its instinctive genius, the undeniable progress of killing the old belief in academic beauty and replacing it with individual temperament [*caractère*], Impressionism has killed itself by failing to take into account that temperament must be susceptible to generalization, and through realism they have accomplished only the brilliant reporting of anecdote, only illustration."[68]

The Symbolists scorned the Impressionists for their submissive attitude toward nature. They wished to eliminate nature as the prime agent in the creative process and to reinstate the artist's mind as the active and generating source of the sensation that becomes the work of art. But while they and the generations that followed them might denigrate the passivity of being "only an eye," we must keep in mind today that from this passivity and responsiveness to nature sprang originality, according to the nineteenth-century Romantic view that had nurtured both Monet and Cézanne. This view was to be superseded in the twentieth century by a more traditional and conventionally gendered understanding of the avant-garde artist's relationship to nature, and this change was one that was set into motion by the Symbolists. We should not be misled by their concern for

subjective feeling and expression, concerns that they shared in common with the Impressionists. For the real issue at stake in defining the relationship and the differences between Symbolism and Impressionism is not the subjective/objective dichotomy that formerly structured critical debate on this subject. The underlying issue is that of control, or, to put it in terms of yet another of the gendered dualisms of patriarchal discourse, domination/submission—male art controlling female nature. When seen in these terms, Symbolism is not a continuation of Impressionist subjectivity, but rather a masculinization of it.

It is the consistent gendering of both the technique of Impressionism in general and of the landscape school in particular as female and feminine in the critical literature from the late 1880s on that announces the basis for Symbolism's assertion of a subjectivity that is conceptual rather than emotional, universalizing rather than personal. The feminine gendering of Impressionism by critics seems to occur most frequently, in fact, during the decades of Symbolism's rise and ascendancy among the French avant-garde, in the late 1880s and throughout the 1890s. Its survival into the early years of the twentieth century may be illustrated in the writings of such critics as Claude Roger-Marx, who asserted in 1907: "The term impressionist announces a manner of perception in noting what is beautiful which corresponds so well to the hyperaesthesia and sensitivity of women."[69] It was in this climate and within this context that the reimposition of a masculinist mode of possessing nature became a prime objective for Symbolist theorists and artists in the 1890s. And in these terms, I would argue, the critical and theoretical literature of Symbolism and Post-Impressionism should be seen in part as a backlash against the feminizing threat of a particular aspect of the Romantic tradition—an aspect of that tradition that had threatened to gain ascendancy in nineteenth-century French painting with the ever-increasing popularity of the landscape school.

While the Symbolists expressed scorn for science, they nevertheless shared fully in its masculinist assumptions about the world of nature. For this reason, Symbolism's attitude toward science is one that is best understood in terms of a competition rather than a rejection. Not incidentally, the language of Symbolist aesthetic theory and criticism is as gendered as the language of the sciences that Symbolism scorned. In particular, the terms with which the Symbolists were inclined to cast their agenda in regard to nature can often echo the gendered metaphors that attended, as we have seen, upon the "birth" of modern science in the seventeenth century. Like Bacon, who envisioned the scientific enterprise as "a chaste and lawful marriage between Mind and Nature,"[70] the Symbolist painters believed that "the impression of nature must be wedded to the esthetic sentiment which chooses, arranges, simplifies and synthesizes. The painter ought not to rest until he has given birth to the child of his imagination. . . begotten by the union of his mind with reality."[71]

With such statements, Symbolism privileged artistic conceptualization (gendered in the nineteenth century as masculine) over the sensory response to nature (gendered as feminine) and used this as a strategy to distance itself from the femininity associated with the Romantic and Impressionist landscape schools. But this strategy functioned simultaneously as a bid to surpass the masculinity of science itself, by asserting the priority of art over science in the realm of their shared preoccupation, the domination and transcendence over female nature. For by definition, the scientific method of observation and experimentation

remained dependent upon the base "matter" of "detestable nature," as Aurier termed it. The Symbolists, on the other hand, claimed to give form to ideas and feelings that were generated from within; and while not dependent for inspiration upon external reality, they nevertheless believed themselves capable of revealing and fixing its very essence. Thus, Symbolism regendered art as male in relation to female nature, rejecting Impressionism's feminized role, but also rejecting science and asserting its own superiority over a science that still depended for its raison d'être upon the material world.

In terms of the gender metaphor, then, Symbolism's scorn for science may be interpreted as an attempt to reverse the hierarchic positions that had been assigned by positivism to science and art in nineteenth-century France. The Symbolists' simultaneous rejection both of science and of Impressionism was based ostensibly on what the latter two shared—i.e., a dependence (albeit of a very different sort) upon nature. But at heart, this dual rejection grew out of Symbolism's desire to claim for itself what science possessed and what Impressionism most conspicuously lacked—a masculinized position of dominance over the natural world, one that might in turn endow the artist and art in general with a position of cultural superiority in relation to science.

The Republican Defense of Science and The Regendering of Impressionism

Symbolism's critique of science and of Impressionism must be situated in the context of a series of broader philosophical and political challenges that were being posed to the cultural hegemony of positivist science in France during the 1890s, challenges to which Symbolism contributed and from which it received essential support. During the first decades of the liberal and anticlerical Third Republic—a period when many of France's most influential political leaders had professional training in the sciences—reason and scientific determinism became enshrined as central values in French political and cultural life and were considered to be the keys to progress in the modern world. But even this period was not unmarked by conflict between traditional faith and the new cult of science. Catholic scientists in particular had long chafed against the positivist view of the incompatibility of science and traditional religious faith as well as the positivist assertion that science, the new religion, could solve all problems in the modern world, including those in the realm of morality.

In 1889 the publication of Paul Bourget's novel *Le Disciple* made apparent how deep the cleavage of opinion in France on these issues had become and opened the floodgates to a decade of heated debate over the social and ethical position of science in the modern world. Bourget's novel was read as an attack upon science and an indictment of its moral irresponsibility; its appearance signaled a major defection from the positivist fold by a writer who had formerly aligned himself

with the values of the naturalist school led by Zola, Flaubert, and de Maupassant. It was quickly answered by Ernest Renan's controversial treatise *The Future of Science* (*L'Avenir de la science: Pensées de 1848*). Originally written in 1848–1849 as a young man's response to the political events of that era, the book had been conceived, in Renan's words, as an expression of "the new faith which with me had replaced shattered Catholicism" and as an assertion of his belief "that science alone is capable of improving the unhappy lot of man here below."[72] Belatedly published in 1890 in the new climate created by recent attacks on the cult of science, Renan's book stood in the 1890s as a major philosophical defense of science against those who would question its moral authority and place limits upon its social and ethical influence.[73]

In a decade that saw an escalating debate over what detractors increasingly referred to as "the bankruptcy of science," the pro- and antiscience forces in France clearly divided themselves along political lines. For the liberal and anticlerical supporters of the Third Republic, politicians such as Marcellin Berthelot and Georges Clemenceau and writers such as Emile Zola and Anatole France, science was a positive creed, synonymous with progress, liberty, justice, and the very notion of the Republic itself. The challenge to positivist science and its pretensions, on the other hand, couched as a struggle between materialism and mysticism, reason and faith, was identified in the 1890s with the forces of neo-Catholicism and political conservatism in France. While the artists and writers of the Symbolist generation tended to align themselves with this conservative position, Monet and the supportive critics who were closest to him from the 1890s on—men such as Georges Clemenceau, Georges Lecomte, Octave Mirbeau, and Gustave Geffroy—were political liberals and freethinkers who rejected traditional forms of religious belief as well as the new art that sought to embody and reinstate them.[74] As Georges Lecomte wrote, for example, in condemnation of the Nabis and their art:

> Exterior objects, their proper meaning scorned, are only of concern as material representatives of the ideal archetype, as the finite manifestation of infinite Beauty, of God. They concern themselves with expressing faith by plastic means and, on behalf of religion, they sacrifice the essential plastic qualities.[75]

In place of such "reborn religiosities," as he called them, Lecomte advocated instead a modern art that would take its inspiration from "natural splendors with their infinite poetry, mysterious and not mystical."[76]

When Monet's Cathedral series was exhibited to the public in 1895, it immediately became central to this argument (colorplates 2 and 3). For in spite of the ostensible subject of these paintings, they were widely regarded, by friend and foe alike, as secular images, without traditional religious content or meaning.[77] The light that Monet painted at Rouen Cathedral, his liberal supporters contended, was not the divine light of an outmoded Catholic tradition—the light of day transformed by those "most sacred windows" of the Gothic Cathedral—but nature's light, experienced as a living reality and within the context of real life, on the building's façade. (Monet in fact had not even bothered to enter the cathedral until his work on the series was well underway.[78]) For these writers, Monet's paintings returned the cathedral to the world of nature and restored the

vital connection between humans and the natural world that the teachings of the Church had torn asunder. In a discussion of Monet's Cathedral series published in 1898, the historian and critic Léon Bazalgette (a friend of Geffroy's and an admirer of Clemenceau's), set the stage in precisely these terms: "The individual, whom Christian dogma had isolated from nature, felt more and more that between her and himself existed the most indestructible and the deepest attachment. . . . Nature, formerly proscribed as a receptacle of impurities, regains its place and its dignity."[79]

But even more to the point, Monet's restoration of the cathedral to the world of nature could also be construed as reducing and restoring the cathedral and traditional religion to the domain of science. For the investigation, control, and demystification of nature were considered the proper sphere of science, which had been proclaimed by earlier nineteenth-century positivism to be the new religion of the modern world. Bazalgette continued:

> Thought, which no longer accepts any dogma, any revelation, submits the world to its passionate investigation. Truth is born little by little of the free and impartial examination of man, who takes his place in the immense series of beings and of worlds. . . . It has been remarked that this conception presents a certain analogy with the doctrine known by the name of pantheism. It leads, it is true, to a new pantheism, infinitely broader than the old conception, wholly impregnated with reality and science. . . . The painter of the cathedrals has sprung from there.[80]

And from the perspective of this new secular pantheism, ruled by science, Bazalgette then proceeded to describe Monet's art in the all too familar and gendered language of science's mastery and dominion over the natural world. Of Monet's achievement in the Cathedral series, he wrote:

> He squarely faced reality, that of yesterday, of today and of all times: it is with the vision of modern man that he forced it to reveal its secrets. From his canvases life spills out, stripped of every symbol, of every kind of artifice or lie. It is there in front of us, trembling and naked; and how much its reality seems superior to the wan effigies that we have been called upon so many times to admire![81]

Even Clemenceau, despite his sensitivity to the singularity and the poetry of Monet's emotional responses to nature, had adduced the science of optics as the key to understanding what he referred to as Impressionism's "conquest of light."[82] In his influential essay *"Révolution de Cathédrales"* (from which Bazalgette had taken inspiration), written by Clemenceau in reponse to the exhibition of the Cathedral series in 1895, the statesman-turned-critic had celebrated Monet's visual acuity and sensitivity. He had spoken of "the disconcerting mystery of his retinal screen" and had written of "the eye of Monet" as a "precursor," which "precedes and guides us in the visual evolution that will render our perception of the universe more penetrating and more subtle."[83] He quoted liberally from Edmond Duranty's description (written some twenty years earlier) of Impressionist color as a parallel to the prismatic components of white light, and he concluded his discussion with Duranty's assertion that "the most learned

physicist would find no fault with their analyses of light."[84]

During the last, difficult decades of Monet's life, Georges Clemenceau was one of Monet's closest friends and most devoted admirers, lending moral support and encouragement to the aging artist as he struggled against impending blindness to complete the monumental Water Garden series that was to become Monet's gift to the French state.[85] For Clemenceau, Monet's art had a special meaning for Republican France, standing in a certain sense for the very soul of the nation—its traditional roots as well as its will to progress in a secularized modern world. The secular pantheism espoused in the 1890s by liberal Republicans such as Clemenceau was designed to counter a resurgent Catholicism's attacks upon the hegemony of positivist science by replacing mystical experience with the mysteries of nature—mysteries that science, according to the positivist creed, clearly had the power to fathom and control. For Clemenceau, Monet's art was the perfect embodiment of these essentially political aspirations, and Monet himself was the priest of a new secular religion, one which the anticlerical Third Republic could happily embrace.

I emphasize, however, that in this instance it was not necessarily the artist or the art that were political in their intentions—although the polemical uses to which both the artist and his art were put by others clearly were. Instead of interpreting Monet's choice of motifs for his later series paintings as a cynical and self-conscious effort to intervene in and to forge a public identity for himself around the political life of his country (as recent writers, such as Paul Hayes Tucker, are now inclined to do), I would stand instead by the spirit of Monet's own avowed, albeit relative, disinterest in such matters, an attitude expressed, for example, in a letter of 1889, in which he said: "I go less and less to Paris where the only thing people talk about is politics."[86] This is not to say, of course, that Monet was totally unaware of contemporary politics. His own liberal and Republican leanings are well known. But these were not the real basis for or the substance of his long friendship with Clemenceau. And in this regard we might take note of the extent to which Clemenceau himself, throughout his writings on Monet, took special care not to implicate the artist in the ideological speculations and theories that he was inclined to build upon Monet's work. (Such statements as "it goes without saying that Monet never entertained any theories about this matter" or "one did not speak to Monet of these matters" often recur.[87])

Nevertheless, the friendship between Monet and Clemenceau and the desire on the part of politically liberal critics in their circle to heroize the artist and his work in a context of progress and enlightenment were important factors in helping to codify for later historians the specious association of Impressionism with science. For just as Symbolism's rejection both of science and Impressionism has erroneously led later historians to assume a fundamental connection between the latter two, the defense and embrace of both science and Impressionism on the part of liberal Republicans in the 1890s has also worked to reinforce the mistaken notion of an intrinsic and indeed a causal link between science and Impressionism. Even Clemenceau himself, of course, had not meant to imply or to promote the idea of so literal a connection. Ironically, in *Claude Monet, Les Nymphéas*, the extended appreciation he published in 1928 as a memorial to Monet, who had died two years earlier, Clemenceau found himself struggling with what was already becoming an uncomfortable as well as a rooted and

intractable myth about Monet and the Impressionists, one for which he had inadvertently helped to prepare the soil.

In "The Critic Criticized," an entire chapter of his book, Clemenceau took issue with both the spirit and the substance of efforts made by the writer Louis Gillet in his book *Trois variations sur Claude Monet* (Paris, 1927) to link in too literal a way the effects of Impressionist painting with scientific and metaphysical issues. Stressing the uniqueness of Monet's eye and the range of his palette and exhorting the critic to look really closely at Monet's canvases, Clemenceau denied Gillet's contention that Monet achieved the delicate "pulverization" of light in his works through the operations of optical mixture, that is to say, by systematically dividing his colors and painting with juxtaposed strokes of the primaries. Monet, he asserted (and he did this over and over again throughout the book), had no theory: "He would not have understood that in the name of a *doctrine*, one might have proposed to him that he do something other than what he saw. . . . his secret is that of all the great painters. They do not have the same retina; that is what distinguishes them."[88]

Ever critical of the illusory, even if it purported to have a scientific basis, Clemenceau was disdainful of Gillet's claim for Monet that "never has a painter more resolutely denied matter" and of his assertion that Monet, in accordance with the discoveries of modern science, had attempted to reduce the visible world to a "dance of the atoms." Understandably reluctant to define and to limit his friend's artistic achievement in this way—as a simple parallel to or illustration of the perhaps transitory pronouncements of contemporary science—Clemenceau responded:

> I myself have gone beyond that. I see in this pulverization of things encountered by Monet at the end of his brush nothing beyond a happy transposition of cosmic realities, such as modern science has revealed to us. I do not pretend that Monet has reproduced the dances of the atoms. I say simply that he has made us take a great step toward the emotional representation of the world and of its elements by distributions of light corresponding to the vibratory waves that science has discovered. Is it not possible that our present atomic conception may change? Monet's genius would nonetheless have made us progress incomparably in our sensations of the world, which we must always take into account, whatever may be the future of our science.[89]

He treated more respectfully, but no less emphatically, the critic Camille Mauclair's observation that the Impressionists' treatment of light in their pictures "coincided with the great modern discoveries that have revealed to us the modes of luminous energy in action." While willing to admit coincidental parallels, Clemenceau nevertheless resisted and took this opportunity to defuse the notion, already gaining currency, of a linkage between Impressionism and scientific objectivity. He asserted: "Personally I can see in this only the remarkable parallelism of our emotional and mental evolutions occurring simultaneously."[90] And elsewhere in the book, apparently newly sensitized to the need to make adequate and fundamental distinctions between science and art in general and the scientist and the Impressionist in particular, Clemenceau wrote:

The Gendering of Impressionism

We have arrived today, however, at a state of knowledge in which science and art, profoundly differentiated, have for a common starting point an intensive cultivation of sensory reactions. The scientist orders his sensations of experience in order to derive from them the right to generalize. The artist contents himself with these harmonious emotions in order that he may be able to realize, up to the very limits of possibility, the penetrating acuteness of his sensibility.[91]

And, finally, in a statement of relative value that acknowledges the limitations of science in the face of the powers of art, a statement that reverses and belies the positivist assumptions that had supported his own long-held philosophical and political beliefs, Clemenceau wrote: "In art. . . it is always a matter of changing states of particular sensitivities, in reaction to our contact with the external world. And in this mental realm, the artist will overtake or even outstrip the scientist, in attempting to raise himself above a simple knowledge machine, to the peak of sensation."[92]

◆ ◆ ◆

The challenge to the authority of science in France that surfaced in the debates of the 1890s, though posing no practical threat to the ascendancy of science in a technological world, nevertheless continued unabated in French cultural circles through the 1930s and had an important impact on the tenor of philosophical, literary, and artistic discourse.[93] In this climate, one in which the values of art were distinguished from and pitted against those of science, Impressionism now came to be seen increasingly in an unfavorable light because of its presumed association with science. For despite Clemenceau's belated protestations, by the 1930s this idea had become firmly entrenched: the art of Monet was now widely understood by critics as an art of optical realism, devoid of human values, an art that had been historically aligned with and guided by the positivist spirit of the mid-nineteenth century. Thus it was that in 1932 Roger Fry said of Monet that he "cared only to reproduce on his canvas the actual visual sensation as far as that was possible," describing him as an artist who "aimed almost exclusively at a scientific documentation of appearances."[94] And in 1934 James Johnson Sweeney wrote critically of Monet's Impressionism and of the positivist milieu that had given rise to it that "the encouragement of a scientific, detached impassivity struck directly at any link with the emotions."[95] Critics of the 1930s who had inherited the idea of a connection between Impressionism and science may have been encouraged in their skewed evaluation of Impressionism by the dominant philosophy of science in their own day—the so-called "logical positivism" of Carnap and the Viennese Circle, which represented a further hardening of the mechanical and mathematical models of modern Baconian science and nineteenth-century positivism. Applying to Impressionism, then, a contemporary, 1930s idea of what "good science" should be, these critics would have found that notion to be incompatible with their own period's ideal of "good art," and as a result Impressionism would understandably have been found wanting.

That the historically specious association of Impressionism with the objectivity of science would have nevertheless persisted in such a hostile critical climate—and at a time, moreover, when Impressionism was already enjoying widespread popularity as the modern style of choice among the middle classes—

appears perplexing at first. But it becomes less so when one recognizes that this critical stance may well have been the lesser of two evils—the greater of the two being the accusations of passivity before nature and the resulting association with femininity that the rhetoric of Symbolism had helped to promote for Impressionism in the 1890s. It was this troubling association that the mythic connection between Impressionism and science became instrumental in dissipating, so that Impressionism might be appropriately regendered for a century that has come to place upon it both enormous monetary and cultural value.

The feminine gendering of the Impressionist style and attitude, though widespread in the criticism of the 1890s, did not in fact survive into the later twentieth century. It seems to have dropped out of the literature fairly early in the century, although it was still apparently being combated, even as late as 1928, by Clemenceau, whose text is filled with gratuitous and in all probability compensatory assertions about the "virility" of both Monet and his enterprise. Early on in Clemenceau's book there are many physical descriptions of Monet that stress his power and his manhood, his ability to impose his will (not on nature, significantly, but on the marshaling of his own powers), as well as many descriptions of the act of painting as a battle or a duel. Of Renoir's portrait of Monet at work in 1875, for example, Clemenceau wrote:

> . . . the working attitude is that of a youthful ease in which virility is already placing its accents of resolution. . . .The eyes which are flames of overflowing interrogation, fix themselves with an irresistible force of penetration upon the passages of light guarding their secrets. Here it is really a battle that is going on—the first wave of attack which nothing will be able to stop.[96]

This countering insistence upon the virility of Impressionism and the Impressionists may have become increasingly necessary in the first years of the twentieth century to support the style's early and astounding commercial success with entrepreneurial collectors both in France and elsewhere in the world, particularly in the United States.[97] In France itself, among the earliest collectors and supporters of Impressionism in the 1870s, 1880s, and 1890s were department-store magnates such as Ernest Hoschedé, industrialists such as Henri Rouart, textile manufacturers such as Jean Dollfus, and bankers such as Isaac de Camondo.[98] Innovators in business and industry, these men saw in the fluid, unstable, and wholly untraditional style of the Impressionists a vanguard art that reflected the modern spirit of entrepreneurial initiative and originality, an art that responded to and depicted the changing and dynamic modern world that they had been instrumental in shaping. Ironically, then—in another striking demonstration of the way in which distinctly different and even opposing interpretations of the same phenonomena can exist side by side within the same culture— the very elements of style and attitude that had made Impressionism a feminine art in the eyes of its earliest, culturally conservative detractors (its fluidity and instability) seem to have made it a masculine and virile art for this at first small but steadily growing group of independently minded patron-collectors— these captains of industry who valued Impressionism for its originality and modernity. Many of these men, interestingly enough, had collected the art of the Barbizon painters before they collected Impressionist paintings, seeing in both

the expression of unique temperament and sensibility—the expression, if you will, of Romantic individualism. And that single aspect of the Romantic ethos, pervasive throughout the modern era, has indeed continued to adhere to Impressionism and to color our responses to it to the present day.

Impressionism, then, gendered as female by its conservative critics and its Symbolist rivals in the 1890s, has been regendered and restored to masculinity in the twentieth century by virtue of its mythic connection with science, a connection that, in turn, has been supported by the ideological concerns and the outlook of capitalist collectors who identified with Impressionism and invested it with their own image. In spite of this, however, it should be noted that Impressionism has continued to be the subject of a precarious duality of gendering in the art criticism, art history, and the art markets of the late twentieth-century world.

As the much sought-after possession of the entrepreneurial classes, the monetary value of Impressionist paintings has steadily, indeed astronomically, increased throughout the second half of the twentieth century. It is in this role, as the visible sign of the wealth and power of its individual and corporate owners, that Impressionism—like all art in the technological twentieth century (as in the positivist nineteenth)—has functioned as the stereotypical female in the male entrepreneurial world. In this sense, its function as a commodity in the twentieth century has not differed radically from the traditional social role assigned to actual females, despite the shifting inroads that have been made by an active feminist movement during both the early and later decades of this century.

At the same time, however, in our commodified world, greater monetary and prestige value has been assigned consistently to art that is understood in some way to exemplify or to privilege the socially constructed attributes of masculinity—for example (to use the value-laden, descriptive terms of standard critical accounts), the scientifically based rigor of Renaissance art over the sensual playfulness and perversity of Mannerism; neoclassical virility and moral fervor over the feminine frivolity, superficiality, and amorality of the Rococo; or, in the twentieth century, conceptual abstraction versus what in the days before feminist enlightenment used to be called "mere" decoration.[99]

Thus it is not really surprising that the "feminine" side of Impressionism's relationship with nature has been buried or transformed over the course of the twentieth century. The anxiety that it has left behind, however, continues to resurface in the art historical and critical literature, where it takes the form of exaggerated efforts to establish and defend the masculinity of the movement. In this category, broadly speaking, I would place art history's current emphasis on the political and sociohistoric interpretation of Impressionist painting, most clearly exemplified by the influential work of T. J. Clark, whose analysis of the "bourgeois" art of the Impressionists emphasizes the contextual phenomena of popular culture and class identity in a Paris that had been transformed and "modernized" by the building campaigns of Baron Haussmann during the Second Empire.[100] Insofar as this approach seeks to objectify Impressionism and to place its meaning outside the artist, it preserves and reinforces the movement's "masculine" identity by continuing its alignment with stereotypically gendered notions about Realism in nineteenth-century French painting. Also in this category I would place recent scholarship's insistence upon searching for signs of urban and industrial elements—factory chimneys, railroad bridges and the

like—in even the most bucolic of Monet's landscapes. These issues and the social dynamic they are said to have supported as well as reflected have been foregrounded in Impressionist scholarship by writers such as Clark and Paul Hayes Tucker despite the fact that Monet himself clearly sought to ignore and evade these signs of urban encroachment, as he retreated first from Argenteuil to Vétheuil and then finally to his own protected garden at Giverny. Given the gender symbolism implicit in the urbanized landscape—the imposition of factories and railroads upon female nature by male technology—these preoccupations, too, might be seen as yet another instance of our own era's unceasing efforts to virilize the Impressionist movement.[101]

These efforts to masculinize Impressionism, of course, have also included continuing scholarly attempts to forge connections between the methods and attitudes of the Impressionists on the one hand and the way in which science was being practiced in their day on the other. We might cite, for example, Joel Isaacson's proposed analogy between Monet's working methods in the 1860s and the scientific method outlined by the physiologist Claude Bernard in his *Introduction à l'étude de la médecine expérimentale* of 1865. Still struggling, unselfconsciously, with the Symbolists' gendered characterization of Monet as "only an eye," Isaacson, in the 1980s, sets out to prove that Monet was, so to speak, a thinking eye, an artist whose stance in regard to nature was active, not passive. "He was a positivist," Isaacson writes, "in the sense of a commitment to science, data, experimental investigation. . . .His primary instrument was the eye, guided by a mind that reached out, probed, questioned, and tested what he saw." Isaacson cites the distinction made by Bernard and Comte before him in the nineteenth century between observation and experiment. The observer, wrote Bernard, "listens to nature and writes under its dictation," while "the mind of the experimenter must be active, which is to say, it must interrogate nature." In accordance with this distinction, one that we may now recognize as traditionally gendered in both the arts and the sciences, it was Monet's aim, according to Isaacson, "to take painting beyond observation, to claim for it, by his actions, a more deliberate experimental role in the continuing realist inquiry into the appearances and understanding of nature."[102] And in this same spirit of attempting to turn Monet into a cerebral and active investigator, the art historian Charles F. Stuckey has written that Monet was "fascinated by the premises of retinal physiology," further attributing to this alleged fascination with scientific precepts not only aspects of Monet's style but also his motifs—self-consciously selected, according to Stuckey, in order to "draw attention to the distinction between sensation and perception" and in response to the discoveries of Müller and Helmholtz.[103]

In the more popular critical literature, contemporary efforts to virilize Impressionism can take the form of far more direct assertions of the masculinity not only of the Impressionists but also, at times, of those who have devoted themselves to the study and interpretation of their nature-dependent art. In a review of the recent exhibition *Monet in the '90s: The Series Paintings*, for example, the novelist John Updike wrote of "the strenuous lessons in boldness Monet gave himself" and felt compelled to comment upon the exhibition's organizer, Paul Hayes Tucker, in surprisingly personal terms. Gendering the art historian cum scientist in this case as male and the work of art cum nature as female, Updike wrote: "Paul Tucker, a six-foot-six former all-New England tackle, now an art professor in Boston, used all his muscular powers of research and persuasion to

draw over ninety of the series paintings from their hiding places on four continents over the last four years."[104]

The persistent anxiety over the unstable gendering of Impressionism that underlies such scholarly projects and critical statements is clearly pertinent to our inquiry. For they simultaneously reveal and attempt to counter deeply ingrained cultural fears. And they draw, no doubt unconsciously, upon what we may now clearly recognize as an ancient and influential system of signification that has gendered a passive natural world as female and an active, experimental science as male—a hierarchical language that has been used extensively in the twentieth century to regender Impressionism.

CHAPTER 10

Impressionism and Modernism

In women are incarnated the disturbing mysteries of nature, and man escapes her hold when he frees himself from nature.
—Simone de Beauvoir, *The Second Sex*, 1949

This book began by asking why Impressionism, an art that was based on the subjectivity of vision and that emphasized the expression of feeling and emotion generated by contact with nature, came to be seen in the twentieth century as an art of optical realism devoid of human values. In order to answer the question, we recast it to ask why Impressionism, an art gendered as female both by its conservative critics and its avant-garde competitors at the turn of the century, was effectively regendered in the art history and criticism of the twentieth century and endowed with the stereotypical attributes of masculinity? In these terms, we have already suggested the usefulness of Impressionism as a symbol for the French Republic and its not unrelated value as a symbol of entrepreneurial power and creative individualism for wealthy patrons and corporate collectors. The gradual cooption of Impressionist painting for these social and political purposes, already begun in the late nineteenth century, only intensified and escalated throughout the twentieth century, as Impressionism, on a worldwide basis, came to be one of the most beloved and highly valued art styles of the modern era. Its usefulness, moreover, as a pedigree for modernist abstraction has led, ironically, to its close and, as I will now argue, erroneous association with that modernist tradition, a tradition that has aggressively gendered itself as male.

The narrative of mainstream modernism has been described by the art historian Carol Duncan as a progression in which art "gradually emancipates itself from the imperative to represent convincingly or coherently a natural, presumably objective world." Duncan has pointed to the prevalence of images of

women at all the critical junctures in this modernist drive toward a transcendent abstraction—in particular, images of threatening, repellent, or physically dismembered women such as those in Picasso's *Demoiselles d'Avignon* or in De Kooning's Woman series. The centrality of these images as modernist icons, she says, has been confirmed not only by their treatment in our written histories but also by their prominent installation at The Museum of Modern Art in New York City: Picasso's *Demoiselles*, for example, dominates the first Cubist gallery, and De Koonings's *Woman I* has been positioned strategically at the threshold to the Abstract Expressionist collections. Pointing to the gendered basis of the modernist enterprise, Duncan asks: "What, if anything, do nudes and whores have to do with modern art's heroic renunciation of representation?" And in answer she suggests that for male artists and historians, these paintings have functioned as important symbols of a struggle that has defined modern art's most prestigious undertaking: the struggle to achieve transcendence over a material nature, long gendered as female and regarded as both threatening and inferior, in order to reach the so-called higher realms of abstraction.[105]

It was the formalist critic Clement Greenberg, writing in the 1950s, who first appropriated the late art of Monet to serve as a radical precursor to modernism in general and to Abstract Expressionism in particular. Long discredited among the avant-garde supporters of Cubism and Surrealism, Monet's late works, with their suppression of value contrast and illusionism and their resulting emphasis on surface and foreground, were validated and "made possible" once again in the eyes and in the words of Greenberg by the emergence of the work of Clyfford Still and Barnett Newman, both of whom admired Monet.[106] Although Greenberg assumed along with his contemporaries that Monet's aim was to record visual experience impassively and that his motives were "quasi-scientific," the critic nevertheless dismissed Monet's own intentions vis-à-vis nature—whatever they might have been—as irrelevant and instead used abstraction and what he took to be Monet's inadvertent rejection of nature as the criteria according to which the artist's modernity and his historical importance for the twentieth century might be defined. On the relation of Monet's art to nature and science, Greenberg wrote:

> The quasi-scientific aim he set himself in the 1890s—to record the effects of light on the same subject at different times of day and in different weather—may have involved a misconception of the purposes of art; but it was also, and more fundamentally, part of an effort to find a new principle of consistency for art. . . a more comprehensive principle; and it lay not in Nature, as he thought, but in the essence of art itself, in art's "abstractness." That he himself could not recognize this makes no difference.[107]

While Monet's efforts to capture the effects of Mediterranean light with "incandescent" colors may have resulted in pictures that "conveyed the truth of subtropical air and sun as never before. . . the result as *art*," Greenberg maintained, "was cloying. . . . Monet's example," he declared, "shows as well as any how abysmally untrustworthy a mistress Nature can be for the artist who would make her his only one."[108] Yet according to Greenberg, Monet's art was unexpectedly and fortuitously saved from subservience to this "untrustworthy mistress." He explained:

The literalness with which Monet registered his "sensations" could become an hallucinated literalness and land him on the the far side of expected reality, in a region where visual fact turned into phantasmagoria that became all the more phantasmagorical because it was without a shred of fantasy. . . .Nature, prodded by an eye obsessed with the most naive kind of exactness, responded in the end with textures of color that could be managed on canvas only by invoking the autonomous laws of the medium—which is to say Nature became the springboard for an almost abstract art.[109]

Interpreting the narrowed range of value contrasts to be found in Monet's late work not as an expressive choice but as a way of "returning painting to the surface," Greenberg then made the influential pronouncement: "The first seed of modernism, planted by the Impressionists, has turned out to be the most radical of all."[110]

Is Impressionism the foundation for modernism in painting—as has so often been claimed in the wake of Greenbergian formalism in the second half of the twentieth century? I would argue that it is not, and I would offer the artist's attitude toward nature and the gendered dichotomies that attitude has traditionally been called upon to reflect and reinforce as the key to the assignment of the "modernist" designation. These are criteria that we can use as well to question and refine broader philosophical definitions of modernism, which have placed and privileged not Impressionism per se but Romanticism as its source. In the view of twentieth-century cultural historians and philosophers—from Arthur O. Lovejoy to Morse Peckham to Michel Foucault—the modernist twentieth century, with its emphasis on personal expression and originality, can itself be regarded as part of the Romantic era, an era that banished the normative values and universalizing attitudes of the "classical episteme" (Foucault's term) that had preceded it.[111]

But even though Romanticism has unquestionably been a major influence on art throughout the nineteenth and twentieth centuries, Romanticism itself, as we have seen, was not monolithic. On the basis of art's gendered attitude toward nature, we have isolated and defined a minority current within Romantic painting, one that surfaced primarily among the landscape painters as opposed to the figurative painters of heroic narrative (e.g., Rousseau versus Delacroix). Both valued originality, but each had a very different understanding of what it was and how it was to be achieved. Among the landscape painters, truth to a living nature—in subjective terms, according to the unique character of each artist's eye and sensibility—was viewed as the prerequisite for personal expression and personal style. The other and ultimately dominant current saw originality residing in transcendence over a mindless and inferior natural world.

Once this crucial—and gendered—distinction among "Romanticisms" is made, the complexity of the interrelationships among artists and movements in late nineteenth-century France can be more easily appreciated and the flaws in art history's traditional and simplistic patterning of these phenomena more readily perceived. In a letter to his brother Theo, for example, Vincent van Gogh wrote from Arles in 1888:

I should not be surprised if the Impressionists soon find fault with my way of thinking, for it has been fertilized by Delacroix's ideas rather than by theirs. Because instead of trying to reproduce exactly what I have before my eyes, I use color more arbitrarily, in order to express myself forcibly.[112]

Such a statement, of course, can and has been interpreted according to the dictates of a binary historiography to support the notion that Impressionism and Romanticism were antithetical to one another and that the Post-Impressionists, in turn, rejected the superficial visual realism of the Impressionists to return to the expressive goals of Romanticism as embodied in the work of Delacroix. A recognition of different attitudes toward nature within the Romantic tradition itself, however, both complicates and clarifies the issues. Van Gogh's dilemma and choice (one that was conflicted and not easily resolved) was in reality a choice between different currents within Romanticism. In his desire to be an arbitrary and expressive colorist, an artist who could capture nature and paint portraits that would be imbued with "the thoughts, the soul of the model,"[113] he was being inspired by the Delacroix who had regarded nature as "but a dictionary" and who had felt free to confer upon nature "a totally new physiognomy"—and not by the very different side of Romanticism that the landscape school represented and that the Impressionist landscape painters perpetuated.

The lesson learned and taught by the Romantic and Impressionist landscape painters of the nineteenth century—the lesson that nature cannot be dominated or possessed—led in the twentieth century to a rejection of nature that was presaged and prepared for by the Symbolists and their drive to transcend the physical, material world—the world of female nature. If the artist could not actively possess nature, then he could reject her. But on no account could he acknowledge—as, in the view of their critics, the "passive" landscape painters of Romanticism and Impressionism came perilously close to doing—her hegemony as the source of human sensation and art.

Symbolism might thus be viewed as the nineteenth century's final effort to reimpose intellectual control on nature and to "reveal her secrets" in the old, traditional terms of the gendered dialogue that has conventionally supported art's efforts to rival the active and masculinized enterprise of the sciences. In this sense, a major turning point in the history of art does indeed occur in the early twentieth century in the "primitivism" of Picasso and the Expressionists, where nature (often embodied as woman) is presented as a threatening, ferocious, and untamable force: a fitting prelude to twentieth-century art's decisive turn in the direction of abstraction and non-objectivity—i.e., modernism's rejection of a female nature that could not otherwise be dominated and controlled.[114]

In a 1949 essay entitled "On the Role of Nature in Modernist Painting," Clement Greenberg set forth a theoretical argument for this transition from the older Albertian position that the artist can rival and transcend nature by discovering and taking possession of her secrets to the modernist rejection of nature—art's withdrawal from the traditional arena of struggle with female nature and its safe removal to another and "higher" plane. But even here, embedded in the rhetoric of high modernism, the idea of possessing nature and of going her one better still persists, albeit as a submerged undercurrent in a formalist theory that pretends to have set for itself a very different agenda. Greenberg wrote:

When Braque and Picasso stopped trying to imitate the normal appearance of a wineglass, and tried instead to approximate, by *analogy*, the way nature opposed verticals in general to horizontals in general—at that point, art caught up with a new conception and feeling of reality that was already emerging in general sensibility as well as in science.

This "new conception and feeling of reality" is defined by Greenberg as a new conception of space, "an uninterruped continuum that connects instead of separating things," providing an experience that is "far more intelligible to sight than to touch." By implication, sight is something that Greenberg associates with the conceptual (and masculine) undertakings of the artist and the scientist, while touch belongs traditionally to the material world of female nature—"detestable nature," to borrow the language of the symbolist critic Aurier. And indeed Greenberg's attitude is one that has much in common with that of the Symbolists, for he continued: "We no longer peer through the object-surface into what is not itself; now the unity and integrity of the visual continuum, as a continuum, supplants tactile nature as the model of the unity and integrity of pictorial space." This proves, according to Greenberg, that abstract art is still "naturalistic," for now, instead of merely imitating visual experience, "the picture plane as a total object represents space as a total object." Thus, he concluded, "Art and nature confirm one another as before." We cannot help but notice, however, that the nature of which Greenberg speaks must still depend for its definition upon science, and it is a nature whose secrets are still to be stolen and revealed by art—an art, which, as in the Renaissance, still seeks to rival and supplant "her."[115]

At issue today in the philosophical identification of modernism with Romanticism is the changing status of subjectivity, which in turn, as poststructuralist analysis has taught us to recognize, is an issue of power. In the Romantic/modernist tradition, subjectivity has been a privileged attribute of art only when it has taken a masculinized form. From the figurative painters of the Romantic movement in the nineteenth century to the Abstract Expressionists of the twentieth century, male artists have appropriated and absorbed into their own domain the traits of feeling and sensibility, conventionally gendered as female, which they have regendered by linking their own identities as artists to an intensified assertion of art's "active" and masculinized dominance over female nature. In view of what constitutes originality in these terms (i.e., in terms of the artist's relationship to nature), Romantic and Impressionist landscape painting presented, as we have seen, an aberrant discourse, one that set out to challenge establishment values in the nineteenth century but that ended in the twentieth century by being absorbed and pressed into the service of those very same hierarchic and gender-laden values.

While the particular phenomena to which patriarchal culture attaches masculine and feminine labels may change over time, what remains constant is the privileging of whatever happens at the moment to hold the masculine—usually the "objective"—position. Romanticism and modernism problematized this traditional arrangement by regendering subjectivity, predictably privileging masculine subjectivity over feminine subjectivity, but nonetheless conferring new validity upon subjectivity as a cultural position. While we owe to postmodern

and poststructuralist analysis the exposure of this mechanism, it is one that, ironically, may hold a key to the feminist deconstruction of postmodernism itself. For in its relation to modernism (as in Symbolism's relation to Impressionism), postmodernism has played the same old game of attempting to discredit what came before it by feminizing it. While modernism associated itself with the gendered subjectivity of a masculinized Romanticism in positive terms, postmodernism has equated modernism with Romanticism in an entirely pejorative sense. By elevating indeterminancy and interpretive multiplicity, by demonstrating the impossibility of an autonomous subjectivity, and by thus declaring that in older Romantic terms the author is dead, postmodernism has set itself to dismantling the subjectivity of modernism, thus assuming for itself a position of superior objectivity. While it purports to expose and discredit polarizing dichotomies, then, postmodernism exploits and relies on them in order to position (and privilege) itself in relation to the modernist "other," to which it has thus assigned the female role in patriarchal culture's ongoing and still powerful system of binary and gendered oppositions.

◆ ◆ ◆

The struggle of nineteenth-century artists to define their position and the position of art in general in relation to nature and to science was complex. Over the course of the twentieth century, the history and dimensions of that struggle have been flattened by an essentially masculinist criticism that has sought to assimilate Impressionism into our culture's dominant view of a natural world, gendered as female, conquered and dominated not only by a male science and technology but also by art. Seeking to legitimize not only Impressionism but art itself, which had been cast in the nineteenth century as the stereotypical female in a male scientific world, art historians have missed or misread the tensions that were inherent in the dialogue between art and "normal" science in the nineteenth century and have mistakenly and misleadingly described the Impressionists as artists who self-consciously adopted the teachings and methods of modern science and who attempted to be "objective" in relation to a passive and mechanistic natural world.

There is a fundamental irony, of course, in our century's alignment of Impressionism with a Baconian/Cartesian conception of the goals and procedures of an objective science. For unlike the positivist heirs to this science in the nineteenth century who saw themselves in archetypally dualistic terms as separate from nature, in a subject/object relationship that aimed for mastery and domination over a passive natural world whose "secrets" had to be "unveiled" and controlled, the Impressionists (like the Romantic landscape painters who preceded them) were artists who saw themselves as a receptive and responsive part of the natural world, thus assuming an attitude toward nature that was at once more humble and more assertively individualistic.

It was from this "passive" attitude toward nature, as their contemporaries deemed it, that the widespread characterization in the 1890s of Impressionist landscape painting as a "feminine" art was derived. As Impressionism's acceptance and value have grown over the last one hundred years, that characterization, in turn, has given rise to art historical and critical efforts to bestow legitimacy upon Impressionism in more conventionally acceptable and prestigious terms—to regender it, in other words by endowing it with the culturally defined

attributes of masculinity, and these efforts have distorted our understanding of both the artists and their art. From the late nineteenth century on a variety of competing interests and modes of interpretation have in fact been brought to bear upon the the reception and interpretation of Impressionism. But the one consistent point of reference, as we have seen, has been the perception and evaluation of the movement in terms of the socially constructed attributes of gender.

NOTES

INTRODUCTION

1. Roger Fry, *Characteristics of French Art* (London: Chatto and Windus, 1932), p. 127.

2. Kermit S. Champa, *Studies in Early Impressionism* (New Haven: Yale University Press, 1973), pp. xiv and xvii.

3. Meyer Schapiro, "The Nature of Abstract Art," *Marxist Quarterly* vol. I, no. 1 (January–March 1937), p. 83. Reprinted in Meyer Schapiro, *Modern Art, Nineteenth and Twentieth Centuries: Selected Papers* (New York: George Braziller, 1978), pp. 185–211; this quote, p. 192.

4. See especially, Timothy J. Clark, *The Painting of Modern Life, Paris in the Art of Manet and His Followers* (New York: Alfred A. Knopf, 1985); Robert Herbert, *Impressionism: Art, Leisure, and Parisian Society* (New Haven: Yale University Press, 1988); Paul Hayes Tucker, *Monet at Argenteuil* (New Haven: Yale University Press, 1982); and Tucker, *Monet in the '90s: The Series Paintings* (New Haven: Yale University Press, 1990); also the essays by Richard Brettell, Scott Schaefer, Sylvie Gache-Patin, and Françoise Heilbrun in *A Day in the Country: Impressionism and the French Landscape* (Los Angeles: Los Angeles County Museum of Art, 1984).

5. Schaefer, "The French Landscape Sensibility," in *A Day in the Country*, pp. 57–58.

6. Walter J. Friedlaender, *David to Delacroix*, trans. Robert Goldwater (Cambridge: Harvard University Press, 1952; first German edn., 1930), pp. 1–11.

7. Carol Duncan has discussed the importance of the Romantic impulse for later nineteenth-century art in terms of the influence of the Romantic traditions of "fantasy painting" and "*la vie moderne*" on the figure paintings of artists like Manet, Degas, Renoir, and Morisot. On this and on the relationship between Rococo and Romantic art, see Carol Duncan, *The Pursuit of Pleasure: The Rococo Revival in French Romantic Art* (New York: Garland Publishing, 1976), especially pp. 109–115.

8. James Johnson Sweeney, *Plastic Redirections in Twentieth-Century Painting* (Chicago, 1934), p. 6; cited by George Heard Hamilton, *Claude Monet's Paintings of Rouen Cathedral*, Charlton Lectures on Art (Newcastle upon Tyne, England: University of Newcastle upon Tyne, 1959), pp. 6–7.

9. Clement Greenberg, "The Later Monet," *Art News*, November 1956. Reprinted in Greenberg, *Art and Culture* (Boston: Beacon Press, 1961), pp. 42 and 44.

10. Hamilton, *Claude Monet's Paintings of Rouen Cathedral*, p. 4.

11. Ibid., p. 18.

12. Ibid., p. 15.

13. Ibid., p. 26.

14. Ibid., p. 14.

15. Ibid., p. 14. In later publications, Hamilton continued to define Impressionism in these terms: see his *19th and 20th Century Art* (New York: Harry N. Abrams, 1970), p. 100.

16. See Joel Isaacson, *Claude Monet: Observation and Reflection* (Oxford: Phaidon Press, 1978); also, Isaacson, *The Crisis of Impressionism 1878–1882* (Ann Arbor: University of Michigan Museum of Art, 1980).

17. Richard Shiff, "The End of Impressionism: A Study in Theories of Artistic Expression," *The Art Quarterly* vol. I, no. 4 (Autumn 1978), pp. 338–378.

18. Shiff, "The End of Impressionism," in *The New Painting: Impressionism 1874–1886* (San Francisco: The Fine Arts Museums of San Francisco, 1986), p. 87, n. 2.

19. See in particular John House, *Claude Monet: His Aims and Methods c.1877–1895*, doctoral dissertation, Courtauld Institute, London, 1976; Grace Seiberling, *Monet's Series*, doctoral dissertation, Yale University, 1976 (New York: Garland Publishers, 1981); Isaacson, *Claude Monet*; Robert Herbert, "Method and Meaning in Monet," *Art in America* vol. 67, no. 5 (September 1979), pp. 90–98; and John House, *Monet: Nature into Art* (New Haven: Yale University Press, 1986).

20. Friedlaender, *David to Delacroix*, pp. 1–11.

21. Charles Blanc, *Grammaire des arts du dessin* (Paris, 1867), p. 22. See also, John Gage, "Color in Western Art: An Issue?" *The Art Bulletin* vol. 72, no. 4 (December 1990), pp. 518–541.

22. See in particular, Michel Foucault, "What Is an Author?"(1969), in *Foucault's Language, Counter-Memory, Practice: Selected Essays and Interviews*, ed. and trans. Donald F. Bouchard (Ithaca: Cornell University Press, 1977); and Roland Barthes, *S/Z* (New York: Hill and Wang, 1974).

23. Diego Martelli, "Gli Impressionisti" (lecture of 1879; first published in Pisa 1880), in *Scritti d'arte di Diego Martelli*, ed. Antonio Boschetto (Florence: Sansoni, 1952), p. 106. On the names applied to and preferred by the "Impressionists," see Stephen F. Eisenman, "The Intransigent Artist or How the Impressionists Got Their Name," in *The New Painting: Impressionism 1874–1886*, pp. 51–59.

24. Thomas Kuhn, *The Structure of Scientific Revolutions* (Chicago: University of Chicago Press, 1962).

25. See Linda Nochlin, "Courbet's Real Allegory: Rereading The Painter's Studio," in *Courbet Reconsidered* (Brooklyn, N.Y.: The Brooklyn Museum, 1988), pp. 17–41; Michael Fried, "Courbet's 'Femininity,'" in *Courbet Reconsidered*, pp. 43–53; and Fried, *Courbet's Realism* (Chicago: University of Chicago Press, 1990).

PART I: IMPRESSIONISM AND ROMANTICISM

1. Théodore Duret, *Les Peintres impressionnistes* (Paris: Librairie Parisienne, 1878), p. 12. [Eng. edn., *Manet and the French Impressionists*, trans. J. E. Crawford Flitch (Philadelphia: J. B. Lippincott, 1910)].

2. Phoebe Pool, *Impressionism* (New York: Oxford University Press, 1967), pp. 30–31.

3. On this phenomenon, Basil Taylor has written that "Constable's connections with French nineteenth-century art have been wishfully exaggerated by writers seeking to prove the historical influence of English painting . . ." and that "the idea that Constable himself was an Impressionist has helped to misdirect the understanding of his method," in *Constable, Paintings, Drawings and Watercolours* (Oxford: Phaidon Press, 1973), pp. 46–47. Nevertheless, as recently as 1966, John Basket wrote of Constable that "he foreshadowed the Impressionists in their scientific attempts to break up light into component parts," in *Constable's Oil Sketches* (New York: Watson-Guptill, 1966), p. 11. Similar ideas have misinformed the popular literature on Turner as well. See for example the comments in D.M. Robb and J.J. Garrison, *Art in the Western World*, rev. edn. (New York: Harper and Row, 1942 and 1953), pp. 777–778.

4. Théophile Gautier, *Histoire du romanticisme, suivie de notices romantiques et d'une étude sur la poésie française 1830–1868* (Paris: G. Charpentier Editeur, 1877), p. 294; as cited and trans. by Eugenia Parry Janis, in André Jammes and Eugenia Parry Janis, *The Art of French Calotype* (Princeton, N.J.: Princeton University Press, 1983), pp. 106 and 125, n. 226. In her writing on nineteenth-century French photography Janis is exceptional among present-day art historians for the extent to which she stresses aesthetic continuity in the nineteenth-century French tradition. This ap-

proach is central to her entire introductory essay for *The Art of French Calotype* (pp. 3–125), but for a specific and pertinent example, see her discussion of the Romantic underpinnings of Courbet's Realism (p. 23).

5. Paul Hayes Tucker, *Monet at Argenteuil* (New Haven: Yale University Press, 1982), for example, pp. 81ff, 149, 176.

6. Ibid., pp. 19–20; this quote, p. 19.

7. Robert Rosenblum, *Modern Painting and the Northern Romantic Tradition: Friedrich to Rothko* (New York: Harper and Row, 1975), p. 70. A similar position is taken on this picture by Tucker, *Monet*, p. 19.

8. Helmut Börsch-Supan, *Caspar David Friedrich*, trans. Sarah Twohig (New York: George Braziller, 1974), p. 112.

9. Robert Herbert, "Method and Meaning in Monet," *Art in America* vol. 67, no. 5 (September 1979), pp. 90–108, these observations, p. 104.

10. Ibid., p. 106.

11. Philipp Otto Runge, letter of 1802 to his brother Daniel, in *Hinterlassene Schriften* (Hamburg, 1840), p. 9; trans. in William Vaughan, *Romantic Art* (New York: Oxford University Press, 1978), p. 138.

12. Charles Sterling and Margaretta M. Salinger, *French Paintings, A Catalogue of the Collection of the Metropolitan Museum of Art*, vol. II, "XIX Century" (Greenwich, Conn.: New York Graphic Society, 1966), p. 94.

13. *Monet Unveiled: A New Look at Boston's Paintings*, exh. cat. (Boston: Museum of Fine Arts, 1977), p. 46.

14. The germinal essay on this phenomenon is Lorenz Eitner's "The Open Window and the Storm-Tossed Boat: An Essay in the Iconography of Romanticism," *The Art Bulletin* vol. 37, no. 4 (December 1955), pp. 281–290.

15. On this aspect of Friedrich's work, see Rosenblum, *Modern Painting and the Northern Romantic Tradition*, pp. 36–37.

16. On analogies between English Romantic poetry and painting, see Laurence Binyon, "English Poetry in its Relation to Painting and the Other Arts," *Proceedings of the British Academy*, vol. VIII (London, 1918); also, Kurt Badt, *John Constable's Clouds* (London: Routledge and Kegan Paul, 1950), chapter IX ("Wordsworth and Constable"); Karl Kroeber, *Romantic Landscape Vision: Constable and Wordsworth* (Madison: University of Wisconsin Press, 1975); and Karl Kroeber and William Walling, eds., *Images of Romanticism: Verbal and Visual Affinities* (New Haven: Yale University Press, 1978).

17. George Heard Hamilton, *Claude Monet's Paintings of Rouen Cathedral*, Charlton Lectures on Art, (Newcastle upon Tyne, England: University of Newcastle upon Tyne, 1959), p. 14.

18. Georges Rivière, "L'Esposition des Impressionnistes," *L'Impressionniste* no. 1 (April 6, 1877), pp. 2–6, in Lionello Venturi, *Les Archives de l'Impressionnisme*, 2 vols. (Paris and New York: Durand Ruel, 1939; reprinted, New York: Burt Franklin, 1968), vol. II, p. 312. This and all subsequent translations, unless otherwise indicated, are my own.

19. Ibid., vol. II, p. 311.

20. Jules Castagnary, "L'Exposition du boulevard des Capucines: Les Impressionnistes," *Le Siècle*, April 29, 1874. Cited and trans. by Richard Shiff, "The End of Impressionism: A Study in Theories of Artistic Expression," *The Art Quarterly*, new series, vol. I, no. 4 (Autumn 1978), p. 338.

21. Philippe Burty, "Exposition des Impressionnistes," *La République Française*, April 25, 1877, in Venturi, *Les Archives de l'Impressionnisme*, vol. II, p. 291.

22. Emile Zola, "Le Naturalisme au Salon," *Le Voltaire*, June 19, 1880, in Venturi, *Les Archives de l'Impressionnisme*, vol. II, p. 279.

23. Burty, "Chronique du jour," *La République Française*, April 16, 1874, in Venturi, *Les Archives de l'Impressionnisme*, vol. II, p. 288.

24. Alexandre Pothey, "Expositions," *La Presse*, March 31, 1876, in Venturi, *Les Archives de l'Impressionnisme*, vol. II, p. 302.

25. Pothey, "Beaux-Arts," *Le Petit Parisien*, April 7, 1877, in Venturi, *Les Archives de l'Impressionnisme*, vol. II, p. 303.

26. Jacques Nicolas Paillot de Montabert, *Traité complet de la peinture*, 9 vols. (Paris: Delion, 1829–1851), vol. I, "Dictionnaire des Termes de Peinture," p. 153.

27. The phrase quoted is from a popular late nineteenth-century handbook on painting by the conservative painter Ernest Hareux, *La peinture à l'huile en plein air* [Paris, n.d. (1890s)], p. 35.; cited and trans. by Albert Boime, *The Academy and French Painting in the Nineteenth Century* (Oxford: Phaidon Press, 1971), p.153.

28. Vittorio Imbriani, *La Quinta Promotrice* (Naples, 1868); reprinted in Imbriani, *Critica d'arte e prose narrative*, ed. Gino Doria (Bari: Giuseppe Laterza e Figli, 1937), pp. 1–168; these quotes, pp. 45 and 49. For a translation and discussion of other passages from this review, see Norma Broude, *The Macchiaioli: Academicism and Modernism in Nineteenth-Century Italian Painting*, doctoral dissertation, Columbia University, New York, 1967, pp. 78–81; Broude, "The Macchiaioli: Effect and Expression in Nineteenth-Century Florentine Painting," *The Art Bulletin*, vol. 52 (March 1970), pp. 18–19. On Imbriani, his background, training, and philosophical orientation, see also, Benedetto Croce, "Intorno all'unità delle arti: II. Una teoria della 'Macchia,'" *Problemi di Estetica* (Bari: Giuseppe Laterza e Figli, 1910), pp. 236–237.

29. Boime, *The Academy and French Painting*, p. 170. On the concept of effect in nineteenth-century European painting, see also chapter IX, pp. 166–172; and Broude, *The Macchiaioli*, chapters II and III, pp. 35–161; and Broude, "The Macchiaioli," pp. 11–21.

30. See F. W. J. v. Schelling, "Uber das Verhaltnis der Bildenden Künste zu der Natur" (1807), *Werke*, ed. O. Weiss, 3 vols. (Leipzig, 1907), vol. III, pp. 385–425, and especially pp. 397–398 and 415–416.

31. On this phenomenon, see Suzanne Epstein, "The Relationship of the American Luminists to Caspar David Friedrich," unpublished master's essay, Columbia University, New York, 1964, pp. 29ff.; also, René Wellek, *Confrontations: Studies in the Intellectual and Literary Relations between Germany, England and the United States During the Nineteenth Century* (Princeton, N.J.: Princeton University Press, 1965); and Stanley M. Vogel, *German Literary Influences on American Transcendentalists*, Yale University Studies in English, vol. 127 (New Haven: Yale University Press, 1970). On parallels and differences between the American Luminists and Northern European landscape painting, see also, Barbara Novak, "Influences and Affinities: The Interplay Between America and Europe in Landscape Painting Before 1860," in *The Shaping of Art and Architecture in Nineteenth-Century America* (New York: The Metropolitan Museum of Art, 1972), pp. 27–41; and Novak, *Nature and Culture: American Landscape and Painting 1825–1875* (New York: Oxford University Press, 1980). In France, recognition of the expressive power of light and shadow may also have derived in part from the seventeenth-century academic conception of the "modes," which was revived in the 1820s in the writings of such theorists as Humbert de Superville, in *Essai sur les signes inconditionnels dans l'art* (Leyden, 1827–1832), and Paillot de Montabert, in *Traité complet*. The idea that predictable states of feeling can be induced by specific arrangements or "modes" of line, color, and tone prevailed well into the second half of the century and was popularized by such writers as David Sutter in *Philosophie des Beaux-Arts* (Paris, 1858) and Charles Blanc, *Grammaire des arts du dessin* (Paris, 1867); see William I. Homer, *Seurat and the Science of Painting* (Cambridge: M.I.T. Press, 1964), pp. 210–212.

32. Letter dated October 23, 1821, to John Fisher, in R. B. Beckett, ed., *John Constable's Correspondence*, 6 vols. (Ipswich: Suffolk Records Society, 1962–1968), vol. VI, p. 78.

33. Letter dated May 8, 1824, to John Fisher, in C. R. Leslie, *Memoirs of the Life of John Constable* (Oxford: Phaidon Press, 1951), p. 121.

34. Letter dated October 23, 1821, to John Fisher; in Beckett, *John Constable's Correspondence*, vol. VI, p. 77. Similar ideas were expressed during this period in Germany by Carl Gustav Carus, who wrote: "The sky in all of its clarity is the quintessence of air and light, is the real image of the infinite. . . this image of infinity is a powerful intimation of the mood of the whole landscape of which it is the covering vault, and in fact becomes the most essential and most glorious part of the whole landscape." *Nine Letters on Landscape Painting*, first edn., 1831; cited by Badt, in *John Constable's Clouds*, trans. Stanley Goodman (London: Routledge & Kegan Paul, 1959), p. 34.

35. John Constable, Introduction to *English Landscape: Twenty-two Landscapes intended to display the phaenomena of the chiar'oscuro of nature*, reprinted in Andrew Shirley, *The Published Mezzotints of David Lucas after John Constable* (Oxford: Clarendon Press, 1930), p. 220.

36. Ibid., p. 242.

37. Ibid., p. 3.

38. Sir Kenneth Clark, *John Constable: The Haywain* (London: Percy Lund Humphries and Co., The National Gallery, The Gallery Books, no. 5, 1944?), pp. 7–8.

39. John Gage, *Colour in Turner: Poetry and Truth* (London and New York: Studio Vista Limited and Praeger, 1969), pp. 106–117.

40. Ibid., p. 117.

41. Ibid., pp. 42–52, especially pp. 51–52.

42. Ibid., pp. 120–122; this quote, p. 122.

43. John Ruskin, *Modern Painters*, 5 vols. (1843–1860), reprinted in John Ruskin, *Works*, 12 vols. (New York: J. Wiley, 1885), vol. I, pp. 172–173.

44. Jean Bouret, *The Barbizon School* (Greenwich, Conn.: New York Graphic Society, 1973), p. 223.

45. Alfred Sensier, *Souvenirs sur Théodore Rousseau* (Paris, 1872), cited and trans. in Bouret, *The Barbizon School*, p. 223.

46. T. Thoré, *Salon de 1844, précédé d'une lettre à Théodore Rousseau* (Paris, 1844), p. 106.

47. Ibid., pp. 107–108.

48. Ibid., p. 3.

49. Prosper Dorbec, *L'Art du paysage en France: Essai sur son évolution de la fin du XVIIIe siècle à la fin du Second Empire* (Paris, 1925), p. 89.

50. Philippe Burty, "Théodore Rousseau," *Gazette des Beaux-Arts* 24 (1868), pp. 305–325; this quote, p. 313.

51. Ibid., p. 317.

52. Ibid., pp. 317–318.

53. *Revue des Races Latines* (Paris, 1859), pp. 19ff; cited in Aaron Scharf, *Art and Photography* (London: The Penguin Press, 1968), p. 108.

54. For a discussion of similar problems and issues in Italian painting of the second half of the nineteenth century, see Nancy Jane Gray Troyer, *The Macchiaioli: Effects of Modern Color Theory, Photography, and Japanese Prints on a Group of Italian Painters, 1855–1900*, doctoral dissertation Northwestern University, Evanston, 1978, chapters IV and V; and, Broude, *The Macchiaioli: Italian Painters of the Nineteenth Century* (New Haven: Yale University Press, 1987), chapter IV.

55. Jammes and Janis, *The Art of French Calotype* (Princeton, N.J.: Princeton University Press, 1983), pp. XV–XVI, 89, 91.

56. Ernest Lacan, "Le Photographe — Esquisse photographique du photographe artiste," *La Lumière*, January 15, 1853, p. 11; Eng. trans. in Jammes and Janis, *The Art of French Calotype*, p. 263.

57. Jammes and Janis, pp. 34–35, 114, n. 80.

58. Lacan, "Le Photographe," in Jammes and Janis, *The Art of French Calotype*, p. 263.

59. Gustave Le Gray, *Photographie. Traité nouveau des procédés et manipulations sur papier . . . et sur verre* (Paris: Lerebours and Secretan, 1854), p. 2 (first edn., 1852); cited and trans. in Jammes and Janis, *The Art of French Calotype*, pp. 98 and 124, n. 206.

60. Henri de la Blanchère, *L'Art du photographe, comprenant les procédés complets sur papiers et sur glace negatifs et positifs* (Paris: Amyot, 1859), pp. 38 and15; cited and trans. in Jammes and Janis, *The Art of French Calotype*, pp. 99, 124 ,n. 213, and p. 125, n. 214.

61. See Janis, "The History of Photography, A Methodological Note," preface to Jammes and Janis, *The Art of French Calotype*, pp. xi–xviii; this quote, p. xi.

62. On Corot and photography, see Scharf, *Art and Photography*, pp. 13, 64–66, 257, n.5, and 263, n.24; also Jammes and Janis, *The Art of French Calotype*, pp. 82–83, 89, 162, and 184–185.

63. Etienne Moreau-Nélaton raconté par lui-même et par ses amis (Geneva, 1946), vol. I, pp. 83, 89, 90, 97, 98.

64. Théophile Silvestre, *Histoire des artistes vivants* (Paris, 1856), pp. 92–92; cited and trans. by John Rewald, *The History of Impressionism* (New York: The Museum of Modern Art, 1961), p. 101.

65. For Corot's letter, see Denis Rouart, *Correspondance de Berthe Morisot* (Paris, 1950), p. 11; cited and trans. by Rewald, *The History of Impressionism*, p. 101. On the perspective that Morisot as a woman brought to her depiction of public and private spaces, see Griselda Pollock, "Modernity and the Spaces of Femininity," in *Vision and Difference* (London and New York: Routledge, 1988), pp. 50–90

66. Quoted by Marthe De Fels, *La Vie de Claude Monet* (Paris, 1929), p. 38.

67. See Kermit S. Champa, *Studies in Early Impressionism* (New York: Yale University Press, 1973), p. 68. In chapter VII (which bears the unfortunate title "Pissarro — The Progress of Realism"), pp. 67–79, Champa discusses the influence of Rousseau on Pissarro's *View of a Haywagon*

of 1858 and that of Corot on Pissarro's *Prairies at La Roche-Guyon* of 1859. On Pissarro's early life and work, see also, Paula Harper and Ralph E. Shikes, *Pissarro: His Life and Work* (New York: Horizon Press, 1980); *Camille Pissarro, 1830–1903*, exh. cat., (London, Paris, and Boston: Hayward Gallery, Grand Palais, and Museum of Fine Arts, 1980–1981); and Richard Brettell, *Pissarro and Pontoise: The Painter in a Landscape* (New Haven: Yale University Press, 1990).

68. Cited and trans. by Rewald, *The History of Impressionism*, pp. 456 and 458.

69. For example, Monet's statement of 1897: "There is only one master here — Corot. Compared to him, the rest of us are nothing." Reported by François Fosca, cited and trans. in Madeleine Hours, *Corot* (New York: Abrams, 1972), pp. 49–50.

70. Thiébault-Sisson, "Claude Monet, An Interview," originally published in *Le Temps*, Paris, November 27, 1900, trans. and reprinted by Durand-Ruel. The translation was reprinted as "Claude Monet: The Artist as a Young Man," in *Art News Annual*, 1957, part II, pp. 127–128, 196–199; and as "An Interview with the Artist in 1900," in Linda Nochlin, ed., *Impressionism and Post-Impressionism, 1874–1904, Sources and Documents* (Englewood Cliffs, N.J.: Prentice-Hall, 1966), pp. 36–43; this quote, p. 38.

71. Boudin, notes from his sketchbooks, in G. Cahen, *Eugène Boudin, sa vie et son oeuvre* (Paris, 1900), pp. 181, 184, 194; cited and trans. by Rewald, *The History of Impressionism*, p. 38.

72. Daniel Wildenstein, *Claude Monet: Biographie et catalogue raisonné*, 3 vols. (Lausanne and Paris: Bibliothèque des Arts, 1974–1979), vol. I, letter 2, p. 419.

73. Ibid., vol. I, letter 3, pp. 419–420.

74. Thiébault-Sisson, "Claude Monet, An Interview" (1900), in Nochlin, *Impressionism and Post-Impressionism*, p. 41. On Jongkind's influence, see also, *Jongkind and the Pre-Impressionists: Painters of the Ecole Saint-Siméon*, exh. cat. (Williamstown, Mass.: Sterling and Francine Clark Art Institute, 1977), pp. 25–63.

75. Letter dated September 17, 1862; quoted by Victorine Hefting, *Jongkind, sa vie, son oeuvre, son époque* (Paris: Arts et Métiers Graphiques, 1975), p. 37. On the nature of Jongkind's plein-air activity, long thought by scholars to have been confined to watercolor, see Hefting, pp. 35 and 41.

76. See Rewald, *History of Impressionism*, p. 93.

77. See Wildenstein, *Claude Monet*, vol. I, nos. 17–19 (1864) and nos. 56–60 (1865).

78. Rewald, *History of Impressionism*, p. 96.

79. Ibid., p. 115.

80. Letter dated October 7, 1890, in Wildenstein, *Claude Monet*, vol. III, letter 1076, p. 258.

81. See Hélène Toussaint, *Théodore Rousseau, 1812–1867*, exh. cat. (Paris: Musée du Louvre, 1967), p. 59.The phrase quoted is Mlle Toussaint's, trans. in Bouret, *The Barbizon School*, p. 163.

82. Bouret, *The Barbizon School*, p. 223.

83. See Monet's letter to Bazille regarding this experience, in Wildenstein, *Claude Monet*, vol. I, letter 9, pp. 420–421.

84. Rewald, *The History of Impressionism*, p. 114, where the two pictures by Jongkind are also reproduced.

85. Etienne Moreau-Nélaton writes of Monet's enthusiasm for Jongkind, to whom he attached himself, losing no opportunity *"de s'instruire auprès de lui,."* in *Jongkind raconté par lui-même* (Paris: Laurens, 1918), pp. 85–86.

86. Joel Isaacson has connected *Impression: Sunrise* with Whistler's *Nocturnes* (views of the Thames), and has pointed out that examples of the *Nocturnes* would have been accessible to Monet through an exhibition of Whistler's works held at Durand-Ruel's early in 1873; see *Claude Monet: Observation and Reflection* (Oxford: Phaidon Press, 1978), pp. 21 and 204. Moreover he suggests and underscores the irony of the possibility "that the name of the Impressionist movement derives from a work that had its immediate stimulus in a pictorial image rather than in nature, an image produced by an American expatriate living in London, who had been guided in his creation of that image by an abstract aesthetic ideal" (p. 21). Recent exposure to the even tonalities of Whistler's pictures may indeed have made Monet more sensitive to situations of diffused light in nature, like the one that he encountered at Le Havre and that we observe

in *Impression: Sunrise*. I cannot agree, however, with Isaacson's contention that Whistler's pictures may have been the primary stimulus for Monet's work. In particular, the loose and responsive brushwork of *Impression: Sunrise*, so markedly different from Whistler's smooth and stylized surfaces, suggests that the picture's primary and immediate inspiration could only have been a direct experience in nature (see also chapter 3). On this picture from a different point of view, see Paul Hayes Tucker, "Monet's *Impression, Sunrise* and the First Impressionist Exhibition: A Tale of Timing, Commerce, and Patriotism," *Art History 7* (December 1984), pp. 465–476.

87. Rewald, *The History of Impressionism*, p. 39. Other sources claim that Monet purchased the painting in 1856; see Madeleine Fidell-Beaufort and Janine Bailly-Herzberg, *Daubigny*, Eng. trans. by Judith Schub (Paris: Editions Geoffroy-Dechaume, 1975,) p. 23.

88. Rewald, *The History of Impressionism*, p. 132; and Barbara Ehrlich White, ed., *Impressionism in Perspective* (Englewood Cliffs, N.J.: Spectrum Books, 1978), p. 152.

89. In 1866 Daubigny fought unsuccessfully for the work of Renoir and Cézanne, but managed to have Pissarro's work admitted. Among those who exhibited at the Salon of 1868 were Pissarro, Monet, Bazille, Degas, Morisot, Renoir, and Sisley (see Fidell-Beaufort, *Daubigny*, pp. 57 and 60).

90. Fidell-Beaufort, *Daubigny*, p. 46.

91. Sketches for these appear already in a letter of October 28, 1857, written by Daubigny to his friend Geoffroy-Dechaume. Their correspondence between the years 1843 and 1873 is published in Fidell-Beaufort, *Daubigny*, pp. 247–265.

92. Frédéric Henriet, *Le Paysagiste aux champs* (Paris: Faure, 1866). Henriet's description is quoted by E. Moreau-Nélaton, *Daubigny raconté par lui-même* (Paris: Laurens, 1925), pp. 73–75.

93. Henriet, *Les Campagnes d'un paysagiste* (Paris, 1891); quoted by Moreau-Nélaton, *Daubigny raconté par lui-même*, p. 118.

94. Henriet, *Les Campagnes d'un paysagiste*, quoted and trans. in Fidell-Beaufort, *Daubigny*, p. 55.

95. From the *Moniteur Universel*, June 20, 1852; cited by Fidell-Beaufort, *Daubigny*, p. 45.

96. Cited and trans. in Fidell-Beaufort, *Daubigny*, p. 53.

97. See Baudelaire's response to Daubigny's work at the Salon of 1859, cited by Fidell-Beaufort, *Daubigny*, p. 50.

98. Zacharie Astruc, *Les 14 Stations du Salon, Août 1859*, (Paris, 1859), p. 303; cited and trans. in Fidell-Beaufort, *Daubigny*, pp. 49–50.

99. Henriet, "Daubigny," *L'Artiste*, 1857, pp. 179–182 and 195–198; this passage cited by Moreau-Nélaton, *Daubigny raconté par lui-même*, p. 68.

100. Champa, *Studies in Early Impressionism*, pp. 71–72.

101. Ibid., p. 75.

102. Alan Bowness, "Introduction," *The Impressionists in London*, exh. cat. (London: The Arts Council of Great Britain, 1973), pp. 7, 13, 14–15; this quote, p. 13.

103. Ibid., p. 13.

104. Ibid., pp. 14–15.

105. Wynford Dewhurst, *Impressionist Painting* (London, 1904), pp. 31–32; cited by Bowness, *The Impressionists in London*, p. 14.

106. Camille Pissarro, *Letters to His Son Lucien*, ed. John Rewald, trans. Lionel Abel (New York: 1943), pp. 355–56; cited by Bowness, *The Impressionists in London*, p. 14.

107. Diary of Theodore Robinson, entry of August 5, 1892, Frick Art Reference Library, New York; cited by Grace Seiberling, *Monet's Series*, doctoral dissertation, Yale University, 1976 (New York: Garland Publishing, 1981), p. 194.

108. René Gimpel, *Journal d'un collectionneur, Marchand de tableaux* (Paris, 1963), p. 88; trans. William Seitz, *Claude Monet* (New York: Abrams, 1960), p. 24; cited by Bowness, *The Impressionists in London*, p. 15.

109. Bowness, *The Impressionists in London*, p. 15.

110. Ibid., pp. 24–25. On Monet's London series, see also Seiberling, *Monet's Series*, pp. 192–208.

111. Bowness, *The Impressionists in London*, p. 25–26.

112. Rewald, *History of Impressionism*, p. 263.

113. Observed by Rewald, ibid., p. 262.

114. For a reproduction, see Wildenstein, *Claude Monet*, vol. I, no. 172.

115. Ibid., vol. I, letter 9, pp. 420–421.

116. Ibid., vol. I, letter 22, p. 422.

117. Ibid., vol. I, letter 11 (Sainte-Adresse, October 14, 1864), p. 421.

118. Hugh Honour, *Romanticism* (New York: Harper and Row, 1979), pp. 61–63.

119. Wildenstein, *Claude Monet*, vol. I, letter 44, pp. 425–426.

120. W. Burger, *Salons de T. Thoré, 1844–1848* (Paris: Renouard, 1868), p. 381; quoted and trans. by Boime, *The Academy and French Painting*, p. 180.

121. Reported after Jongkind's death by his friend Louis de Fourcaud in the preface to the sale catalogue of Jongkind's works, December 8–9, 1891; cited by Moreau-Nélaton, *Jongkind raconté par lui-même*, p. 133.

122. Ernest Hareux, *La Peinture à l'huile en plein air* (Paris, n.d.), p. 38; cited and trans. by Albert Boime, *The Academy and French Painting*, p. 170.

123. E. Hareux, *L'Art de faire un tableau*, (Paris, n.d.), p. 49; cited and trans. by Boime, *The Academy and French Painting*, p. 218, n. 24.

124. Karl Robert, *Traité pratique de peinture à l'huile. Paysage* (Paris, 1884), pp. 87–89; cited and trans. by Boime, *The Academy and French Painting*, p. 153. For a discussion of the relationship of these sketching procedures to academic practice in the nineteenth century, see Boime, pp. 149–165 in particular.

125. Quoted and trans. by Boime, *The Academy and French Painting*, p. 180. For more on the connection between spontaneity in sketching and the concept of originality, see pp. 173ff.

126. P. G. Hamerton, "Portrait and Landscape," *Portfolio*, 1891, p. 179; cited by Boime, *The Academy and French Painting*, p. 171.

127. Charles Blanc, "Salon de 1866," *Gazette des Beaux-Arts* 21 (1866), p. 41.

128. Journal entries for May 21, 1853, and October 26, 1853; see *The Journal of Eugène Delacroix*, trans. by Walter Pach (New York: Grove Press, 1961), pp. 313 and 339–340.

129. Wildenstein, *Claude Monet*, vol. I, letter 8, p. 420.

130. Ibid., vol. I, letter 11, p. 421. On the paintings that Monet refers to in this letter, see Wildenstein nos. 24, 26, and 28.

131. Ibid., vol. I, letter 12, p. 421.

132. Ibid., vol. I, letter 53, p. 427.

133. Champa, *Studies in Early Impressionism*, p. 63. Among the pictures painted by Monet at La Grenouillère, Champa would include W. 138 (which was probably painted on the island of La Grande Jatte), while he omits W. 136.

134. Isaacson, "Review of Champa, *Studies in Early Impressionism*," in *The Art Bulletin* 57 (September 1975), pp. 453–454. Monet's Grenouillère paintings are catalogued by Wildenstein, nos. 134, 135, and 136. A painting by Monet of the site at La Grenouillère, thought by Wildenstein to be his catalogue no. 136, was submitted by Monet to the Salon of 1870 and refused (see Wildenstein, *Claude Monet*, vol. I, p. 46 and n. 345). This painting, formerly in a German collection and now lost, is known only through an old photograph, which is too poor in quality to allow for an accurate assessment of its state of finish. On Monet's *Bathers at La Grenouillère* (W. 135), bequeathed to The National Gallery, London, in 1979 and then cleaned and restored, see the series of articles by Michael Wilson, Martin Wyd, and Ashok Roy in *The National Gallery Technical Bulletin* 5 (1981), pp. 14–25.

135. Isaacson, "Review of Champa, *Studies in Early Impressionism*," p. 454.

136. Maurice Guillemot, "Claude Monet," *La Revue Illustrée*, March 15, 1898; quoted and trans. by Boime, *The Academy and French Painting*, p. 172.

137. ("*L'enveloppe, la même lumière répandue partout.*") Letter of October 7, 1890; in Wildenstein, *Claude Monet*, vol. III, letter 1076, p. 258.

138. Reported by Aimé Gros, *F.-L. Français* (Paris, 1902), p. 87; quoted and trans. by Boime, *The Academy and French Painting*, p. 155. Even the Academy in the nineteenth century was willing to regard the *étude* as a self-sufficient work with its own qualities and value. In this regard, Boime cites the authoritative pronouncement of the *Dictionnaire de l'Académie des Beaux-Arts* (1858), in which it is said that an *étude* made from nature might "be a work in its own right, independently of any intention to use it elsewhere" (Boime, p. 150).

139. This passage from Wordsworth is related to the painting procedures of Constable by Kurt Badt, *John Constable's Clouds*, trans. Stanley Goodman (London: Routledge and Kegan Paul, 1950), p. 82.

140. Wildenstein, *Claude Monet*, vol. III, letter 1076, p. 258.

141. On this debate, see Steven Z. Levine, "The 'Instant' of Criticism and Monet's Critical Instant," *Arts Magazine*, March 1981, pp. 114–121.

142. Octave Mirbeau, "Claude Monet," *Exposition Claude Monet—Auguste Rodin* (Paris: Galerie Georges Petit, 1889), p. 14; cited and trans. by Levine, "The 'Instant' of Criticism and Monet's Critical Instant," p. 120.

143. Letter dated June 21, 1926, in Evan Charteris, *John Sargent* (London, 1927), p. 131; cited by Grace Seiberling, "The Evolution of an Impressionist," in *Paintings by Monet*, ed. Susan Wise (Chicago: The Art Institute, 1975), p. 20.

144. Theodore Robinson, "Claude Monet," *Century Magazine* 44 (September 1892), p. 696.

145. Duc de Trévise, "Le pèlerinage de Giverny" (interview with Monet in 1920), *Revue de l'art ancien et moderne* vol. 51, nos. 282 and 283 (January and February 1927), p. 126.

146. Lilla Cabot Perry, "Reminiscences of Claude Monet from 1889–1909," *American Magazine of Art* 18 (March 1927), pp. 119–125; reprinted in *Lilla Cabot Perry: An American Impressionist*, catalogue by Meredith Martindale with the assistance of Pamela Moffat (Washington, D.C.: The National Museum of Women in the Arts, 1990), pp. 115–118; this quote, p. 117.

147. Duc de Trévise, "Le pèlerinage de Giverny," p. 126.

148. Ibid., p. 126.

149. In a letter to Durand-Ruel from Giverny on July 22, 1883, Monet wrote: "The weather has been very bad for several days and I am taking advantage of it to work indoors and finish as many canvases as possible for you; but that is not as easy as you think, since I am anxious above all to give you things that I am satisfied with" (Wildenstein, *Claude Monet*, vol. II, letter 366, p. 230). See also Wildenstein, vol. II, letters 367 and 368 (July 27 and 29, 1883), p. 230, also to Durand-Ruel. These letters are cited by Seiberling, "The Evolution of an Impressionist," p. 21.

150. Wildenstein, *Claude Monet*, vol. II, letter 741, p. 287.

151. Boime, *The Academy and French Painting*, pp. 156 and 166.

152. See John House, *Claude Monet: His Aims and Methods c.1877–1895*, Doctoral dissertation, Courtauld Institute, London, 1976; House, *Monet: Nature into Art* (New Haven: Yale University Press, 1986); and Robert Herbert, "Method and Meaning in Monet," *Art in America*, September 1979, pp. 90–108.

153. Herbert, "Method and Meaning in Monet," p. 94.

154. Other theories exist, of course, to explain the origins and functions of Impressionist brushwork. Contemporary supporters, for example, attributed a descriptive function to the separate strokes, which permitted the artists, they said, to capture "'the mobility of the atmosphere,' 'the iridescence of the surrounding air,' 'the aerial quivering,' 'the sensation of high wind,' 'the movement of the vibrations of heat,' etc.," see Oscar Reutersvard, "The Accentuated Brush Stroke of the Impressionists: The Debate Concerning Decomposition in Impressionism," *Journal of Aesthetics and Criticism* X (March 1952), pp. 273–278; reprinted in White, *Impressionism in Perspective*, pp. 44–50, this quote, p. 46.

155. Duc de Trévise, "Le pèlerinage de Giverny," p. 126.

156. Bouret, *The Barbizon School*, p. 223.

157. Pothey, "Beaux-Arts," *Le Petit Parisien*, April 7, 1877, in Venturi, *Les Archives de l'Impressionnisme*, vol. II, p. 303.

158. For a psychological reading of Monet's technique and its meaning, see Steven Z. Levine, "Monet, Madness, and Melancholy," *Psychoanalytical Perspectives on Art* 2(1987), pp. 111–132; also, Levine, "Monet, Fantasy, and Freud," *Psychoanalytical Perspectives on Art* 1 (1985), pp. 29–55.

PART II: IMPRESSIONISM AND SCIENCE

1. Gendered attitudes toward color in the Renaissance are explored by Patricia L. Reilly, "The Taming of the Blue: Writing Out Color in Renaissance Theory," in *The Expanding Discourse: Feminism and Art History*, eds. Norma Broude and Mary D. Garrard (New York: HarperCollins, to appear 1992). See also John Gage, "Color in Western Art: An Issue?" *The Art Bulletin* 72(December 1990), pp. 518–541, for a useful survey of the recent literature on color in Western art from the Renaissance through the early twentieth century.

2. The standard older histories of modern science include Herbert Butterfield, *The Origins of Modern Science 1300–1800* (New York: Macmillan, 1962; first edn., 1949); and William Cecil Dampier, *A History of Science and Its Relations with Philosophy and Religion* (Cambridge: Cambridge University Press, 1968; first edn.,1929). See, also, Roy Porter, ed., *Man Masters Nature: Twenty-Five Centuries of Science* (New York: George Braziller, 1988); Nicholas Pastore, *Selective History of Theories of Visual Perception 1650–1950* (New York: Oxford University Press, 1971); and specific entries in *Dictionary of Scientific Biography* (New York: Scribner, 1970). A useful synthetic overview is provided by Hans Eichner, "The Rise of Modern Science and the Genesis of Romanticism," *PMLA* 97(1982), pp. 8–30.

3. Immanuel Kant, "The Idea for a Universal History from a Cosmopolitan Point of View" (1784) and "An Answer to the Question:'What is Enlightenment?'" (1784), in *Kant's Political Writings*, ed. H. Reiss (Cambridge: Cambridge University Press, 1977), pp. 41–53 and 54–60. See also the discussion by Genevieve Lloyd, *The Man of Reason: "Male" and "Female" in Western Philosophy* (Minneapolis: University of Minnesota Press, 1984), pp. 64–73.

4. On Schelling's *Naturphilosophie* and its impact on the science of his period, see in particular D. M. Knight, "German Science in the Romantic Period," in *The Emergence of Science in Western Europe*, ed. Maurice P. Crosland (London: Macmillan, 1975), pp. 161–178; D. M. Knight, "The Physical Sciences and the Romantic Movement," *History of Science* 9 (1970), pp. 54–75; W. D. Wetzel, "Aspects of Natural Science in German Romanticism," *Studies in Romanticism* 10 (1971), pp. 44–59; and B. Gower, "Speculation in Physics: The History and Practice of Naturphilosophie," *Stud. Hist. Phil. Sci.* 3 (1973), pp. 301–356.

5. Knight, "German Science in the Romantic Period," p. 166.

6. Ibid., p. 164. Knight speaks of a "dynamical Newtonian tradition" and cites several recent historians of science who identify a "dynamical Newtonianism" (pp. 171 and 176, n. 18). Nevertheless, the major influence of Newton's work as it has been understood, supported, or rejected for several centuries has been mechanical.

7. Ibid., p. 164.

8. Ibid.

9. Ibid., p. 165.

10. Arthur O. Lovejoy, *The Great Chain of Being* (Cambridge: Harvard University Press, 1936).

11. Cited by Eichner, "The Rise of Modern Science," p. 16.

12. National styles of science are explored in *The Emergence of Science in Western Europe*, ed. Maurice P. Crosland (London: Macmillan, 1975); this observation, p. 10.

13. Ernst Mach, *Die Mechanik in ihrer Entwickelung historisch-kritisch dargestellt*, first edn., 1883; English trans. by T. J. McCormack (Chicago, 1893; second Eng. edn., London, 1902). On Mach, see Dampier, *A History of Modern Science*, pp. 155–156, 196, 295, 455, 458. More generally on the history of science in relation to philosophical thought in France and Germany during the nineteenth century, see Dampier, pp. 288–320.

14. René P. Le Bossu, *Traité du poème épique* (Paris: Michel le Petit, 1675), p. 1; cited by Eichner, "The Rise of Modern Science," p. 17.

15. See Marjorie Hope Nicolson, "Newton's *Opticks* and Eighteenth-Century Imagination," *Dictionary of the History of Ideas* (New York: Scribner, 1973), vol. III, pp. 391–399.

16. Ibid., p. 398.

17. Ibid.

18. On these, see Barbara Maria Stafford, *Voyage into Substance: Art, Science, Nature, and the Illustrated Travel Account, 1760–1840* (Cambridge: The MIT Press, 1984). This book provides a thorough account of the complementary relationship that was forged between art and science during the Enlightenment, as reflected specifically in European illustrated travel accounts from this period.

19. See Klaus Berger, *Géricault et son oeuvre* (Paris: Grasset, 1952), pp. 79–80.

20. For a full discussion of Chevreul's work in relation to Delacroix's art, see Lee Johnson, *Delacroix* (New York: W. W. Norton & Co., 1963), pp. 63–72. Johnson considers the question of whether Delacroix could have known or been influenced by Chevreul's ideas when he painted the *Women of Algiers* in 1834, as Charles Blanc and Paul Signac later implied; and he discusses the impact of Blanc's analysis of the *Women of Algiers* on the Post-Impressionists later in the century. He also points to elements of Delacroix's color practice in the *Taking of Constantinople* that were consonant with the color theories of Chevreul, making a case for the influ-

ence of Chevreul on Delacroix at this time.

21. On recent findings, see Gage, "Color in Western Art," p. 529 and notes 108–111.

22. See Badt, *John Constable's Clouds*, p. 57. On Constable's interest in meteorology, see also, Louis Hawes, "Constable's Sky Sketches," *Journal of the Warburg and Courtauld Institutes* 32 (1969), pp. 344–365; and Paul D. Schweizer, "John Constable, Rainbow Science, and English Color Theory," *The Art Bulletin* 64 (September 1982), pp. 424–445.

23. From Constable's notes for lectures on landscape painting delivered at the Royal Institution in 1833 (Lecture IV, June 16, 1833), in C. R. Leslie, *Memoirs of the Life of John Constable* (Oxford: Phaidon Press, 1951), p. 323.

24. Letter of November 10, 1835, quoted by Badt, *John Constable's Clouds*, p. 57.

25. Badt, *John Constable's Clouds*, especially p. 54. For further consideration of the importance of such schemata for Constable (including Constable's copies after cloud drawings by Cozens), see E. H. Gombrich, *Art and Illusion: A Study in the Psychology of Pictorial Representation* (Princeton, N.J.: Princeton University Press, Bollingen Series, 1972), pp. 175–178.

26. Letter of October 23, 1821 to John Fisher, in Leslie, *Memoirs of the Life of John Constable*, p. 85.

27. Ibid., p. 323.

28. From Coleridge's description of conversations with Wordsworth in the spring of 1798 that gave rise to the latter's *Lyrical Ballads*. See S. T. Coleridge, *Biographia Literaria* (London, 1817), quoted by Hugh Honour, *Romanticism* (New York: Harper and Row, 1979), p. 72.

29. See Trevor H. Levor, "Coleridge, Chemistry, and the Philosophy of Nature," *Studies in Romanticism* 16 (1977), pp. 349–379.

30. Ibid., p. 349.

31. Honour, *Romanticism*., pp. 65–66; Constable's remark is from a letter of May 9, 1823, quoted by Leslie, *Memoirs of the Life of John Constable*, p. 101.

32. The phrase is Badt's, *John Constable's Clouds*, p. 27.

33. Quoted by Badt and trans. by Stanley Godman, in Badt, *John Constable's Clouds*, p. 25.

34. Ibid.

35. See D. G. Charlton, *Positivist Thought in France During the Second Empire 1852–1870* (Oxford: Oxford University Press, 1959); and W. M. Simon, *European Positivism in the Nineteenth Century* (Ithaca: Cornell University Press, 1963).

36. This issue is treated by Henry Guerlac, "Science and French National Strength," *Essays and Papers in the History of Modern Science* (Baltimore: The Johns Hopkins University Press, 1977), pp. 496ff.

37. Quoted and trans. by Linda Nochlin, *Realism* (Harmondsworth and Baltimore: Penguin Books, 1971), p. 42.

38. Pierre Gratiolet, *De La Physionomie et des mouvements d'expression* (Paris: J. Hetzel, 1865), especially pp. 141–148. See also pp. 389–436 for an essay by Louis Grandeau on the life and work of Gratiolet and a bibliography of his writings. I am indebted to Meyer Schapiro, whose lectures first made me aware of Gratiolet's work and its relevance for the period out of which Impressionism comes.

39. See Nochlin, *Realism*, pp. 40–45; Marianne Marcussen, "Duranty et les impressionnistes," *Hafnia Copenhagen Papers in the History of Art* (1978) pp. 24–42; and (1979) pp. 27–49; and Charles F. Stuckey, "Monet's Art and the Act of Vision," *Aspects of Monet*, eds. John Rewald and Frances Weitzenhoffer (New York: Abrams, 1984), pp. 107–121.

40. Emile Zola, "The Realists in the Salon," *L'Evénement*, May 11, 1866, trans and ed. Elizabeth Gilmore Holt, *From the Classicists to the Impressionists: A Documentary History of Art and Architecture in the Nineteenth Century* (New York: Doubleday Anchor Books, 1966), p. 385.

41. Ibid., pp. 386–388.

42. Leonardo da Vinci, *Paragone, A Comparison of the Arts*, trans. Irma Richter (London: Oxford University Press, 1949), Trat. 19, p. 54.

43. For examples of such criticism, see Oscar Reutersvard, "The 'Violettomania' of the Impressionists," *Journal of Aesthetics and Art Criticism* 9 (December 1950), pp. 106–110; reprinted under the title "Journalists (1876–1883) on 'Violettomania,'" in Barbara Ehrlich White, ed., *Impressionism in Perspective* (Englewood Cliffs, N. J.: Prentice-Hall, 1978), pp. 38–43.

44. Edmond Duranty, *La Nouvelle Peinture: à propos du groupe d'artistes qui expose dans les galeries Durand-Ruel* (Paris: Dentu, 1876). All subsequent references are to this edition, and all quoted passages appear in my own translation. See also *The New Painting: Impressionism 1874–1886* (San Francisco and Washington, D.C.: The Fine Arts Museums of San Francisco and the National Gallery of Art, 1986), where Duranty's essay is reprinted in the original French (pp. 477–484) and in English translation (pp. 37–47).

45. Duranty, *La Nouvelle Peinture*, p. 20.

46. Ibid., p. 21.

47. Ibid., p. 22.

48. Marcussen, "Duranty et les impressionnistes," (1978), pp. 24–42; and (1979), pp. 27–49. In the first of these articles, Marcussen offers documentary support for the contention that Duranty wrote his pamphlet in conjunction with the second group exhibition of the Impressionists, thereby establishing that these artists and their work had indeed been the subject of Duranty's remarks (a proposition that has been questioned by scholars, since Duranty mentioned none of these artists by name). More direct evidence that supports this identification has since been offered by Efrem G. Calingaert, who notes that the Italian critic Diego Martelli owned a copy of the 1876 edition of *La Nouvelle Peinture* annotated in Duranty's hand with the names of the artists discussed in his text; see Calingaert, "More 'Pictures-within-Pictures': Degas' Portraits of Diego Martelli," *Arts Magazine* 62 (Summer 1988), p. 44, n.29

49. The editions in Duranty's possession included: Hippolyte Taine, *De l'Intelligence* (Paris, 1870); Charles Blanc, *Grammaire des arts du dessin, architecture, sculpture, peinture*, second edn. (Paris, 1870); Amédée Guillemin, *La Lumière* (Paris, 1874); E. H. Haeckel, *Histoire de la création des êtres organisés d'après les lois naturelles* (Paris, 1874); Ernst Brücke and Hermann von Helmholtz, *Principes scientifiques des Beaux Arts. Essais et fragments de théorie, suivis de l'optique et la peinture* (Paris, 1878). Marcussen proposes Guillemin's *La Lumière* as the work on which Duranty depended in 1876 for his description of prismatic color and the "phenomenon of decomposition" (Marcussen: 1979, pp. 29 and 35). She states more generally that the other books listed above also influenced the terms in which Duranty chose to characterize "the new painting." It should be noted, however, that the scientific descriptions of sensory and optical experience that these texts provide, and which were taken up by later writers on Impressionism, are not dealt with directly by Duranty in his pamphlet of 1876.

50. Marcussen, "Duranty et les impressionnistes" (1979), p. 45.

51. Marcussen, "Duranty et les impressionnistes" (1978), p. 35.

52. Duranty, *La Nouvelle Peinture*, p. 30.

53. Ibid., p. 27.

54. Ibid., pp. 33, 36.

55. Ibid., pp. 34–35.

56. On the aesthetic of these artists and the criticism that surrounded their early work, see Norma Broude, *The Macchiaioli: Italian Painters of the Nineteenth Century* (New Haven: Yale University Press, 1987); and Broude, "The Macchiaioli: Effect and Expression in Nineteenth-Century Florentine Painting," *The Art Bulletin* 52 (March 1970), pp. 11–21.

57. Martelli's relationship to the Macchiaioli is discussed in Broude, "The Macchiaioli as 'Proto-Impressionists': Realism, Popular Science and the Re-shaping of Macchia Romanticism, 1862–1886," *The Art Bulletin* 52 (December 1970), pp. 404–414; and in Broude, *The Macchiaioli*, 1987, especially chapter VI. See also the biography by Baccio Maria Bacci, *Diego Martelli, l'amico dei "Macchiaioli"* (Florence: Mazza, 1952); Alessandro Marabottini, "Diego Martelli," in A. Marabottini and V. Quercioli, eds., *Diego Martelli, Corrispondenza Inedita* (Rome: De Luca, 1978), pp. 9–75, especially pp. 18–19; and Piero Dini (with the collaboration of Alba del Soldato), *Diego Martelli* (Florence: Edizioni Il Torchio, 1978).

58. Martelli later described one of these gatherings in an article entitled "Giuseppe De Nittis," *Fieramosca*, September 13, 1884; reprinted in *Scritti d'arte di Diego Martelli*, ed. Antonio Boschetto (Florence: Sansoni, 1952), pp. 127–128.

59. The portraits are catalogued by P. A. Lemoisne, *Degas et son oeuvre* (Paris: 1946–1949), vol. II, nos. 519 and 520. On Degas's earlier visits to Florence and his friendships with Italian artists, see Lamberto Vitali, "Three Italian Friends of Degas," *Burlington Magazine* 105 (1963), pp. 266–272; and Broude, "An Early Friend of Degas in Florence: A Newly

Identified Portrait Drawing of Degas by Giovanni Fattori," *Burlington Magazine* 115 (November 1973), pp. 726–735.

60. In a letter of July 1878, Martelli wrote:"'Birds of a feather flock together,' says the proverb, and I have become very involved with a congenial Impressionist who is one of the strongest of the lot and whose name is Pissarro. I went with him a few days ago to visit a pastry cook [Eugène Murer, a patron of the Impressionists], who has a collection of paintings that for the most part I should like to have" (Bacci, *Diego Martelli*, p. 61).

61. The paintings are catalogued by L. R. Pissarro and L. Venturi, *Camille Pissarro, son art, son oeuvre*, 2 vols. (Paris, 1939), no.405 (*Paysage, Environ de Pontoise*, dated 1877) and no. 451 (*Dans le Jardin Potager*, dated 1878). They appeared in the catalogue of the 1879 Promotrice exhibition as no. 113 ("*La tosatura della siepe, studio dal vero in Francia*") and no. 250 ("*L'approssimarsi della bufera, studio dal vero fatto in Francia*"). Subsequently, they became part of Martelli's own collection and were bequeathed to the Galleria fiorentina d'arte moderna.

62. Letter to Cecco Gioli, September 1878, in Bacci, *Diego Martelli*, pp. 62–63.

63. See Martelli's undated letter to Giovanni Fattori, written in Paris probably early in 1879; first published by Ugo Ojetti, "Macchiaioli e Impressionisti," *Dedalo* I (1920–1921), pp. 759–760.

64. Diego Martelli, "Gli Impressionisti" (Conferenza del 1879), in *Scritti d'arte di Diego Martelli*, pp. 106–108.

65. George Berkeley, "An Essay Towards a New Theory of Vision," in *The Works of George Berkeley, Bishop of Cloyne*, 9 vols., eds. A. A. Luce and T. E. Jessop (London, 1948–1957), vol. I, pp. 234, 235 (SS156, SS158).

66. Johann Wolfgang von Goethe, *Theory of Colours*, trans. Charles Eastlake (London, 1840), pp. XXXVIII–XXXIX.

67. Hermann von Helmholtz, *Treatise on Physiological Optics*, 3 vols., ed. James Southhall (Rochester, N.Y.: Optical Society of America, 1924–1925), vol. III, pp. 8–9, 18–20. First edition: *Handbuch der Physiologischen Optik* (Leipzig, 1857–867); French trans. Emile Javal and N. Th. Klein, *Optique physiologique* (Paris, 1867). On Helmholtz, see also the standard biography by Leo Koenigsberger, *Hermann von Helmholtz*, trans. Frances A. Welby (Oxford, 1906; reprinted, New York: Dover, 1965).

68. Helmholtz, *Treatise on Physiological Optics*, vol. III, p. 3.

69. Marcussen, "Duranty et les impressionnistes" (1979), p. 38.

70. Martelli, who died in 1896, bequeathed his personal papers and books (over three thousand volumes) to the Biblioteca Marucelliana in Florence. The book in question is preserved among them (Bib. Marucelliana / LEGATO MARTELLI, B.1, 367).

71. Diego Martelli, "Su l'arte" (Conferenza del 1877), *Scritti d'arte di Diego Martelli*, p. 93.

72. Charles Ephrussi, in *Chronique des Arts*, April 23, 1881, p. 134; quoted in Oscar Reutersvard, "The Accentuated Brushstroke of the Impressionists: The Debate Concerning Decomposition in Impressionism," *Journal of Aesthetics and Art Criticism* 10(March 1952), pp. 273–278; reprinted in White, ed., *Impressionism in Perspective*, pp. 44–50; this quote (trans. L. S. Gruber), p. 49.

73. See François Fosca, "Jules Laforgue et la Gazette des Beaux-Arts," *Gazette des Beaux-Arts* 57(February 1961), pp. 123–125. On Laforgue, see also, M. Dufour, *Une philosophie de l'impressionnisme, étude sur l'esthétique de Jules Laforgue* (Paris, 1904); Michael Collie, Jules Laforgue (University of London: The Athlone Press, 1977); and David Arkell, *Looking for Laforgue: An Informal Biography* (New York: Persea Books, 1979). On the aesthetics of Charles Henry and his friendship with Laforgue, see José A. Argüelles, *Charles Henry and the Formation of a Psychophysical Aesthetic* (Chicago: University of Chicago Press, 1972), especially pp. 54–102; also the review of Argüelles' book by Herschel B. Chipp, in *The Art Bulletin* 60(March 1978), pp. 182–83.

74. Jules Laforgue, "L'Art impressionniste," in *Jules Laforgue, Oeuvres complètes* (Paris: Mercure de France, 1902–1903), vol. IV: *Mélanges posthumes*, pp. 133–145. Published in English under the title "Impressionism: The Eye and the Poet," trans.William Jay Smith, *Art News* 55 (May 1956), pp. 43–45; reprinted in Linda Nochlin, ed., *Impressionism and Post-Impressionism 1874–1904* (Englewood Cliffs, New Jersey: Prentice-Hall, 1966), pp. 15–20, these passages, pp. 15 and16.

75. Ibid., in Nochlin, *Impressionism*, p. 17.

76. Ibid., p. 20.

77. Ibid., p. 18.

78. Ibid.

79. Thoré, *Salon de 1844, précédé d'une lettre à Théodore Rousseau* (Paris, 1844), pp. 107–108.

80. Laforgue, "L'Art impressionniste," in Nochlin, *Impressionism*, p. 19.

81. Ibid., pp. 18–19.

82. In a letter of August 1888 to Signac, first published by John Rewald "Querelles d'Artistes," *Georges Seurat* (Paris: Editions Albin Michel, 1948), pp. 112–116; trans. and reprinted in Norma Broude, ed., *Seurat in Perspective* (Englewood Cliffs, N. J.: Prentice-Hall, 1978), pp. 103–107, this quote, p. 105.

83. Félix Fénéon, "Les Impressionnistes en 1886 (VIIIe Exposition Impressionniste)," *La Vogue*, June 13–20, 1886, pp. 261–275; reprinted with additions late in 1886 as a pamphlet under the title *Les Impressionnistes en 1886*; modern edn., in Fénéon, *Au-delà de l'impressionnisme*, ed. Françoise Cachin (Paris: Hermann, 1966), pp. 57–73; excerpts trans. by Nochlin in her *Impressionism*, pp. 108–110. On Fénéon's role as a critic, see Cachin, "Introduction" to Fénéon, *Au-delà de l'impressionnisme*, pp. 11–28, and Broude, "Introduction," *Seurat in Perspective*, pp. 3 ff.

84. See William I. Homer, *Seurat and the Science of Painting* (Cambridge: M.I.T. Press, 1964), pp. 17 ff.; on variants of this letter, see p. 268, n. 20.

85. Sometime before 1879, while still "au collège," Seurat, according to his own account, had read Charles Blanc's *Grammaire des arts du dessin* (Paris, 1867), which contained a discussion both of Chevreul's theories and Delacroix's ideas about color. He also read Blanc's essay on Delacroix, first published in the *Gazette des Beaux-Arts* (January and February 1864) and reprinted in *Artistes de mon temps* (Paris, 1876). See Homer, *Seurat and the Science of Painting*, pp. 17–18, 29–36, and 271–272, n. 46. On Blanc's attitudes and influence, see also Albert Boime, "Seurat and Piero della Francesca," *The Art Bulletin* 47(June 1965), pp. 265–271 (excerpts reprinted in Broude, *Seurat in Perspective*, pp. 155–162); and M. Song, *Art Theories of Charles Blanc, 1813–1882* (Ann Arbor: UMI Research Press, 1984).

86. Paul Signac, *D'Eugène Delacroix au neo-impressionnisme* (Paris: Editions de la Revue Blanche, 1899); first published serially in the *Revue Blanche* in 1898 and in the *Revue populaire des Beaux-Arts* in 1898–1899; modern edn., ed. Cachin (Paris: Hermann, 1964), this quote, pp. 96–97, trans. and reprinted in Broude, *Seurat in Perspective*, pp. 58–59.

87. For translations of substantial excerpts from this book as well as a general summary in English of its contents, see Nochlin, *Impressionism*, pp. 117–123.

88. Recently, scholars have taken up the question of how up-to-date or even accurate in scientific terms Seurat's practice really was, pointing, for example, to the limited and retardataire nature of his attachment to the ideas of Chevreul and Rood and his lack of interest in the work of Helmholtz. See Alan Lee, "Seurat and Science," *Art History* 10 (1987), pp. 203–226; and John Gage, "The Technique of Seurat: A Reappraisal," *The Art Bulletin* 69(1987), pp. 448–454.

89. In 1894, for example, Signac complained in his diary that the contemporary painter Jean-François Raffaëlli "is so well versed in our technique that he believes it consists solely in placing a red next to a blue in order to obtain violet, and a yellow beside a blue to make green"—see John Rewald, "Extraits du journal inédit de Paul Signac, I, 1894–1895," *Gazette des Beaux-Arts*, July–September 1949, p. 169. On the actual composition and arrangement of Seurat's palette, see William Innes Homer, "Notes on Seurat's Palette," *The Burlington Magazine* 101(May 1959), pp. 192–193; reprinted in Broude, *Seurat in Perspective*, pp. 116–120.

90. For examples drawn from early editions of Helen Gardner's *Art Through the Ages* and Robb and Garrison's *Art in the Western World*, see J. Carson Webster, "The Technique of Impressionism: A Reappraisal," *The College Art Journal* 4 (November 1944), pp. 3–4.

91. Ibid., pp. 3–22; excerpts reprinted in Broude, *Seurat in Perspective*, pp. 93–102.

92. John Rewald, *Post-Impressionism* (New York: The Museum of Modern Art, 1956), p. 86.

93. See Pissarro s letter (March 1886), in *Camille Pissarro, Letters to His Son Lucien*, ed. John Rewald with Lucien Pissarro, trans. Lionel Abel (New York: Pantheon Books, 1944), pp. 73–74; reprinted in Broude,

Seurat in Perspective, pp. 48–49.

94. The adjective is Alfred Sisley's, in a letter of April 21, 1898, cited by Rewald, *Seurat* (Paris, 1948), p. 126. On contemporary reactions to Seurat's technique, see also Broude,"New Light on Seurat's 'Dot': Its Relation to Photo-Mechanical Color Printing in France in the 1880s," *The Art Bulletin* 56 (December 1974), pp. 581–589, reprinted in Broude, *Seurat in Perspective*, pp. 163–175.

95. Rewald, *Post-Impressionism*, p. 90.

96. Letter of February 21, 1889, trans. by Rewald in *Post-Impressionism*, p. 130.

97. Camille Pissarro, letter sent to Henri van de Velde on March 27, 1896, but perhaps drafted earlier; trans. John Rewald in his *Georges Seurat* (New York: Wittenborn, 1946), p. 68; reprinted in Nochlin, *Impressionism*, p. 59.

98. See for example Ernst Brücke's statement of purpose in his *Principes scientifiques des Beaux Arts* (Paris, 1878), p. 8.

PART III: THE GENDERING OF IMPRESSIONISM

1. Griselda Pollock writes: "Going beyond offering feminist readings of individual modernist paintings or oeuvres we need to analyze the systems which generated them." See "Screening the Seventies: Sexuality and Representation in Feminist Practice—a Brechtian Perspective," in *Vision and Difference: Femininity, Feminism and the Histories of Art* (London and New York: Routledge, 1988), p. 159.

2. See Richard Shiff, "The End of Impressionism: A Study in Theories of Artistic Expression," *The Art Quarterly*, vol. I, no. 4 (Autumn 1978), pp. 338–378. Revised and reprinted as part one of Shiff's *Cézanne and The End of Impressionism: A Study of the Theory, Technique and Critical Evaluation of Modern Art* (Chicago: University of Chicago Press, 1984), pp. 3–52; and as "The End of Impressionism," in *The New Painting: Impressionism 1874–1886* (San Francisco: The Fine Arts Museums of San Francisco, 1986), pp. 61–89.

3. George Heard Hamilton, *Claude Monet's Paintings of Rouen Cathedral*, Charlton Lectures on Art, University of Newcastle upon Tyne (Newcastle upon Tyne, England, 1959).

4. See Maurice Bloch and Jean H. Bloch, "Women and the Dialectics of Nature in Eighteenth-Century French Thought," in *Nature, Culture and Gender*, eds. Carol P. MacCormack and Marilyn Strathern (Cambridge: Cambridge University Press, 1980), pp. 25–41. The roots of the nature/culture dichotomy in ancient myth and philosophy are uncovered in a forthcoming book by Mary D. Garrard, who explores the relevance of the concept for art and theory in the Renaissance. I am indebted to her for many valuable discussions and insights on these issues.

5. The relevant literature includes: Claude Lévi-Strauss, *The Elementary Structures of Kinship* (Boston: Beacon, 1969); Lévi-Strauss, *The Raw and the Cooked* (New York: Harper and Row, 1969); Sherry B. Ortner, "Is Female to Male as Nature is to Culture?" in *Woman, Culture and Society*, eds. Michelle Zimbalist Rosaldo and Louise Lamphere (Stanford: Stanford University Press, 1974), pp. 67–88; and Carol P. MacCormack, "Nature, Culture and Gender: A Critique," in MacCormack and Strathern, eds., *Nature, Culture and Gender*, pp. 1–23.

6. Aristotle, *De Generatione Animalium*, trans. A. Platt in J.A. Smith and W.D. Ross, eds., *The Works of Aristotle* (Oxford: Oxford University Press, 1910), pp. 716a, 732a, 737a, 741b, 767b. On the philosophical tradition in general, see Genevieve Lloyd, *The Man of Reason: "Male" and "Female" in Western Philosophy* (Minneapolis: University of Minnesota Press, 1984).

7. On the issue of gender differentiation as both a construct of and a contributing factor in the evolution of modern science, the germinal studies (in order of their publication) include: Carolyn Merchant, *The Death of Nature: Women, Ecology, and the Scientific Revolution* (San Francisco: Harper and Row, 1980); Brian Easlea, *Science and Sexual Oppression: Patriarchy's Confrontation with Woman and Nature* (London: Weidenfeld and Nicolson, 1981); Evelyn Fox Keller, *Reflections on Gender and Science* (New Haven: Yale University Press, 1985); Sandra Harding, *The Science Question in Feminism* (Ithaca: Cornell University Press, 1986); and Linda Schiebinger, *The Mind Has No Sex? Women in the Origins of Modern Science* (Cambridge: Harvard University Press, 1989).

8. René Descartes, *Discourse on Method*, trans. L.J. Lafleur (London: Liberal Arts Press, 1956), pt. 6, p. 40.

9. "What we encounter in Cartesian rationalism," says Karl Stern, "is the pure masculinization of thought," in *The Flight From Woman* (New York: Noonday Press, 1965), p. 104. See also Susan Bordo, "The Cartesian Masculinization of Thought," *Signs: Journal of Women in Culture and Society* vol. II, no. 3 (Spring 1986), pp. 439–456.

10. Bacon's use of sexual metaphor is most fully discussed by Evelyn Fox Keller, upon whose work my own account closely depends. See in particular her "Gender and Science," *Psychoanalysis and Contemporary Thought* vol. I, no. 3 (1978), pp. 409–433; "Baconian Science: A Hermaphroditic Birth," *Philosophical Forum* vol. 11, no. 3 (1980), pp. 299–308; and *Reflections on Gender and Science*, pp. 33–54. See also Lloyd, *The Man of Reason*, pp. 10–17; and Easlea, *Science and Sexual Oppression*, pp. 83–86.

11. Francis Bacon, *The Refutation of Philosophies*, trans. B. Farrington, in *The Philosophy of Francis Bacon: An Essay on Its Development from 1603 to 1609 with new translations of fundamental texts* (Liverpool: Liverpool University Press, 1964), p. 131.

12. Bacon, *The Masculine Birth of Time*, chapter 1, in Farrington, *The Philosophy of Francis Bacon*, p. 62.

13. Bacon, *The Masculine Birth of Time*, chapter 2, in Farrington, *The Philosophy of Francis Bacon*, p. 72.

14. J. Spedding, R.L. Ellis, and D.D. Heath, eds., *The Works of Francis Bacon*, 14 vols. (1857–1874; reprinted Stuttgart: F.F. Verlag, 1963), vol. 5, p. 506.

15. Adam Sedgwick, "Vestiges of the Natural History of Creation," *The Edinburgh Review* 82 (1845); cited by Easlea, *Science and Sexual Oppression*, p. 103.

16. Emil du Bois-Reymond, "Civilization and Science," *Popular Science Monthly* 13 (1879), p. 262; cited by Easlea, *Science and Sexual Oppression*, p. 2.

17. Ludmilla Jordanova, *Sexual Visions: Images of Gender in Science and Medicine Between the Eighteenth and Twentieth Centuries* (Madison: The University of Wisconsin Press, 1989), p. 87. See also, Jordanova, "Natural Facts: A Historical Perspective on Science and Sexuality" (1980), in MacCormack and Strathern, eds., *Nature, Culture and Gender*, pp. 42–69; and Harding, *The Science Question in Feminism*, pp. 117–118. The statue was first published and discussed in terms of modern science's gendered drive for dominion over nature by Carolyn Merchant, *The Death of Nature*, pp. 189–191.

18. See Mary D. Garrard, "Leonardo da Vinci: Female Portraits, Female Nature," in *The Expanding Discourse: Feminism and Art History*, eds. Norma Broude and Mary D. Garrard (New York: HarperCollins, to appear 1992).

19. Humphry Davy, *A Discourse, Introductory to a Course of Lectures on Chemistry* (London: J. Johnson, 1802), no. 16.

20. Laura Crouch, "Davy's *A Discourse, Introductory to a Course of Lectures on Chemistry*: A Possible Scientific Source of *Frankenstein*," *Keats-Shelley Journal* 27 (1978), pp. 35–37; and Anne K. Mellor, "*Frankenstein*: A Feminist Critique of Science," in *One Culture: Essays in Science and Literature*, ed. George Levine (Madison: The University of Wisconsin Press, 1987), pp. 287–312.

21. Mellor, "*Frankenstein*: A Feminist Critique of Science," in *One Culture*, pp. 302–305.

22. Mellor, "*Frankenstein*: A Feminist Critique of Science;" see also Mellor, "Possessing Nature: The Female in *Frankenstein*," in *Romanticism and Feminism*, ed. Mellor (Bloomington: Indiana University Press, 1988), pp. 220–232.

23. Alan Richardson, "Romanticism and the Colonization of the Feminine," in *Romanticism and Feminism*, ed. Mellor, pp. 13–25. Androgyny as an attribute of male "genius" during the Romantic period is also explored by Christine Battersby, *Gender and Genius: Towards A Feminist Aesthetics* (Bloomington: Indiana University Press, 1989).

24. Mellor, "On Romanticism and Feminism," intro. to *Romanticism and Feminism*, p. 7. See also, Marlon B. Ross, "Romantic Quest and Conquest: Troping Masculine Power in the Crisis of Poetic Identity," in *Romanticism and Feminism*, pp. 26–51.

25. Charles Baudelaire, "The Painter of Modern Life" (1863) and "The Life and Work of Eugène Delacroix' (1863), in *The Painter of Modern Life and Other Essays*, trans. Jonathan Mayne (Oxford: Phaidon Press, 1964), these quotes, pp. 30 and 45.

26. Baudelaire, "The Life and Work of Eugène Delacroix," *The Painter of Modern Life and Other Essays*, pp. 45 and 46.

27. Baudelaire, "The Salon of 1846," in *The Mirror of Art: Critical Studies by Baudelaire*, trans. and ed. Jonathan Mayne (Garden City, New York: Doubleday Anchor Books, 1956), p. 57.

28. Baudelaire, "The Life and Work of Eugène Delacroix," *The Painter of Modern Life and Other Essays*, p. 46.

29. On the eight group exhibitions, see *The New Painting: Impressionism 1874–1886* (San Francisco: The Fine Arts Museums of San Francsico, 1986). For a study of the effects of gendered discourse on French art criticism, in terms other than those explored here, see Anne Higonnet, "Writing the Gender of the Image: Art Criticism in Late Nineteenth-Century France," *Genders* 6 (Fall 1989), pp. 60–73.

30. William H. Gerdts, "Impressionism in the United States," in *World Impressionism*, ed. Norma Broude (New York: Abrams, 1990), p. 36. The comments quoted by Gerdts are from "The Fine Arts: The French Impressionists," *The Critic* 120 (April 17, 1886), pp. 195–196.

31. Tamar Garb, "'L'Art Féminin': The Formation of a Critical Category in Late Nineteenth-Century France," *Art History* 12 (March 1989), pp. 39–65. See, also, the introduction by Kathleen Adler and Tamar Garb to the new edition of *Berthe Morisot: The Correspondence*, ed. Denis Rouart (New York: Moyer Bell Limited, 1987), pp. 6–8; Adler and Garb, *Berthe Morisot* (Oxford: Phaidon Press, 1987), pp. 57 and 64–65.

32. C. Dissard, "Essai d'esthétique féminine," *La Revue feministe* I (1895), p. 41; cited by Garb, "'L'Art Féminin'", p. 63, note 51.

33. Henri de Varigny, "Femme," *La Grande Encyclopédie*, vol. 17, pp. 143–170; cited and translated by Garb, "'L'Art Feminin,'" pp. 49 and 63, note 44. The *Grande Encyclopédie* was published in thirty-one volumes from 1886 to 1902. The *Larousse Grand dictionnaire universel du XIXe siècle* appeared in fifteen volumes from 1865 to 1876, with a two-volume supplement (1878–1890). On the latter, see Roger Bellet, "La Femme dans l'idéologie du *Grand dictionnaire universel* de Pierre Larousse," in *La Femme au XIXe siècle, littérature et idéologie* (Lyon: Presses Universitaires de Lyon, 1979), pp. 19–27. In the 1890s, when science had to reverse its descriptions of the male and female brain, finding that the frontal lobes were actually larger in women than in men, it was decreed that the size of the occipital lobes determined intellectual development, so that science's conclusions regarding women's intellectual inferiority could go unchanged! (See Easlea, *Science and Sexual Oppression*, pp. 144–146.)

34. C. Turgeon, *Le Féminisme français* (Paris, 1907), pp. 169 and 180; cited by Garb, "'L'Art Féminin'", p. 62, note 41.

35. Camille Mauclair, "Les Salons de 1896," *La Nouvelle Revue* 100 (May–June, 1896), pp. 342–343; cited by Garb, "'L'Art Féminin'", p. 60, note 22.

36. Garb, "'L'Art Féminin'", p. 44.

37. Richard Shiff, "The End of Impressionism," in *The New Painting: Impressionism 1874–1886*, p. 73. Shiff's citation of Comte is from Auguste Comte, *Discours sur l'ensemble du positivisme* (Paris, 1848), pp. 276ff. On positivism, see also D.G. Charlton, *Positivist Thought in France During the Second Empire 1852–1870* (Oxford, 1959).

38. The phrase is June Wayne's. See her "Male Artist as Stereotypical Female," *Art Journal* 32 (Summer 1973), pp. 414–416 for a discussion of the feminization of the male artist in twentieth-century America; and Mary D. Garrard, "'Of Men, Women and Art: Some Historical Reflections," *Art Journal* 35 (Summer 1976), pp. 324–329, for a consideration of the gendered identity of art itself in nineteenth-century American culture.

39. Auguste Comte, "Leçon 50," *Cours de philosophie positive*, vol. IV (Paris, 1839); trans. Harriet Martineau, in *Women, the Family, and Freedom: The Debate in Documents*, vol. I: *1750–1880*, eds. Susan Groag Bell and Karen M. Offen (Stanford: Stanford University Press, 1983), pp. 220–221.

40. Ibid., p. 221.

41. Auguste Comte, *Système de politique positive*, vol. I (Paris, 1848); trans. J. H. Bridges, in *Women, the Family, and Freedom*, p. 224.

42. Susan Bordo, "The Cartesian Masculinization of Thought," *Signs: Journal of Women in Culture and Society* 11 (Spring 1986), p. 456.

43. For example, see Carol M. Armstrong's analysis of the ways in which Degas's formal strategies and spatial constructions threatened the traditionally privileged position of the male spectator and worked to ex-ternalize him from the female subjects of the bather compositions ("Edgar Degas and the Representation of the Female Body," in *The Female Body in Western Culture: Contemporary Perspectives*, ed. Susan R. Suleiman (Cambridge: Harvard University Press, 1986), pp. 230–241.

44. Griselda Pollock, "Modernity and the Spaces of Femininity," in *Vision and Difference: Femininity, Feminism and the Histories of Art* (London and New York: Routledge, 1988), pp. 50–90.

45. Georges Clemenceau, *Claude Monet, Les Nymphéas* (Paris: Plon, 1928), p. 101.

46. Lilla Cabot Perry, "Reminiscences of Claude Monet from 1889–1909," *American Magazine of Art* 18 (March 1927), pp. 119–125; reprinted in *Perry: An American Impressionist*, catalogue by Meredith Martindale with the assistance of Pamela Moffat (Washington, D.C.: The National Museum of Women in the Arts, 1990), pp. 115–118, this quote, p. 117.

47. As reported by Ambroise Vollard, *Paul Cézanne* (Paris, 1914), p. 88; and Joachim Gasquet, *Cézanne* (Paris, 1921), p. 90.

48. The reliability of these "witness" accounts was first called into question by John Rewald, *Cézanne, Geffroy et Gasquet suivis de souvenirs sur Cézanne de Louis Aurenche et des lettres inédites* (Paris, 1959), pp. 51–55; and by Theodore Reff, "Cézanne and Poussin," *Journal of the Warburg and Courtauld Institutes* 23 (1960), pp. 150–174.

49. Letter dated 23 October 1905 to Emile Bernard, in *Paul Cézanne: Letters*, ed. John Rewald (London: Cassirer, 1941), pp. 251–252.

50. Shiff, *Cézanne* (1984), p. 7. Shiff's work on these issues has been published in three overlapping versions (see above, note 1). Unless the cited material is unique to one of these versions, I will henceforth cite only the 1984 book, which provides the most complete presentation of the author's argument.

51. Shiff, *Cézanne* (1984), p. 7.

52. Albert Aurier, "Le Symbolisme en peinture: Paul Gauguin," *Mercure de France* II (March 1891), in *Oeuvres posthumes*, ed. Rémy de Gourmont (Paris: Mercure de France, 1893), pp. 205, 208–211; as cited by Shiff, *Cézanne* (1984), pp. 45 and 46.

53. Aurier, "Essai sur une nouvelle méthode de critique" (1892), *Oeuvres posthumes*, p. 176; as cited by Patricia Townley Mathews, *Aurier's Symbolist Art Theory and Criticism* (Ann Arbor: UMI Research Press, 1986), p. 22.

54. Aurier, "Les Peintres symbolistes" (1892), *Oeuvres posthumes*, p. 294; as cited by Mathews, *Aurier's Symbolist Art Theory*, p. 22.

55. Mathews, *Aurier's Symbolist Art Theory*, p. 22.

56. Aurier, "Eugène Carrière" (1891), *Oeuvres posthumes*, p. 279; as cited by Mathews, *Aurier's Symbolist Art Theory*, p. 46.

57. Mathews, ibid., cites the pertinent writings.

58. Aurier, "Raffaëlli" (1890), *Oeuvres posthumes*, p. 250; as cited by Mathews, *Aurier's Symbolist Art Theory*, p. 110.

59. Octave Mirbeau, "Vincent van Gogh," *L'Echo de Paris*, 31 March 1891, p. 1; as cited by Shiff, *Cézanne* (1984), p. 50.

60. Henri Matisse, "Notes of a Painter" (1908), trans. and reprinted in Alfred H. Barr, Jr., *Matisse, His Art and His Public* (New York: The Museum of Modern Art, 1951), p. 120.

61. Roger Fry and Desmond MacCarthy, "The Post-Impressionists," *Manet and the Post-Impressionists* (London: Grafton Galleries, 1910), p. 7; as cited by Shiff, *Cézanne*, p. 158.

62. Fry and MacCarthy, "The Post-Impressionists," pp. 8–9; as cited by Shiff, *Cézanne*, p. 158.

63. Shiff, *Cézanne*, p. 158.

64. Ibid., p. 36.

65. Ibid., pp. 50–52, and Shiff, "The End of Impressionism," in *The New Painting*, p. 86.

66. Shiff, *Cézanne*, p. 11.

67. Ibid., p. 159.

68. Camille Mauclair, "Les Salons de 1896," *La Nouvelle Revue* 100 (May–June, 1896), pp. 342–343; cited by Garb, "'L'Art Féminin,'" p. 60, note 22; translation mine.

69. Claude Roger-Marx, *Gazette des Beaux-Arts*, 1907, p. 507; as cited by Griselda Pollock, *Mary Cassatt* (London: Jupiter Books, 1980), p. 21.

70. Bacon, *The Refutation of Philosophies*, trans. B. Farrington, in *The Philosophy of Francis Bacon*, p. 131.

71. Gauguin's instructions to his disciple Paul Sérusier, as reported in W. Verkade, *Le Tourment de Dieu* (Paris, 1926), pp. 75–76; as cited in

John Rewald, *Post-Impressionism* (New York: The Museum of Modern Art, 1956), p. 206.

72. Ernest Renan, *The Future of Science: Ideas of 1848* (London: Chapman and Hall, 1891), pp. V and XI.

73. On these issues, see Henry Guerlac, "Science and French National Strength" (1951), in *Essays and Papers in the History of Modern Science*, (Baltimore: The Johns Hopkins University Press, 1977), pp. 491–509; and Harry W. Paul, "The Debate over the Bankruptcy of Science in 1895," *French Historical Studies* 5 (Spring 1968), pp. 299–327.

74. For a discussion of these issues, see Robert L. Herbert, "The Decorative and the Natural in Monet's Cathedrals, " *Aspects of Monet*, eds. John Rewald and Frances Weitzenhoffer (New York: Abrams, 1984), pp. 160–179.

75. Georges Lecomte, "L'Art contemporain." *La Revue indépendante* 23 (1892), p. 23; as cited and translated by Herbert, "The Decorative and the Natural in Monet's Cathedrals," p. 167 and note 16.

76. Lecomte, p. 29; as cited by Herbert, "The Decorative and the Natural in Monet's Cathedrals," p. 167 and note 17.

77. See Herbert, "The Decorative and the Natural in Monet's Cathedrals." On the responses of contemporary critics to the Cathedral series, see Steven Z. Levine, *Monet and His Critics* (New York: Garland Publishing, 1976), chapter IV, pp. 177–222.

78. See Monet's letter to Alice Hoschedé, 23 March 1895 (Wildenstein 1196); cited by Paul Hayes Tucker, *Monet in the '90s: The Series Paintings* (New Haven: Yale University Press, 1989), p. 186.

79. Léon Bazalgette, *L'Esprit nouveau dans la vie artistique, sociale et religieuse* (Paris: Société d'éditions litteraires, 1898), pp. 384 and 385; as cited and translated by Herbert, "The Decorative and the Natural in Monet's Cathedrals," p. 169.

80. Bazalgette, pp. 385 ff; as cited by Herbert, p. 169.

81. Bazalgette, p. 389; as cited by Herbert, p. 169.

82. The phrase recurs in Clemenceau's discussions of Monet's art. See for example, Georges Clemenceau, *Claude Monet, Les Nymphéas*, pp. 22–24.

83. Georges Clemenceau, "Révolution de Cathédrales," essay of 1895 in *La Justice*, revised and reprinted in Clemenceau, *Claude Monet, Les Nymphéas*, pp. 75–91, these quotes, pp. 86–87.

84. Ibid., pp. 88, 90–91. (The passage that Clemenceau quotes from Duranty can be found here above, in translation, chapter 6.)

85. On the relationship between Monet and Clemenceau, see André Wormser, "Claude Monet et Georges Clemenceau: une singulière amitié," in *Aspects of Monet*, eds. Rewald and Weitzenhoffer, pp. 188–217; also, Jean-Baptiste Duroselle, *Clemenceau* (Paris: Fayard, 1988), pp. 397–416 and pp. 911–921. On contemporary critical reactions to the Nymphéas series and the controversies surrounding Monet's gift of the Nymphéas decorations to the state and their installation in the Orangerie of the Louvre, see Levine, *Monet and His Critics*, chapters VII and VIII, pp. 297–359.

86. Letter of 15 February 1889 to Berthe Morisot (Wildenstein 910). See the discussion in Tucker, *Monet in the '90s*, pp. 11ff and *passim*.

87. Clemenceau, *Claude Monet, les nymphéas* (1928), p. 27.

88. Ibid., pp. 103–105.

89. Ibid., p. 107.

90. Ibid., p. 79.

91. Ibid., pp. 35–36.

92. Ibid., p. 10.

93. See Guerlac, "Science and the French National Strength," in *Essays and Papers in the History of Modern Science*, p. 500.

94. Roger Fry, *Characteristics of French Art* (London: Chatto and Windus, 1932) p. 127.

95. James Johnson Sweeney, *Plastic Redirections in Twentieth-Century Painting* (Chicago, 1934), p. 6.

96. Clemenceau, *Claude Monet, les nymphéas* (1928), p. 23.

97. On Monet's commercial and critical successes from 1889 on, see Levine, *Monet and His Critics*, pp. 95ff and 181ff; also Tucker, *Monet in the '90s, passim*. On the worldwide impact and popularity of French Impressionism, see Norma Broude, "A World in Light: France and the International Impressionist Movement, 1860–1920," in *World Impressionism*, pp. 8–35, and *passim*.

98. See Albert Boime, "Entrepreneurial Patronage in Nineteenth-Century France," in *Enterprise and Entrepreneurs in Nineteenth-and Twentieth-Century France*, eds. Edward C. Carter II, Robert Forster, and Joseph N. Moody (Baltimore: The Johns Hopkins University Press, 1976), pp. 137–207; especially pp. 154ff and 181ff. On related issues, see Linda Whiteley, "Art et commerce d'art en France avant l'époque impressionniste," *Romantisme* 4 (1983), pp. 65–75; and Nicholas Green, "Dealing in Temperaments: Economic Transformations of the Artistic Field in France During the Second Half of the Nineteenth Century," *Art History* 10 (1987), pp. 59–78.

99. On these issues, see Norma Broude, "Miriam Schapiro and 'Femmage': Reflections on the Conflict Between Decoration and Abstraction in Twentieth-Century Art," *Arts Magazine*, February 1980, pp. 83–87; reprinted in *Feminism and Art History: Questioning the Litany*, eds. Norma Broude and Mary D. Garrard (New York: Harper and Row, 1982), pp. 315–329.

100. Timothy J. Clark, *The Painting of Modern Life, Paris in the Art of Manet and His Followers* (New York: Alfred A. Knopf, 1985).

101. See Clark's discussion of "The Environs of Paris," in *The Painting of Modern Life*, pp. 147–204; and Paul Hayes Tucker, *Monet at Argenteuil* (New Haven: Yale University Press, 1982).

102. Joel Isaacson, "Observation and Experiment in the Early Work of Monet," in *Aspects of Monet*, pp. 14–35, these quotes; pp. 17, 24–25, and 34, note 29.

103. Charles F. Stuckey, "Monet's Art and the Act of Vision," in *Aspects of Monet*, pp. 108–121, these quotes, p. 113.

104. John Updike, "Monet Isn't Everything: An Orgy of Impressionism in Boston," *The New Republic*, March 19, 1990, pp. 28–30; these quotes, pp. 28 and 30.

105. Carol Duncan, "The MoMA's Hot Mamas," *Art Journal* 48 (Summer 1989), pp. 171–178; these quotes and remarks; pp. 171–173, 176. See, also, Carol Duncan and Alan Wallach, "The Museum of Modern Art as Late Capitalist Ritual: An Iconographic Analysis," *Marxist Perspectives* 1 (Winter 1978), pp. 28–51; and the observations of Griselda Pollock, "Screening the Seventies," in *Vision and Difference*, p. 159.

106. Clement Greenberg, "'American-Type' Painting" (1955/1958), *Art and Culture* (Boston: Beacon Press, 1961), p. 221.

107. Clement Greenberg "The Later Monet" (1956/1959), in *Art and Culture*, p. 41.

108. Ibid., pp. 41–42.

109. Ibid., p. 42.

110. Ibid., p. 44.

111. Arthur O. Lovejoy, *The Great Chain of Being* (originally published, 1936; Cambridge: Harvard University Press, 1966); Morse Peckham, "Toward a Theory of Romanticism," *PMLA* 66 (1951), pp. 5–23; Michel Foucault, *The Order of Things: An Archaeology of the Human Sciences* (New York: Vintage/Random House, 1973). On this point of view, see also the comments of Hans Eichner, "The Rise of Modern Science and the Genesis of Romanticism," *PMLA* 97 (1982), pp. 8–30. The Romantic philosophy, Eichner argues, may have had continuing validity for the arts in the modern era but not for the sciences. There, he says, it has been unproductive, because it rejected what he regards as the still-valid "basic heuristic assumption of science," the assumption "that the phenomena of the world are causally determined in conformity with the laws of nature."

112. Vincent van Gogh, letter to Theo (1888), in V.W. van Gogh, ed., *The Complete Letters of Vincent van Gogh*, trans. J. van Gogh-Bonger and C. de Dood, 3 vols. (Greenwich, Connecticut: New York Graphic Society, 1958), vol. 3, p. 6.

113. Ibid., vol 3, p. 25.

114. Surrealism, which equated the unconscious with female Nature (fearing its eruptive powers but desiring at the same time to harness and control those powers through art), presents a different but not unrelated side of art's attitude toward nature in the twentieth century, one that also had a major impact on the art of the Abstract Expressionists whom Greenberg championed. On the importance of psychoanalytic discourses for painters of the New York School, see Michael Leja, "Jackson Pollock: Representing the Unconscious," *Art History* 13 (December 1990), pp. 542-565.

115. Clement Greenberg, "On the Role of Nature in Modernist Painting" (1949), in *Art and Culture*, pp. 171–174.

Aquado, Count Olympe, *36*
 Ile des Ravageurs, Meudon, 36
Aristotle, 145
art:
 binary thinking in, 10, 11,
 12–13, 14, 16, 19, 20, 41,
 143, 145, 149–150, 177
 gendered relation between
 nature, science and, 14,
 16, 143, 145–158,
 161–162, 163–165, 167,
 173, 175, 176, 177–178,
 179
 science and, 110, 114–123,
 134, 137, 143, 144, 145,
 161, 179
Aurier, Albert, 160–161, 165,
 178

Bacon, Francis, 112, 146, 148,
 164, 179
 Masculine Birth of Time, The,
 146
Barbizon school, 9, 30, 34,
 35, 40, 41, 43, 53, 55, 57,
 70, 127, 136, 151, 171
Barrias, Louis Ernest, 147,
 147
 *Nature Unveiling Herself
 Before Science,* 147, *147*
Baudelaire, Charles, 54, 149,
 150–151
Bazalgette, Léon, 167
Bazille, Jean-Frédéric, 43,
 65, 68, 71–72, 74
Beauvoir, Simone de, 174
Berkeley, George, 132
Bernard, Claude, 113, 173
Blake, William, 115, 120
Blanc, Charles, 14, 70, 139,
 143
Boime, Albert, 31, 79
Bordo, Susan, 154
Boudin, Eugène, 41–42, *42,*
 64, 68, 151
 Beach at Trouville,42
Bourget, Paul, 165–166
 Disciple, Le, 165–166
Bowness, Alan, 57, 64
Brücke, Ernst Wilhelm von,
 113, 143
Burty, Philippe, 28, 29,
 34–35

Carus, Carl Gustav, 120–121
Cassatt, Mary, 155, 156, *157*
 Woman and Child Driving,
 156, *157*
Castagnary, Jules, 28, 121
Cézanne, Paul, 159, 160, 163
Champa, Kermit, 8, 55
Chesneau, Ernest, 35
Chevreul, Eugène, 116–117,
 139

chiaroscuro, 30, 32, 33, 131
 see also effect; light
Clark, Kenneth, 32
Clark, T. J., 9, 172, 173
Clemenceau, Georges, 157,
 166, 167–170, 171
Coleridge, Samuel Taylor,
 119–120
color, 110, 130–131, 132,
 135, 158
 in Delacroix's works,
 116–117, 139
 in Impressionist works,
 124, 125–126, 127, 131,
 138, 139, 167
 in Monet's works, 169
 in Neo-Impressionist
 works, 138–141
 Newton and, 114, 115, 126
 Rousseau on, 35
 in Turner's works, 33, 63
Comte, Auguste, 121, 143,
 153–154, 173
 see also positivism
Constable, John, 17, 23–24,
 31–33, 57, 61, 62, 65,
 117–119, 120, 127
 Cloud Study, 118, 119
 Haywain, The, 57,
 colorplates 16, 17
 Weymouth Bay, colorplate 12
Corot, Jean-Baptiste-
 Camille, 17, 37–41, 53, 57,
 62, 64, 65, 73, 74, 79
 *Daubigny Working on His
 "Botin" near Auvers-sur-
 Oise,* 52
 Harbour of La Rochelle, The,
 colorplate 19
 Souvenir of Mortefontaine, 40
Courbet, Gustave, 16, 121,
 122, 125

Daubigny, Charles François,
 17, 41–42, 50–57, 64, 70
 Artist in His Floating Studio,
 52
 Landscape near Pontoise, 56,
 57
 Monet influenced by,
 50–53, 56, 57, 64, 68
 Portjoie on the Seine, 53
 River Scene near Bonnières,
 colorplate 25
 Thames at Erith, The, 60
 *View of the Crystal Palace Park
 in London,* 59
 Windmills at Dordrecht, 62, 64
 working methods of, 53–54,
 55, 64, 69–71
Degas, Edgar, 15, 125, 128,
 128, 130, 151
 Portrait of Diego Martelli, 128
De Kooning, Willem, 175

Woman I, 175
Delacroix, Eugène, 41, *117,*
 122, 149, 150, *150,* 176,
 177
 color as used by, 116–117,
 139
 Death of Sardanapalus, 149,
 150
 sketches of, 70–71
 *Taking of Constantinople by
 the Crusaders,* 116–117, *117*
Descartes, René, 146
Dewhurst, Wynford, 57–63
Duncan, Carol, 174–175
Durand-Ruel, Paul, 56–57,
 64, 78
Duranty, Edmond, 124–127,
 128, 133, 134, 167–168
Dürer, Albrecht, 147, 148
 *Artist and Model:
 Demonstration of Perspective,*
 147, *148*
Duret, Théodore, 13, 17

Easlea, Brian, 16, 146
Effect, 28–68, 69, 128, 130
 defined, 30
 finish vs., 69–80
 impression vs., 30–31
 see also pochades
emotion, 28–68, 69, 70, 80,
 120, 134, 153
English landscape school,
 57–64, 65
Ephrussi, Charles, 134

Fattori, Giovanni, 130, *130*
 *Diego Martelli at
 Castiglioncello,* 57
Fénéon, Félix, 75, 138–139,
 140, 142
figurative painting, 9, 15, 178
 landscape painting vs.,
 150–151, 176
Foucault, Michel, 14–15,
 160, 176
France, Anatole, 10, 166
Friedlaender, Walter J., 10,
 14
 David to Delacroix, 10
Friedrich, Caspar David, 17,
 18–20, *21, 23, 27,* 65,
 colorplate 8
 Chalk Cliffs on Rügen, 19–20,
 colorplate 8
 Stages of Life, The, 21
 *Village Landscape in the
 Morning Light ("The
 Solitary Tree"),* 27
Fry, Roger, 8–9, 10, 162, 170

Gage, John, 33
Garb, Tamar, 151, 152
Garrard, Mary D., 147

Gauguin, Paul, 160, 161
Gautier, Théophile, 17, 54
Geffroy, Gustave, 11, 43, 75,
 163, 166, 167
Géricault, Théodore, 116, *116*
 *Insane Woman, The
 (Monomanie de L'Envie),*
 116
 Portraits of the Insane, 116
Gillet, Louis, 169
Goethe, Johann Wolfgang
 von, 111, 120, 132
Gogh, Vincent van, 22, 160,
 161, 176–177
Greenberg, Clement, 11,
 175–176, 177–178

Hamerton, P. G., 70
Hamilton, George Heard,
 11–12, 28, 145
Hareux, Ernest, 69
Helmholtz, Hermann von,
 10, 113, 132, 133, 134,
 143, 173
Henriet, Frédéric, 53, 54, 55
Henry, Charles, 134
Herbert, Robert, 9, 13, 20,
 21, 79
Honour, Hugh, 120

Imbriani, Vittorio, 30
Impressionism, Impressionist
 works:
 color in, 124, 125–126, 127,
 131, 138, 139, 167
 composition in, 155–157, 158
 effect and emotion in,
 28–68
 effect vs. finish in, 69–80
 entrepreneurs' collecting of,
 171–172, 174
 formalist view of, 8–9, 18
 light in, 125–126, 127, 130,
 167–168, 169
 nature and, 69, 110, 151,
 156–157, 158, 161, 162,
 163, 172, 179
 outdoor painting in, 28, 29,
 69, 124, 127
 paint surface and
 brushwork in, 11, 73, 74,
 79, 80, 151, 152
 Romanticism as opposed to,
 8, 9–10, 11, 14, 18, 110,
 125–126, 144, 145, 177
 Romantic roots of, 10, 15,
 18–24, 31, 69, 70, 110,
 127, 136, 137, 143, 158
 scientific realism as reputed
 objective of, 8–9, 10–11,
 12, 13–14, 15–16, 31, 65,
 110–143, 144, 145, 158,
 160, 162, 163–164, 167,
 168–171, 173, 174, 179

sociohistoric approach to, 8–9, 18, 172
subjectivity of, 13, 31, 69, 110, 126–127, 135–137, 143, 144, 158, 163–164, 174
techniques of, 162, 164, 173
Impressionism, gendering of, 144–180, 172
as feminine, 14, 16, 110, 144, 151, 152, 154–155, 158, 161, 162, 163, 164, 165, 171, 172, 172, 174, 179
feminine to masculine shift in, 110, 144, 165–174, 174, 178–179, 179–180
as masculine, 16, 144, 171–174, 174, 180
Isaacson, Joel, 13, 72, 73, 173

Janis, Eugenia Parry, 35, 37
Jongkind, Johan Barthold, 17, 41, 43, 43, 49, 50, 64, 70, 73, colorplate 21
as Monet's mentor, 42–43, 45–50, 68
Chapel of Notre Dame de Grâce, Honfleur, The, 43
Entrance to the Port of Honfleur (Windy Day), colorplate 21
Port of Antwerp, Sunset, The, 50, 50
View of Notre Dame, Paris, 49
View of Notre Dame at Sunset, 49
Jordanova, Ludmilla, 147

Keller, Evelyn Fox, 16, 146
Knight, D. M., 112
Kuhn, Thomas, 16, 112

Lacan, Ernest, 35–37
Laforgue, Jules, 124, 127, 133, 134–137
landscape painting, 9, 15, 117, 120, 177, 178
effect in, see effect
English school of, 57–64, 65
figurative painting vs., 150–151, 176
Le Gray, Gustave, 37, 38, 43
Forest of Fontainebleau, 38
Leonardo da Vinci, 124
Le Secq, Henri, 36
Sunset in Dieppe, 36
light, 28, 29, 31, 120, 125, 131, 132, 135, 155
in Constable's works, 31–33
in Impressionist works, 125–126, 127, 130, 167–168, 169

in Monet's works, 24, 29, 43, 73, 74, 75–77, 80, 175
Newton and, 114, 115
in Turner's works, 24, 33–34
see also effect
line, 10, 134–135, 158
Littré, Emile, 121, 143, 153
Lorrain, Claude, 50, 51, 62, 155
Seaport with Setting Sun, 51
Lovejoy, Arthur O., 113, 176

MacCarthy, Desmond, 162
Macchiaioli, 30, 127–128, 130, 133
Mach, Ernst, 114
Manet, Edouard, 9, 15, 67, 128, 130, 151, 162
Monet Painting in His Studio-Boat, 67
Marcussen, Marianne, 126
Martelli, Diego, 15, 124, 127–133, 134, 135
Mathews, Patricia, 161
Matisse, Henri, 57, 162
Mauclair, Camille, 152, 163, 169
Merchant, Carolyn, 16, 146
Millet, Jean-François, 12, 17, 23, 34, 43, 44, 57, colorplate 11
Grainstacks, 23
Grain Stacks—Autumn, colorplate 11
Women Carrying Wood, 44
Mirbeau, Octave, 75, 76, 161, 162, 166
modernism, 174–179
Monet, Claude, 15, 18, 31, 43, 57, 139, 142, 151, 155, 157–158, 162, 163, 168–169, 173
Banks of the Seine at Argenteuil, The, 18, 19
Beach at Sainte-Adresse, The, colorplate 13
Boudin and, 41–42
Camille or Woman in a Green Dress, 122, 123
Cathedral of Rouen, Effect of Sunlight, 11–12, colorplate 2
Cathedral of Rouen, West Façade, 11–12, colorplate 3
Chapel of Notre Dame de Grâce, Honfleur, The, 43
Daubigny's influence on, 50–53, 56, 57, 64, 68
English landscape painters and, 57, 61, 63–64, 65
Garden at Sainte-Adresse, 20, colorplate 9

Gare Saint-Lazare, Arrival of a Train, 29
Gare Saint-Lazare, The, colorplates 29, 30, 31, 32
Grain Stack, Effect of Snow, Morning, 11, colorplate 1
Grain Stacks, Setting Sun, 11, colorplate 10
Grenouillère, La, colorplates 27, 28
as pochade, 72–73
Houses of Parliament, The, colorplate 5
Hyde Park, London, 59
Impression, Sunrise, 50, 50, 73, colorplate 23
individuality important to, 65–68
influences on, 41–53, 56, 57, 64, 65, 68
Japanese Footbridge at Giverny, The, colorplate 7
Jetty of Le Havre in Bad Weather, The, 23, 25
Jongkind as mentor of, 42–43, 45–50, 68
Morning Haze, colorplate 15
Mouth of the Seine at Honfleur, colorplate 22
nature and, 175–176
as "only an eye," 13, 159, 163, 167, 169, 173
Oak Tree at Bas-Bréau (Le Bodmer), An, 43, 45
politics and, 166, 168
Poplars on the Banks of the Epte, 78
Port-Domois, 77
Port-Domois at Belle-Ile, 76
River Basin of London, The, 60
Road to the Saint-Siméon Farm, Summer, 46
Road to the Saint-Siméon Farm, Winter, 47
Rocks at Belle-Ile, 26
Seacoast at Trouville, 27
Storm at Belle-Ile, 26
Studio-Boat, The, 66
techniques of, 73–76, 77, 78, 79, 80
Turner and, 17, 50, 63–64
"virility" of, 171
Waterloo Bridge, Effect of Sunlight with Smoke, 61
Windmill at Zaandam, 63, 64
Women Carrying Wood, Forest of Fontainebleau, 43, 44
working methods of, 13, 173
Monet, Claude, works of, 19, 25, 26, 27, 29, 43, 44, 45, 46, 47, 50, 59, 60, 61, 63, 66, 76, 77, 78, 122, colorplates 1–3, 5, 7, 9, 10, 13, 15, 22, 23, 27–32

Cathedral series, 145, 166–167
color in, 169
as documentary in character, 8, 10, 12, 170, 175
Friedrich's works compared with, 18–20
Gare Saint-Lazare series, 12, 28, 74
Grainstack series, 21–23, 75
"Impressionist" vs. "Post-Impressionist," 11–13, 160
light in, 24, 29, 43, 73, 74, 75–77, 80, 175
modernism and, 175–176
motifs in, 18, 20, 21, 23, 43, 45–50, 56, 57, 168, 173
pochades, 71–73, 74, 76, 77, 79, 80
Romantic roots of, 12, 17, 20, 21–23, 24, 65, 74
Morisot, Berthe, 39–40, 41, 151, 152, 155–156, 156, colorplate 20
Harbour at Lorient, The, 39, colorplate 20
Lake in the Bois de Boulogne (Summer Day), 155–156, 156
Müller, Johannes, 113, 173

Naturalism, 9, 10, 14, 121, 122, 123
nature, 110, 111, 112, 113, 120, 161, 167, 174
"effects" of, see effect
gendered relationship between art, science and, 14, 16, 143, 145–158, 161–162, 163–165, 167, 173, 175, 176, 177–178, 179
Impressionism's relation to, 69, 110, 151, 156–157, 158, 161, 162, 163, 172, 179
Romanticism's relation to, 20, 21–23, 24, 69, 110, 143, 147, 149, 150–151, 154–155, 163, 176, 177, 179
Neoclassicism, 10, 14, 150
Neo-Impressionism, 137–143, 144
Newtonian science, 111, 112, 113, 114–115, 126, 148

Objectivity, 16, 110, 134, 145, 146, 154, 178
gendering of, 143
of Impressionism, 8–9, 10–11, 12, 13–14, 15–16, 31, 65, 110–143, 144, 145,

158, 160, 162, 163–164, 167, 168–171, 173, 174, 179

Oersted, H. C., 111, 112

Perry, Lilla Cabot, 78, 157–158

perspective, 147, 154–155, 157

photography, 24, 33, 35–39, 136, 155

Picasso, Pablo, 175, 177, 178

Demoiselles d'Avignon, 175

Pissarro, Camille, 12, 15, 56, *56, 57, 58,* 64, 65, *129,* 138, 139, *140, 141,* 151,

Apple Harvest at Eragny, 140, colorplate 26

Artist's Garden at Eragny, The, 141

Banks of the Marne at Chennèvieres, 55, colorplate 26

Corot as teacher of, 40–41

Daubigny's influence on, 55–56

English landscape painters and, 57–63

In the Kitchen-Garden, 129

Jallais Hill, Pontoise, 56

Landscape, Vicinity of Pontoise, 129

Lower Norwood, London, Effect of Snow, 58

Martelli and, 128–130

Neo-Impressionist works of, 142–143

Pissarro, Lucien, 138, 142

Plato, 145

pochades, 69

of Daubigny, 71

of Monet, 71–73, 74, 76, 77, 79, 80

poets, 114–115, 116, 120, 149

Pollock, Griselda, 155

Pool, Phoebe, 17

Pope, Alexander, 114

positivism, 15, 110, 113, 116, 121, 122, 123, 137, 143, 144, 145, 153, 158, 160, 165, 166, 167, 170, 173

Post-Impressionism, 10, 11, 12, 162, 164, 177

Pothey, Alexandre, 29, 30, 31, 80

Rationality, rationalism, 10, 14, 16, 70, 111, 112, 113, 114, 115, 116, 119, 121, 123, 137, 143, 146, 149, 152, 165, 166, 179

Impressionism aligned with, 10–11, 13

Realism, 10, 13, 16, 121, 122, 123, 163, 172

Impressionism as, 8–9, 10–11, 12, 13–14, 15–16, 31, 65, 110–143, 144, 145, 158, 160, 162, 163–164, 167, 168–171, 173, 174, 179

reason, *see* rationality, rationalism

Renan, Ernest, 166

Renoir, Pierre Auguste, 12, 43, 72, 142, 151, 171

Republic, Third, science and, 165–174

Robert, Karl, 69

Robinson, Theodore, 23, 63, 76, 77, 78

Roger-Marx, Claude, 164

Romanticism, 17–80, 125, 172

effect and emotion in, 28–68

feminization of, 110, 147, 149–150, 164

Impressionism as opposed to, 8, 9–10, 11, 14, 18, 110, 125–126, 144, 145, 177

Impressionism's roots in, 10, 15, 18–24, 31, 69, 70, 110, 127, 136, 137, 143, 158

landscape vs. figurative schools of, 150–151

masculinization of, 179

modernism and, 176, 178–179

nature and, 20, 21–23, 24, 69, 110, 143, 147, 149, 150–151, 154–155, 163, 176, 177, 179

science and, 15, 111–114, 115, 116, 117, 120, 144, 147, 148

Rosenblum, Robert, 18

Modern Painting and the Northern Romantic Tradition: Friedrich to Rothko, 18

Rousseau, Théodore, 12, 17, 24, 30, 34, 41, 43–45, 48, 57, 176, colorplates 6, 18

Edge of the Forest of Fontainebleau at Sunset, The, 45, 48

Forest of Fontainebleau, Morning, The, 45, 48

Road in the Forest of Fontainbleau, Effect of Storm, colorplate 18

Sunset near Arbonne, colorplate 6

working method of, 34–35

Runge, Philipp Otto, 23

Ruskin, John, 33–34

Schapiro, Meyer, 8–9, 73

Schelling, F. W. J. von, 31, 111, 112, 120, 147

Naturphilosophie, 147

System der Naturphilosophie, 111, 112

science, 110, 134, 158

art and, 110, 114–123, 134, 137, 143, 144, 145, 161, 179

gendered relationship between art, nature and, 14, 16, 143, 145–158, 161–162, 163–165, 167, 173, 175, 176, 177–178, 179

Impressionism associated with, 8–9, 10–11, 12, 13–14, 15–16, 31, 65, 110–143, 144, 145, 158, 160, 162, 163–164, 167, 168–171, 173, 174, 179

"normal," 15, 111–114, 115, 143, 144, 179; *see also* positivism

Republican defense of, 165–174

Romanticism and, 15, 111–114, 115, 116, 117, 120, 144, 147, 148

Symbolism and, 164, 165, 168

Seurat, Georges, 75, 138–139, *138,* 141, 142, 151

Sunday Afternoon on the Island of La Grande Jatte, 138, 139

Shelley, Mary Wollstonecraft, 148

Shelley, Percy Bysshe, 115, 149

Frankenstein, or the Modern Prometheus, 148

Shiff, Richard, 13, 16, 153, 159–160, 162–163

Signac, Paul, 138, 139–140, 142

From Delacroix to Neo-Impressionism, 139–140

Sisley, Alfred, 15, 43, 142, 151, 162

sketches, 70–71, 73

see also pochades

Stuckey, Charles F., 173

subjectivity, 15, 16, 110, 111, 114, 134, 143, 149, 153, 178–179

gendering of, 143, 178–179

of Impressionism, 13, 31, 69, 110, 126–127, 135–137, 143, 144, 158, 163–164, 174

Surrealism, 11, 175

Sweeney, James Johnson, 10–11, 170

Symbolism, 10, 11–12, 13, 16, 57, 144–145, 158, 159–165, 166, 171, 177, 178, 179

science and, 168

theory and definition of, 160–161

Taine, Hippolyte, 132, 133, 143

Thoré, Théophile (W. Bürger), 34, 68, 70, 136

Troyon, Constant, 41

Départ pour le marché, Le, 41

Tucker, Paul Hayes, 9, 18, 168, 173–174

Turner, J. M. W., 12, 17, 20–21, 24, 57, 61, 62, 155

Burning of the Houses of Parliament, The, 64, colorplate 4

color and light in works of, 24, 33–34, 63

Fighting Temeraire Tugged to Her Last Berth, The, 20–21, *22,* 57

Monet and, 17, 50, 63–64

Norham Castle, Sunrise, colorplate 14

Peace—Burial of Wilkie, 51, 57

Shipwreck, The, 24

Sun of Venice, The, 57, 64

Sunset: Rouen (?), colorplate 24

Updike, John, 173–174

Wollstonecraft, Mary, 148, 149

women, 151–152, 153–154, 175, 177

Wordsworth, William, 74, 80, 115

Zola, Emile, 10, 28, 122–123, 128, 137, 166